CANON
5D MARK II

THE EXPANDED GUIDE

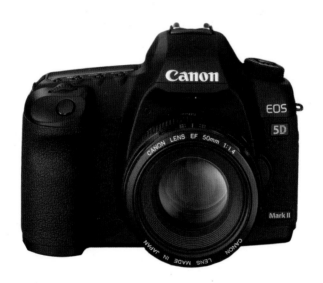

AMMONITE
PRESS

CANON EOS 5D MARK II

THE EXPANDED GUIDE

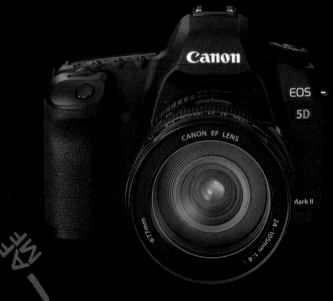

Andy Stansfield

AMMONITE
PRESS

First published 2009 by
Ammonite Press
an imprint of AE Publications Ltd
166 High Street, Lewes, East Sussex BN7 1XU

ISBN 978-1-906672-41-6

British Library Cataloguing in Publication Data:
A catalogue record of this book is available from the British Library.

Editor: Tom Mugridge
Design: Fineline Studios

Typefaces: Frutiger and Palatino
Colour reproduction by GMC Reprographics
Printed and bound in China by Hing Yip Printing Co. Ltd

Contents

Chapter **1**

Overview

The EOS 5D Mk II is the latest offering in Canon's semi-professional range of digital SLRs. This outstanding camera evolved from the EOS D30, picking up technical developments from the EOS-1 range along the way.

First announced in 2000, the EOS D30 offered just over 3 megapixels, 3-point autofocus, 3 frames per second and a burst of 3 JPEGs. Its monitor was just 1.8in (4.5cm) and could only be used for reviewing images already captured. Things have come a long way since then.

Back in the mid-1980s, when camera and lens designers were suddenly making huge inroads in forging new links between electronic and optical components, Canon

CANON EOS 5D Mk II
Those interested in the evolution of camera technology are advised to visit Canon's web site at www.canon.com/cameramuseum.

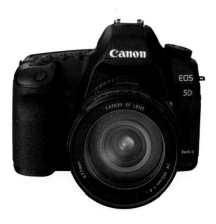

designers were pre-empted by autofocus SLRs from first Minolta, then Nikon. An intense two-year period of research and development followed for Canon who saw that these new cameras would ultimately form the basis of an extensive and flexible system, so every aspect of the camera needed to be stylish as well as practical.

The early Canon EOS models were designed with three criteria in mind: that the introduction of an AF system should not increase the price point; that the camera should be capable of shooting sports events handheld with a 300mm f/2.8 lens or similar; and that autofocus capability should match exposure sensitivity in low-light situations.

In March 1987 they put their ideas to the test with the launch of the first EOS model. EOS stood for Electro Optical System and the camera in question was the EOS 650, which was soon to receive the accolade of European Camera of the Year. Eos was also the Greek goddess of the dawn, described by the ancient writer Hesiod as 'Eos, who brings light to all the mortals of

this Earth'. Fanciful perhaps, but an altogether more suitable explanation of the name that heralded the most successful series of developments in the history of photography.

Ironically, the goddess Eos was the daughter of two Titans. Minolta and Nikon, perhaps?

High-end developments

During the next two years, new models appeared in the form of the EOS 620 and the EOS 630, but the most significant launch was reserved for the EOS 1, which was specifically designed to lure professionals away from other manufacturers' models. To support this drive to attract the high-end user, Canon also had to develop its lenses and worked hard to reach the forefront of lens technology. In particular, they needed to develop a superfast autofocus system that would work in all lighting conditions with the large-aperture lenses favoured by press and sports photographers.

By late 1994, Canon was ready to introduce a new top-of-the-range model in the form of the EOS 1N, which introduced much quieter operation, 5-point AF and a 16-zone evaluative metering system. Its high-speed sister, the EOS-1N RS, boasted a drive capable of ten frames per second, a rate that manufacturers still find hard to beat, even today.

While Canon continued the evolution of its amateur SLRs, introducing innovations like eye-control focusing, the EOS-1N continued to serve professionals well for half a decade.

A new flagship model, the EOS 3, was launched in November 1998, by which time the key areas of metering and autofocus were undergoing rapid development and Canon was about to embark on a decade of model upgrades every 18–24 months.

The Canon EOS 3 utilized a 21-zone metering system linked to AF points, of which there were eventually 45.This increased the speed of operation further, especially when combined with the eye-control

A PERFECT MARRIAGE
Canon's range of SLR cameras marries sophisticated electronics and complex optics to a tough bodyshell.

system. A top shutter speed of 1/8000 sec was also included, along with a claimed lifetime of at least 100,000 shutter operations.

The EOS 1V was introduced in the spring of 2000 with high-speed continuous shooting of up to 9 frames per second and 20 custom functions that could be tailored to each individual. The EOS D30, also launched in 2000, brought into play an affordable digital SLR aimed at the non-professional enthusiast. With its Canon-developed CMOS sensor, the EOS D30 could boast the smallest and lightest body in this sector of the market.

It also heralded a new approach to photography in which those with little experience could access the capabilities of a complex tool using the now-familiar Basic Zone settings indicated by symbols on the Mode Dial. Further foolproofing was added in the form of a 35-zone evaluative metering system and E-TTL (electronic through the lens) metering for its built-in flash. Canon RAW image files could now also be selected instead of JPEG files.

The EOS 1D was introduced in 2001, followed in 2002 by the EOS 1Ds. These took specifications and speed to staggering new levels, and recent updates have continued the trend. Today we can expect to find superfast processors like the 5D Mk II's DIGIC 4; an Integrated Cleaning System on the camera sensor; sophisticated exposure adjustments such as Highlight Tone Priority, and the ability to download a range of Picture Styles, even on entry-level models like the EOS 1000D.

DIGIC 4 PROCESSOR
The heart of any camera is its processor. The EOS 5D Mk II's DIGIC 4 is considerably faster than the EOS 5D's DIGIC II version.

10

Main features

Body
Dimensions: 152 × 113.5 × 75mm
Weight: 810g
Construction: magnesium alloy
Lens mount: EF only
Caution: operating environment
0–40°C at maximum 85% humidity

Sensor & processor
Processor: DIGIC 4
Sensor: 36 × 24mm CMOS
self-cleaning sensor
Effective pixels: 21.1Mp
Total pixels: 22Mp
Colour Filter Type: Primary Colour

File types and sizes
JPEG file sizes range from 5616 × 3744
pixels to 2784 × 1856 pixels with a
choice of fine or normal for each of the
large, medium or small settings. RAW
files are recorded as 5616 × 3744 pixels,
sRAW 1 files as 3861 × 2574 pixels
and sRAW 2 as 2784 × 1856 pixels.
The EOS 5D Mk II can record RAW/
sRAW1/sRAW2 or JPEG files either on
their own or simultaneously in any
combination. Both sRGB and Adobe
RGB colour spaces are supported.

Movie clips are recorded as MOV files
with a maximum duration of 29 min 59
sec and a maximum file size of 4GB.

SENSOR
The Canon EOS 5D Mk II boasts
a self-cleaning CMOS sensor.

Files can be recorded as HD 1920 ×
1080 (16:9 format) or SD 640 × 480
(4:3 format) at 30fps.

Shutter
The EOS 5D Mk II uses an electronically
controlled focal-plane shutter, providing
shutter speeds from 1/8000 sec to 30 sec
in 1/3- or 1/2-stop increments and bulb.
Drive options include single frame,
continuous shooting at up to 3.9fps, a
10-sec self-timer/remote control and a
2-sec self-timer/remote control. Shutter
life is quoted as 150,000 actuations.

Focusing
Three different autofocus modes,
including predictive autofocus, can
be selected to suit static or moving
subjects: One Shot, AI Focus or AI Servo.

Both automatic and manual selection of an AF point, or all AF points, is possible from the nine sensors. The centre AF point is '+' type and sensitive to both the horizontal and vertical characteristics of the subject, whereas the remainder will seek either one or the other. There are also a further six non-selectable AF-assist points within the spot-metering circle which function in AI Servo mode.

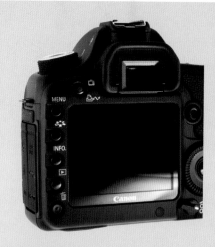

The AF system's working range is from EV -0.5 to EV 18 at 20°C at ISO 100. Autofocus lock is possible in One Shot mode and, when using flash, an AF-assist beam is triggered if selected within the Custom Functions. AF Microadjustment enables minute focus corrections for to up to 20 lenses. Autofocus is not possible on lenses slower than f/5.6, or effectively slower than f/5.6 when using an extender.

LCD monitor
The Clear View TFT high-resolution 3in (7.6cm) monitor, with its 920,000 dots and dual anti-reflection coating, is a vast improvement over previous models. It provides 100% coverage and seven manually selectable levels of brightness or three auto levels. This makes it easy to review captured images and is used in Live View mode

for composing and checking fine detail. Magnification of ×5 and ×10 plus vertical and horizontal scrolling of the magnified portion of the image assist this process. As such, it will be of benefit to those working on a tripod in studio conditions or with static subjects in stable lighting conditions. Manual focus or three AF modes (Quick mode, Live mode and Live Face Detection mode) are possible in Live View mode; two different grid overlays can also be selected.

Exposure
The 35-zone silicon photocell sensor provides four full-aperture TTL metering modes: Evaluative, Partial (8% at centre), Spot (3.5% at centre) and Centre-weighted Average

metering. Evaluative metering can be linked to any AF point. The metering range is EV 1 to EV 20 at 20°C at ISO 100 using a 50mm f/1.4 lens. Both exposure compensation and three-shot auto-exposure bracketing are possible to a maximum of +/-2 stops using either ½- or ⅓-stop increments. Exposure compensation and bracketing can be used together.

Automatic ISO setting can be selected between ISO 100 and ISO 3200, or manual ISO settings can be used between ISO 100 and ISO 6400 in ⅓- or 1-stop increments, expandable to 50 (L), 12,800 (H1) or 25,600 (H2).

Custom Functions
25 Custom Functions are supported, with a total of 71 different settings.

Software
Zoom Browser EX/Image Browser, PhotoStitch, EOS Utility (including Remote Capture, WFT Utility, Original Data Security Tools), Picture Style Editor, Digital Photo Professional.

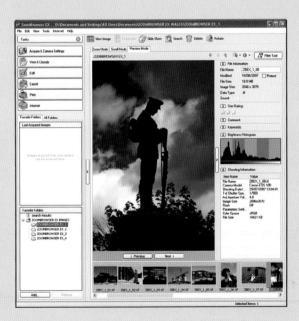

ZOOM BROWSER
Canon software is provided with the EOS 5D Mk II to help you explore its full potential.

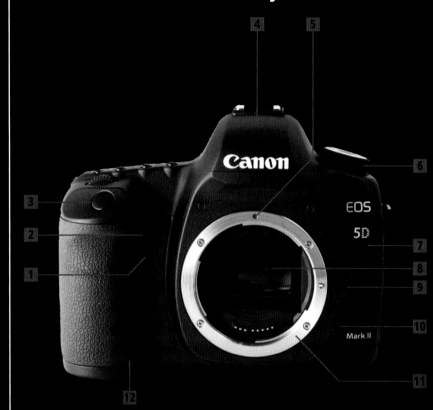

FRONT OF CAMERA

1 Self-timer light

2 Remote-control sensor

3 Shutter-release button

4 Built-in flash

5 EF lens mount index

6 Mode Dial

7 Microphone

8 Reflex mirror

9 Lens-release button

10 Depth-of-field preview button

11 Lens mount

12 DC coupler cord hole

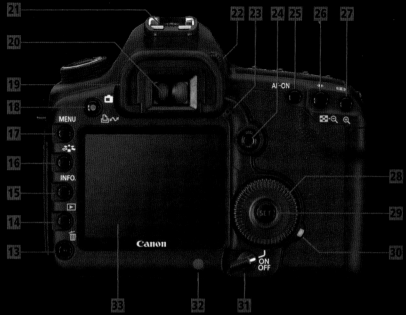

BACK OF CAMERA

13 Erase button
14 Playback button
15 INFO/Trimming orientation button
16 Picture Style selection button
17 MENU button
18 Live View/Print/Share button
19 Eyecup
20 Viewfinder eyepiece
21 Hotshoe
22 Dioptre adjustment
23 Speaker

24 Multi-controller
25 AF-ON button
26 AE lock/FE lock/Index/Reduce button
27 AF point selection/Enlarge button
28 Quick Control Dial
29 Setting/Movie shooting button
30 Access lamp
31 Power on/Quick Control Dial switch
32 Light sensor
33 LCD monitor

TOP OF CAMERA

34 Mode Dial

35 Camera strap eyelet

36 Lens-release button

37 Hotshoe

38 Metering mode/
White-balance selection button

39 AF mode/Drive mode selection button

40 ISO/Flash exposure compensation
selection button

41 Shutter-release button

42 Main Dial

43 LCD top panel
illumination button

44 LCD top panel

45 Dioptre adjustment

46 Focal plane mark

LEFT SIDE

47 PC terminal

48 Remote-control terminal

49 External microphone
in terminal

50 Audio/Video out terminal

51 Digital terminal

52 HDMI mini out terminal

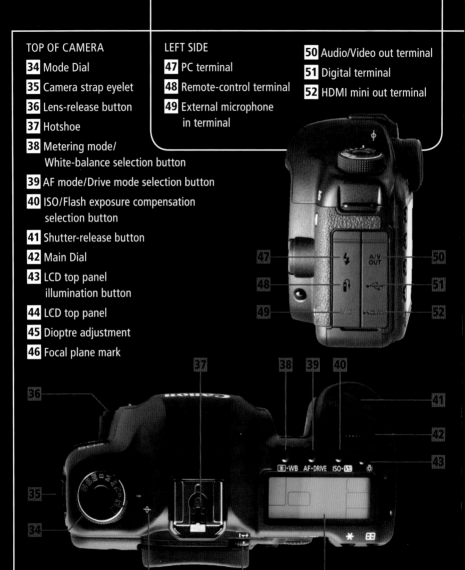

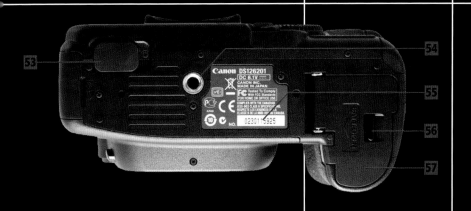

BOTTOM OF CAMERA

53 Extension system terminal

54 Tripod socket (¼in)

55 Camera serial number

56 Battery compartment lock release

57 Battery compartment

RIGHT SIDE

58 Main Dial

59 Camera strap eyelet

60 CompactFlash card cover

61 Shutter-release button

Viewfinder display

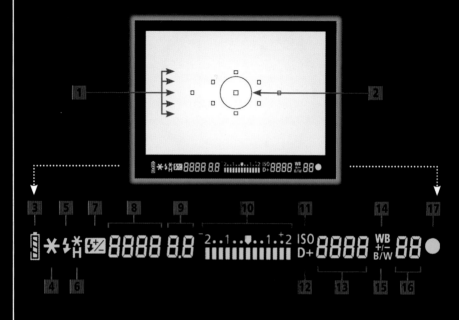

1 Focus points

2 Spot metering circle

3 Battery check

4 AE lock/AEB in progress

5 Flash ready indicator/Improper FE lock warning

6 High-speed sync indicator

7 Flash exposure compensation

8 Shutter speed/Flash exposure lock/ Busy indicator/CompactFlash card full indicator/ CompactFlash card error indicator/ No CompactFlash card indicator

9 Aperture value

10 Exposure level indicator/Exposure compensation indicator/Flash exposure compensation indicator/ Auto exposure bracketing display

11 ISO indicator

12 Highlight Tone Priority

13 ISO speed

14 White-balance correction

15 Monochrome shooting

16 Maximum burst indicator

17 Focus confimation indicator

LCD control panel

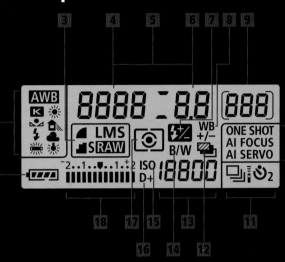

1 Battery check

2 White-balance preset

3 Image format, size and quality

4 Shutter speed/Busy indicator

5 Autofocus point selection/
CompactFlash card full indicator/
CompactFlash card error indicator/
No CompactFlash card indicator/Error
indicator/Cleaning sensor indicator

6 Aperture

7 Flash exposure compensation icon

8 White-balance correction

9 Shots remaining on card/Shots
remaining during white-balance
bracketing/Self-timer countdown/
Bulb exposure time

10 AF mode

11 Drive mode

12 Auto exposure bracketing icon

13 ISO speed

14 Monochrome shooting

15 ISO speed

16 Highlight Tone Priority

17 Metering mode

18 Exposure level indicator/Exposure
compensation indicator/Auto exposure
bracketing display/Flash exposure
compensation indicator/CompactFlash
card writing status

Menu displays

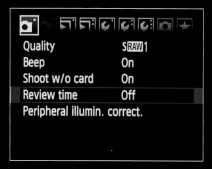

SHOOTING MENU 1 📷
Quality
Beep
Shoot without card
Review time
Peripheral illumination correction

SHOOTING MENU 2 📷
Exposure compensation/AEB
White balance
Custom white balance
White-balance shift/bracketing
Colour space
Picture style
Dust Delete Data

PLAYBACK MENU 1 ▶
Protect images
Rotate
Erase images
Print order
Transfer order

PLAYBACK MENU 2 ▶
Highlight alert
AF point display
Histogram
Slide show
Image jump with 🔆 Main Dial

SET-UP MENU 1 🔧
Auto power-off
Auto rotate
Format
File numbering
Select folder

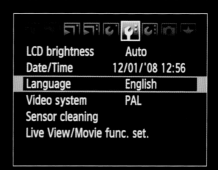

SET-UP MENU 2 🔧
LCD brightness
Date/Time
Language
Video system
Sensor cleaning
Live View/Movie function settings

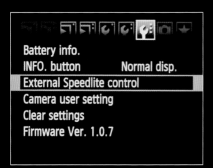

SET-UP MENU 3 🔧
Battery info
INFO button
External Speedlite control
Camera user setting
Clear settings
Firmware version

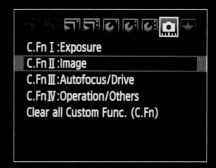

CUSTOM FUNCTIONS MENU 📷
C.Fn I: Exposure
C.Fn II: Image
C.Fn III: Autofocus / Drive
C.Fn IV: Operation / Others
Clear all Custom Functions

For MY MENU, see page 74.

Shooting Functions display

1 Quick Control icon
2 Image recording quality
3 AF point
4 Shooting mode
5 Exposure level/AEB range
6 Shutter speed
7 Aperture value
8 AE lock
9 Picture Style
10 ISO speed
11 Highlight Tone Priority
12 Flash exposure compensation
13 Metering mode
14 Drive mode
15 Shots remaining

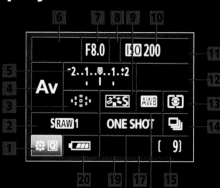

16 White balance
17 Maximum burst indicator
18 AF mode
19 White-balance correction
20 Battery check

Camera Settings display

21 Shots available/Free space on memory card
22 Auto power-off
23 White-balance shift/bracketing
24 C1,C2,C3 shooting mode
25 Colour space
26 Colour temperature
27 Auto rotate setting
28 Transfer by WFT-E4 failed
29 Date/Time

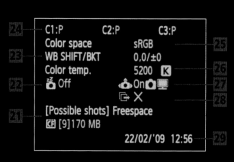

Default settings

OVERVIEW

Camera Settings

Auto power-off	1 min	Auto rotate	On 📷🖥
Beep	On	LCD brightness	Auto: Standard
Shoot without card	On	Date/Time	No changes
Review time	2 sec	Language	No changes
Highlight alert	Disable	Video system	No changes
AF point display	Disable	Camera user settings	No changes
Histogram	Brightness	My Menu settings	No changes
Image jump with 🎛	10 images		

Image Recording Settings

Quality	◢ L
ISO speed	Auto
Picture Style	Standard
Color space	sRGB
White balance	AWB (Auto)
WB correction	Cancelled
WB-BKT	Cancelled
Peripheral illumination correction	Enable/ Correction data retained
File numbering	Continuous
Auto cleaning	Enable
Dust Delete Data	Erased

Shooting Settings

AF mode	One-Shot AF
AF point selection	Automatic selection
Metering mode	⊙ (Evaluative metering)
Drive mode	☐ (Single shooting)
Exposure compensation	0 (Zero)
AEB	Cancelled
Flash exposure compensation	0 (Zero)
Live View shooting	Disable
Custom Functions	No changes

Chapter **2**

Functions

The launch of the Canon EOS 5D Mk II was an eagerly awaited event. Arriving just over three years after its predecessor – a long wait by Canon's standards – rumours and predictions were rife regarding the Mk II's features. When it was finally announced, it certainly wasn't the package that most were expecting. It also introduced a controversial new feature: HD Movie mode.

While Nikon had already introduced a movie-mode DSLR into its range, it lacked the quality that Canon had been quietly developing: an HD version which would compete, at least in terms of quality, with dedicated movie cameras.

For stills shooters, the 5D Mk II boosted its sensor from the EOS 5D's 12.8Mp up to 21.1Mp, skipped a step from the EOS 5D's DIGIC II processor to the vastly superior DIGIC 4 version, and introduced the possibility of shooting at up to ISO 25,600.

All the other developments of the previous three years – an Integrated Cleaning System on the sensor, 3in (7.6cm) LCD monitor with four times the resolution, Live View, sRAW files, Highlight Tone Priority, Auto Lighting Optimizer, Auto Correction of Lens Peripheral Illumination, and AF Microadjustment of lenses in-camera, also found their way onto the Mk II, giving it a vastly superior specification compared to its predecessor.

When it was finally launched, the Canon EOS 5D Mk II was sold as either just the body or as a kit with the EF 24–105mm f/4 L IS, one of the most popular 'walkabout' lenses with professional photographers.

This chapter will explore the 5D Mk II's potential, step by step, by presenting basic information first and examining more complex issues in subsequent sections.

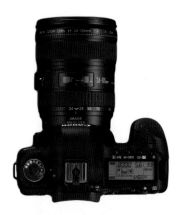

EOS 5D MK II KIT
The 5D Mk II is sold body-only or as a kit with an EF 24–105mm f/4 L IS lens, shown here.

KIT CAR

At the earliest opportunity, take your newly acquired
EOS 5D Mk II with just one lens to an inspirational
location that will provide a variety of subject and
exposure challenges – and play!

Settings
Aperture Priority (Av)
ISO 400
1/1000 sec at f/8
Evaluative metering
White balance: 5200ºK
One Shot AF

Camera preparation

Sometimes it is necessary to change lenses or memory cards in the dark or while holding a conversation with a subject with whom it is important to maintain eye contact. Long before that situation arises, those actions will need to have been practised time and time again until they can be performed automatically. Your camera should function almost as an extension of your body.

Tips

Before changing a lens, ensure that there is no risk from the people or circumstances around you of being caused to drop either camera or lens. Try to avoid changing lenses in windy, dusty or sandy environments.

One solution to the problem of changing lenses in a dusty or sandy environment is to use a changing bag – a lightproof bag about 2ft (60cm) square with zipped access for inserting equipment and two elasticated arm holes. Originally designed for loading light-sensitive film in the camera or to load exposed film into a developing tank, the changing bag can serve a new purpose in the digital era.

Attaching the strap

A camera strap should be used at all times to ensure the safety of your camera. To attach it, pass the end of the strap through either the left-hand or the right-hand eyelet, situated at the top of the camera. Then pass the end of the strap through the buckle, under the existing length of strap that is already threaded through the buckle. Repeat the operation on the other side. Pull lightly to remove most of the slackness, position the buckle as desired, then pull more firmly to ensure the strap will not loosen within the buckle.

Fitting and removing a lens

Remove the rear body cap of the lens to be fitted, and the camera body cap or the lens already fitted to the camera. This is done by depressing the lens-release button while turning the cap or lens anti-clockwise as it is facing you. Align the lens to be fitted, insert it into the camera and turn it clockwise until a faint click can be heard. Check that the AF/MF switch on the lens is set to the desired position.

After removing a lens, ensure that the lens cap is fitted and put it down safely with the rear end up. Fit the rear lens cap as soon as possible. Avoid touching the lens contacts, as dirty contacts can cause a malfunction.

1) Ensure that the camera is switched to **OFF** and that the small red access lamp on the back of the camera next to the ⟳ Quick Control Dial is not illuminated.

2) With the camera facing away from you, the memory card slot cover is on the right side of the camera body. To open it, slide the cover towards you with firm finger pressure and it will swing outwards on its hinges.

3) If removing a memory card, press firmly on the grey memory card eject button located at the bottom of the card slot and slide out the card.

4) To insert a memory card, slide the memory card into the camera's slot with its label side facing you, and with the two parallel rows of minute holes along the card edge to your left. When the card is almost fully inserted, slight resistance will be felt – push a little harder and the card will slide fully home and the eject button will spring back out.

5) Press the cover shut and slide it forwards until it snaps into position.

Common errors

When the red access lamp on the back of the camera (next to the ⟳ Quick Control Dial) is lit or blinking, it indicates that images are being processed – this may include being written, read, erased, or transferred to another device. Do not remove the battery or memory card if the lamp is illuminated or blinking. Either of these actions is likely to damage image data and may cause other camera malfunctions.

Tip

To enable shooting without a memory card inserted, see 📷 Shooting menu 1. This facility can be used for remote shooting when saving direct to the computer.

If the **Err CF** error message appears on the LCD, there may be a problem with your memory card. To save any images already on the card, transfer them to a computer and then attempt to reformat the card in the camera.

Using the EOS 5D Mk II without spectacles is facilitated by the eyepiece dioptre adjustment to the right of the viewfinder. Turn the knob so that the AF points in the viewfinder are sharp. If this is insufficient, ten different versions of the Dioptric Adjustment Lens E are available separately.

Using mains electricity

By using the AC Adaptor Kit ACK-E6 (available separately) you can connect the EOS 5D Mk II to a mains power outlet instead of using battery power. Connect the DC coupler's plug to the AC adaptor's socket. Connect the power cord to the AC adaptor and then to the power outlet. Open the camera's battery compartment and, having removed the battery, insert the DC coupler with its cord running through the notch. Close the battery compartment cover.

Warning!
Never connect or disconnect the power cord while the camera is switched on.

Inserting the battery

The EOS 5D Mk II is equipped with an LP-E6 7.2v DC 1800 m/Ah lithium-ion battery, but can also run on AA/LR6 batteries when using the BG-E6 battery grip, using the special AA battery magazine which comes with the grip.

Turn the camera upside down and locate the battery compartment on the right-hand side. Apply slight pressure to the lock and open the compartment. With the battery contacts downwards and to your left, insert the battery until it locks in position. Shut the battery compartment cover until there is an audible click. To remove the battery, ease the white plastic retaining clip to the side. Once removed, a battery should have its protective cover attached to prevent shorting.

30

Battery charging

Use Battery Charger LC-E6E (also LC-E6) to charge the 5D Mk II's dedicated LP-E6 battery. Remove the battery's protective cover and insert it into the charger. Slide the battery in the direction of the arrow while pressing down on the battery. Connect the power cord to the LC-E6E charger and insert the plug into a mains outlet. With the LC-E6 charger, flip out the prongs and plug the unit directly into a mains outlet. Recharging is indicated by a blinking orange lamp. A constantly illuminated green lamp indicates a fully charged battery. A fully discharged battery will take approximately 150 minutes to recharge fully at 23°C (73°F).

Recharge level	Lamp blinks
0–50%	Once per sec
50–75%	Twice per sec
75–99%	Three times per sec
100%	On continuously

Tip
The battery charger can be used abroad (100–240 v AC 50/60 Hz) with a travel adaptor. Do not attach any form of voltage transformer.

Battery life

The life of any battery will depend upon several factors: working temperature, past treatment of the battery, use of the image review facility, choice of lens and use of the Image Stabilizer, auto power-off setting, long periods with the shutter button partially depressed (as when tracking a moving subject), and especially use of the Live View function. As a rough guide, a fully charged battery (without using Live View) will accommodate 850 shots at 23°C (73°F) or 750 at 0°C (32°F).

You can register the details of a specific battery in-camera and monitor its capacity and recharging performance using **⚙️** Set-up menu 3.

Tips
Even when it is not in use, your camera battery will gradually lose its charge. Remove the battery if the camera is to remain unused for a long period. Storing the battery after it is fully recharged may have a negative effect on the battery's performance.

The camera's operating range is 0–40°C (32–104°F) but at 30–40°C (86–104°F) or 0–10°C (32–50°F) you may find that the battery does not perform optimally.

Basic camera functions

The following pages refer frequently to three of the 5D Mk II's dials. They are key to the camera's operation and it is a good idea to memorize their symbols and location as soon as possible. They are the Mode Dial, the ○ Quick Control Dial and the ⌬ Main Dial. We shall come to the ✳ Multi-controller later. Let's start with the basics.

Switching the camera on

The power switch has three settings:

OFF The camera will not operate.

ON The camera operates but use of the ○ Quick Control Dial is disabled.

⌐ The camera including the ○ Quick Control Dial is fully operational.

Sensor cleaning takes place automatically each time you turn the camera on or off. A message to this effect is displayed briefly on the LCD monitor on the back of the camera. Automatic sensor cleaning can be disabled in ᵮᵀ⁼ Set-up menu 2.

Tips
If the camera is set to power-off automatically after a set interval (ᵮᵀ⁼ Set-up menu 1), partially depressing the shutter button will fully reactivate the camera.

If the power switch is turned to **OFF** while an image file is being written, the camera will finish recording the image before turning itself off.

FUNCTIONS

The 5D Mk II provides two frame-advance modes plus two self-timer settings, all of which fall into the category of Drive mode.

Select the Drive mode setting by pressing the **AF•DRIVE** button above the LCD panel on top of the camera and rotating the ⊙ Quick Control Dial. It can also be changed on the Quick Control Screen.

The 5D Mk II's maximum available burst of continuous images depends upon file quality, drive mode, memory card, and buffer space available. The figure for the number of burst frames possible is shown in the viewfinder at bottom right. This represents the maximum possible burst and therefore assumes continuous shooting even if that mode is not selected. The display shows a maximum of **99**, which indicates 99 or higher.

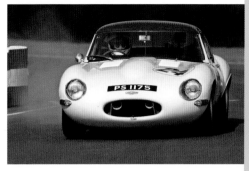

RACING CAR
The EOS 5D Mk II's maximum frame advance of 3.9 fps is fast enough for most situations – even British racing driver Martin Brundle in action.

Drive mode

Drive mode	
Single frame advance	☐
Continuous 3.9 frames/sec	⊒H
Low-speed continuous 3 frames/sec	⊒
Self-timer 10-second delay	☉
Self-timer 2-second delay	☉₂

Mode Dial

The Mode Dial provides ten different shooting modes, each of which will be explained in detail later in this chapter. These include two automated modes and three with user-defined settings, along with a Bulb setting for long exposures. To select the desired mode, turn the dial until its icon is lined up with the mark on the camera body.

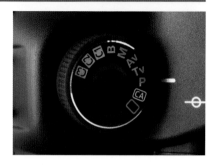

Mode dial			
Full Auto	⬭	Manual	**M**
Creative Auto	**CA**	Bulb (time exposure)	**B**
Program	**P**	User-defined settings	**C1**
Shutter Priority	**Tv**	User-defined settings	**C2**
Aperture Priority	**Av**	User-defined settings	**C3**

Custom exposure modes

The Mode Dial enables you to define a set of parameters and save them as a Camera User Setting. You can do this three times over using the **C1**, **C2** and **C3** settings.

Consider the situations in which you take photographs and identify the key factors that affect each one. For example, you may find it useful to create a group of settings that is suitable for studio or close-up work using Live View, a group for wedding photography incorporating Highlight Tone Priority and noise reduction, and so on.

This function is particularly useful if you use two or more bodies, as you can set up identical Camera User Settings on each body. You can always change to one of the other modes if you need to break away from your favoured settings.

34

Operating the shutter-release button

The shutter-release button has two functions. Partially depressing it brings into play the autofocus and metering functions. Pressing it fully releases the shutter and takes the picture using the focus and exposure settings that were registered when you only partially depressed the shutter release. If the shutter-release button is fully depressed immediately, there will be a momentary delay before the picture is taken. If you have purchased the Battery Grip BG-E6 to go with your camera, then exactly the

same applies to the additional shutter button provided on the battery grip for vertical shooting.

Operating the Main Dial

In **P** mode the ✑ Main Dial used on its own will adjust both aperture and shutter speed while retaining the equivalent exposure. In **Tv** and **M** modes it will adjust the shutter speed, and in **Av** mode it will adjust the aperture. All these functions are explained fully later in this chapter.

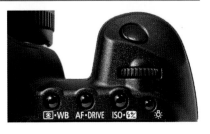

The ✑ Main Dial is also used to adjust the metering mode, autofocus mode, and ISO functions in combination with the buttons located immediately above the LCD panel on top of the camera. After pressing one of these buttons, each of which governs two different functions, the ability to adjust that function will remain active for six seconds. Having adjusted a setting, it is not necessary to wait for the six seconds to elapse:

partially depressing the shutter-release button will immediately return the camera to shooting readiness. Any adjustments made with the ✑ Main Dial will be visible in both the viewfinder and the LCD panel on top of the camera – with two exceptions. When adjusting metering mode or autofocus mode, the viewfinder display is temporarily turned off, so these adjustments can only be seen in the LCD panel on top of the camera.

FUNCTIONS

The EOS 5D Mk II accepts only EF and TS-E lenses. The former type is equipped with an AF/MF switch so you can easily change to manual focusing. This may be necessary in very low light or when you are focusing on something with insufficient contrast for an AF point to latch on to. It may also be useful when photographing landscapes to obtain maximum depth of field, or when taking extreme close-ups – especially if you are using the ×5 or ×10 magnification facility in Live View mode.

The camera is equipped with nine visible AF points which may function as a group or can be selected singly. Except in Creative Auto or Full Auto modes, the **AF•ON** button may also be used to achieve focus. In addition there are six hidden AF-assist points, located above and below the centre AF point and within the spot metering circle, which come into play when AI Servo mode is selected. These

are vertical-line sensitive with f/2.8–f/4 lenses and horizontal-line sensitive with f/5.6 lenses. The centre AF point is doubly sensitive and employs a '+' type sensor which is equally sensitive to the vertical and horizontal characteristics of the subject.

Three AF modes cover most eventualities:

One Shot mode

When you partially depress the shutter-release button, the camera will focus just once on the subject. It will not refocus until you withdraw the pressure and partially depress the shutter-release button again. When focus is achieved, the green focus confirmation light ● and the red AF point(s) that achieved focus will be visible in the viewfinder. There will also be a **beep** unless it has been switched off in Shooting Menu 1. If you continue to hold down the shutter-release button, focus will be locked and you can recompose your picture.

AI Servo mode

AI Servo mode is suited to subjects with sustained movement. This facility is useful when the camera-to-subject distance keeps changing. While you partially depress the shutter-release button, the camera will continue to readjust focus automatically. The exposure settings (normally selected when you partially depress the shutter-release button) will be fixed at the moment the picture is taken.

Tips

If focus cannot be achieved, the ● focus confirmation light will blink and you will not be able to take a picture even if you fully depress the shutter-release button. Under these circumstances, reposition the camera and try again, or switch the lens to manual focus.

36

When AF point selection is automatic and AI Servo is selected, the camera will first use the centre AF point to achieve focus, so it is necessary to place your subject centrally at the start, otherwise focus may track the wrong subject. If the subject moves away from the centre AF point during focus tracking, tracking will continue as long as the subject is covered by an alternative AF point.

In AI Servo mode the **beep** will not sound and the ● focus confirmation light will not be displayed in the viewfinder.

AI Focus

AI Focus is suited to a variety of still and moving subjects. In this mode the camera will switch between One Shot and AI Servo modes according to the movement of the subject. If focus is achieved using One Shot mode but the subject starts to move, the camera will automatically shift to AI Servo mode and track the subject, provided you keep the shutter-release button partially depressed.

Depth-of-field preview

The depth-of-field preview button is on the front of the camera, just below the lens-release button. Pressing it will stop the lens down to the currently selected aperture, providing a more accurate impression of the range of acceptable focus. A smaller aperture (higher f-number) will provide greater depth of field, but the viewfinder will appear darker as you stop down. The exposure is locked while the depth-of-field preview button is depressed.

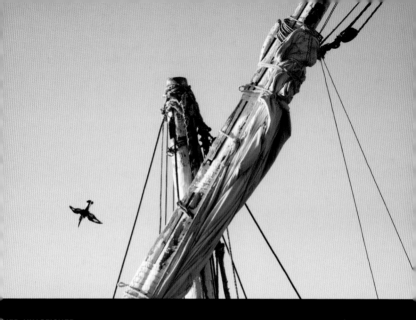

PIED KINGFISHER

The benefits of AI Focus mode are clearly demonstrated in this image.
I had observed the late-afternoon feeding habits of this pied kingfisher
the previous day, so the camera settings were determined in advance.
Selecting f/4 was risky but the kingfisher often dived to a particular spot
below the boat's mast which was on exactly the same plane as its perch.
I also wanted to use a very high shutter speed. AI Focus was selected so
that I could capture this exotic bird on its perch but be instantly ready
to follow its dive when necessary, the camera automatically switching
into AI Servo mode to track the subject. The final image has been
trimmed slightly to improve the composition.

Settings
Aperture Priority (Av)
ISO 800
1/8000 sec at f/4
Evaluative metering
White balance: 5200ºK
AI Focus AF

ISO setting

The ISO speed is the sensor's sensitivity to light and effectively governs the combined exposure values of aperture and shutter speed. A higher ISO speed enables a faster shutter speed and is therefore more useful in low light. However, higher ISO speeds generate more 'noise', producing a more grainy-looking image; so the slower the ISO speed, the crisper the final image. Doubling the ISO figure is equivalent to a 1-stop reduction in exposure and vice-versa.

Automatic ISO setting can be selected between ISO 100 and ISO 3200 (see Tips). Alternatively, manual ISO settings can be used between ISO 100 and ISO 6400 in $\frac{1}{3}$-stop or 1-stop increments, expandable to 50 (L), 12,800 (H1) or 25,600 (H2).

To set the ISO speed, press the **ISO•🔁** button and rotate the 🖐 Main Dial to set the desired ISO speed or Auto ISO. The selected setting is shown in both the viewfinder and the LCD panel on top of the camera. In order to set ISO 50 (L), ISO 12,800 (H1) or ISO 25,600 (H2), it is first necessary to enable ISO expansion in C. Fn I-3 (see page 106).

Tips

Increasing the ISO also increases the effective range of an external flash.

If you are using the Shooting Functions screen in conjunction with the **INFO** button, pressing the **ISO•🔁** button will bring up an ISO setting screen. Use the 🖐 Main Dial to amend the setting.

If Highlight Tone Priority is enabled in C.Fn I-3, the ISO range will be ISO 200–6400.

If Auto ISO is selected in Manual or Bulb modes, the ISO will be fixed at ISO 400.

If Auto ISO is selected in Flash mode, the ISO will be fixed at ISO 400 but will be automatically adjusted if over-exposure would occur at this setting.

The EOS 5D Mk II provides four different metering modes to cover any eventuality:

Centre-weighted average metering ⊏⊐

Gives added bias to readings taken from the centre of the frame, then averages readings from the whole area.

Evaluative metering ◉

Capable of coping with a wide range of lighting situations, including backlighting. It takes readings from 35 different zones.

Partial metering ⊙

Takes readings from just 8% of the frame at the centre and is especially useful if the background is significantly brighter than the subject. Can be used, in effect, as a spot meter with a larger than normal 'spot'.

Spot metering ⊡

Uses an area at the centre of the frame that equals just 3.5% of the viewfinder area. Can be used to take readings from small but important areas of the subject to ascertain an average tone, or any other tone if you know how its exposure will relate to the mid-tone.

To set the metering mode, press ◉•**WB** and rotate the 🗘 Main Dial. The setting is shown in both the viewfinder and the LCD panel on top of the camera, using the symbols ◉ ⊙ ⊡ or ⊏⊐.

If you're using the Shooting Functions screen in conjunction with the **INFO** button, pressing the ◉•**WB** button will bring up a metering mode settings screen. When the screen is active, use the ✳ Multi-controller to highlight the metering setting, then the 🗘 Main Dial to amend the setting.

40

EVALUATIVE METERING
Canon's 35-zone evaluative metering mode coped extremely well with this difficult subject. Only minor corrections were necessary in post-processing.

Settings
Manual (M)
ISO 100
1/400 sec at f/8
Evaluative metering
White balance: Auto
One Shot AF

Image playback

Using Shooting menu 1, immediate automatic playback of an image can be either disabled or enabled for a duration of 2, 4 or 8 seconds, or the image can be displayed indefinitely. With automatic review switched on, the magnification function is not possible. If the automatic image review function is disabled, you can manually review images by pressing the ▶ Playback button to the left of the LCD monitor. The first image to be shown will be the most recent or the last viewed. Use the Main Dial or the Quick Control Dial to scroll through the images.

SINGLE-IMAGE PLAYBACK
The following histogram display options are available during single-image playback.

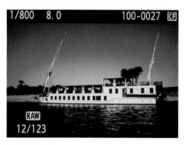

Single image

Single image with both RGB and Brightness histograms

Single image with RGB histogram

Single image with Brightness histogram

42

During playback, press the **INFO** button to change the display style: styles available are Single image, Single image with file quality setting, Histogram display, and Shooting information display. To exit playback from a single-image display, press the ▶ Playback button.

Magnify images

Zoom into the image to a maximum of 10× magnification by pressing the ⊞/⊕ button. Use the ✳ Multi-controller to move around the magnified image.

The ✳/⊟• ⊖ button zooms out again; alternatively, you can return to the full-frame view after zooming in by pressing the ▶ Playback button once.

Index display

Press the ✳/⊟• ⊖ Zoom out button while a full-frame image is displayed to display four images at the same time. Press it a second time to display nine images. The current image is highlighted in blue. To select a different image, rotate the ◯ Quick Control Dial or the � Main Dial. This multi-image display is referred to as the Index display. To revert to Single-image display, press the ⊞/⊕ Enlarge button.

Slide show

In ▶' Playback menu 2, select **Slide show** to run a consecutive display of images on the memory card. You can elect to display all the images on the memory card, images from a single folder, images from a specific date, stills only or movies only. To start or pause Auto Play, press the **SET** button; press it again to resume. In pause mode you can select a different image by rotating the ◯ Quick Control Dial or the ⌫ Main Dial (this will only change images one at a time). Press **MENU** to stop the Slide show. During Auto Play the auto power-off function will not work.

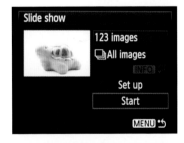

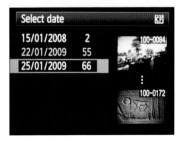

Rotating images

To rotate all portrait-format images automatically, enable Auto Rotate in ↑↑ Set-up menu 1. To rotate a single image, press **MENU** and select Playback Menu 1. Highlight **Rotate** and press **SET**. The display will return to Playback mode. Select the image you wish to rotate and press **SET** again. The image will rotate. Pressing **SET** repeatedly will rotate the image through different orientations.

Deleting images

Method 1

To delete a single or highlighted image, press the 🗑 Erase button and confirm the deletion by highlighting **Erase** and pressing **SET**. Alternatively, select **Cancel** and press **SET** to return to Playback mode.

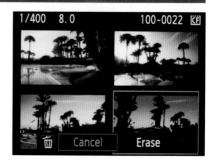

Tips

You can use the **JUMP** facility at any time while carrying out the above operations.

The total number of images you have selected for deletion is displayed to the right of the tick.

You can exit the process at any time by pressing **MENU**.

Protected images cannot be deleted using the above methods unless protection is removed. However, they will be deleted when a memory card is formatted.

Method 2

To delete single, selected, or all images, press **MENU** and use the ⚙ Main Dial to select Playback Menu 1. Select **Erase images** by rotating the ○ Quick Control Dial, then press **SET**. On the next screen, choose **Select and erase images**, **All images on card**, or **All images in folder** and press **SET**. A Cancel/OK option will appear. Select OK and press **SET** to erase the selected images.

If you choose **Select and erase images** and press **SET**, you can scroll through the images using either the ⚙ Main Dial or ○ Quick Control Dial. The latter will

always scroll by one image at a time. However, the 🖒 Main Dial will scroll according to the setting of **Image jump** with 🖒 in Playback menu 2. Pressing ✱/⊞• ⊖ will display three images at a time. Pressing ⊟/⊕ will restore the single-image display.

When you press **SET**, a white tick is added to a box either at the top of the selected image in Single-image display, or above the image when three images are displayed. To cancel the tick, press **SET** again with the image still selected.

You can scroll through consecutive images on the card and select all those you wish to erase by adding a tick as described above. When your selection of images to erase is complete, press 🗑. A Cancel/OK option will appear. Select OK and press **SET** to erase the images.

Protecting images

Press **MENU**. Select Playback menu 1, then **Protect images**. Press **SET**. Using the ✱ /⊞• ⊖ and ⊟/⊕ buttons, you can display a single image, four images or nine images at a time. A key symbol together with the word **SET** is displayed in the top-left corner of the LCD monitor, regardless of how many images are displayed.

Select the image to be protected and press **SET**. A smaller key symbol 🔑 will be displayed to the left of the folder number on the top line of the display to indicate that it is locked and cannot be deleted. To remove protection from the highlighted image, press **SET** again and the 🔑 key symbol will disappear. This operation can be carried out in either Single-image display or Index display (see page 43).

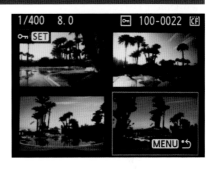

Notes
The 🔑 key symbol should not be confused with the larger key symbol accompanied by **SET**, which is an instruction, not a status indicator.

Protected images will still be erased when you format a memory card.

FUNCTIONS

Full Auto mode

Full Auto mode is a blessing for the less experienced photographer in situations where there is insufficient time to think carefully about camera settings and where lighting (and therefore exposure) is changeable. Basically, in Full Auto mode the camera does the thinking for you. This is often thought of as a basic mode but there is really nothing basic about it at all, as it takes into account most of the settings over which you could have some control

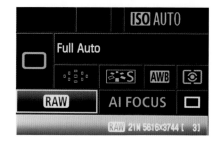

if you chose. The panel opposite indicates the various settings which the camera will select and which you cannot override.

Using Full Auto mode

1) Turn the Mode Dial to ▭.

2) Aim the camera at your subject. Focusing may be easier by placing the centre AF point over the main subject. You can recompose the picture later.

3) Lightly press the shutter button to achieve focus. The in-focus indicator ● and automatically selected AF points will be illuminated in the viewfinder. The exposure settings (aperture and speed) will appear at the bottom of the viewfinder.

4) Retain light pressure on the shutter button to keep the focus locked and recompose the picture before depressing the button fully to take the photograph.

5) After a very brief delay, the captured image will display on the LCD monitor for 2 seconds, unless the review function has been adjusted or switched off.

Tip
Full Auto mode is foolproof when you are photographing a scene with average tones in favourable light (see opposite) but it cannot cope equally well with all eventualities. When you want more control over your results, it is time to move on to Creative Auto (see page 48).

Full Auto mode

Quality setting	All settings are selectable using any one of RAW, sRAW 1, sRAW 2 or six levels of JPEG on their own, or in any combination of JPEG plus one of RAW, sRAW 1 or sRAW 2.
Exposure settings	Evaluative metering using 35 different zones; shutter speed and aperture are chosen to suit the light levels and subject; auto ISO; Standard Picture Style; Auto White Balance and Auto Lighting Optimizer cannot be adjusted
Focus settings	Automatic AF point selection in AI Focus mode (which will track a moving subject as long as you keep the illuminated AF point on it and continue to partially depress the shutter button to lock focus)
Frame advance	Single frame advance; 10 sec self-timer
Notes	Shooting menu 2, the Custom Functions menu and My Menu cannot be accessed in this mode. Options in Set-up menu 3 are restricted

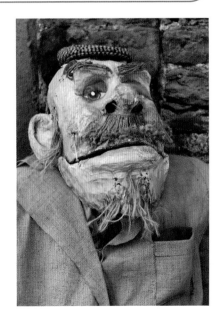

SCARECROW FESTIVAL
With an evenly lit subject and an average range of tones, Full Auto mode is guaranteed to produce a correctly exposed result.

(CA) Creative Auto mode

Creative Auto mode is a new setting, first introduced on the EOS 50D as an additional Basic Zone mode. In essence, Creative Auto adopts the default settings used by Full Auto mode but introduces the possibility of overriding certain settings.

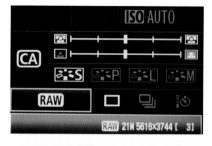

Full control over file-quality settings is provided, allowing you to choose between 27 different combinations of RAW, sRAW 1, sRAW 2 and JPEG formats. Four Picture Styles are incorporated: Standard, Portrait, Landscape and Monochrome – each using only the default parameter settings.

There are two adjustable settings that mark a new approach from Canon: firstly, the degree of background blur; and secondly, the ability to adjust the overall brightness of the image. Each of these adjustments is achieved using a +/-2 incremental sliding scale in the Quick Control Screen. The background-blur scale adjusts the selected aperture in order to change the depth of field, with the corresponding shutter speed changing accordingly – in effect, providing the same function as Program Shift in Program mode. However, the function is presented simply, with a desired result in mind (i.e. an increasingly or decreasingly

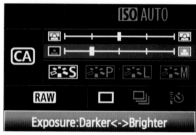

blurred background) and without reference to the technical aspects of aperture and depth of field.

The brightness scale is a way of providing exposure compensation, again concentrating on the desired end result while avoiding the need to explain the business of exposure and the relative properties of aperture and shutter speed.

Full Auto provides 27 different file-quality settings with either One Shot drive or the 10 second self-timer, a total of 54 possible combinations, while Creative Auto offers 8,100 different combinations of settings – more than enough for any novice!

Creative Auto mode

Quality setting	All settings are selectable using any one of RAW, sRAW 1, sRAW 2 or six levels of JPEG on their own, or in any combination of JPEG plus one of RAW, sRAW 1 or sRAW 2.
Exposure settings	Evaluative metering using 35 different zones; shutter speed and aperture are chosen to suit the light levels and subject, but can be adjusted to increase/decrease background blur or to increase/decrease overall brightness; auto ISO; four Picture Styles are selectable: Standard, Portrait, Landscape or Monochrome; Auto White Balance; Auto Lighting Optimizer cannot be adjusted
Focus settings	Automatic AF point selection in AI Focus mode (which will automatically switch to AI Servo mode if linear movement of the subject is detected, tracking the subject as long as you keep it covered by the AF points and continue to partially depress the shutter button)
Frame advance	Single frame advance; continuous (low); 10 sec self-timer
Notes	Creative Auto mode uses the same default settings as Full Auto mode but permits the ability to change some of the settings

Using Creative Auto mode

1) Turn the Mode Dial to **CA**. The Quick Control Screen is displayed.

2) Press the ✴ Multi-controller button into the camera body. The first of the selectable functions will be highlighted in green on the Quick Control Screen. Push ✴ up/down or left/right to select a different function, then rotate either the ⌂ Main Dial or ◯ Quick Control Dial to change the setting. Press the ✴ Multi-controller or partially depress the shutter release to return to the display screen.

3) Aim the camera at your subject. Focusing may be easier by placing the centre AF point over the main subject. You can recompose the picture later.

4) Lightly press the shutter button to achieve focus. The in-focus indicator ● and automatically selected AF points will be illuminated in the viewfinder. The exposure settings will appear at the bottom of the viewfinder.

5) Follow steps 4–5 on page 46.

Understanding exposure

Exposure is a product of two factors, time and aperture – the latter being the size of the opening through which light falls onto the digital camera's sensor. The time is the shutter speed, which is measured in fractions of a second: 1/60, 1/125, 1/250, 1/500, 1/1000 etc.

The aperture (opening) itself is measured in f-stops. The larger the number, the smaller the opening. Each stop represents a halving or doubling of the adjacent stop. Thus f/11 allows half as much light in as f/8 but twice as much as f/16. The sequence runs as follows: f/2.8, f/4, f/5.6, f/8, f/11, f/16, f/22. You can use intermediate settings for both shutter speed and aperture to obtain a more accurate exposure, with the increment set to either $^1/_3$ or ½-stop.

The photograph below was taken with a shutter speed of 1/250 sec and an aperture of f/5.6, but 1/500 sec at f/4 (half the time but twice the light) or 1/125 sec at f/8 (twice the time but half the light) would also have resulted in the correct exposure.

LANGSTROTHDALE, UK
There is a third exposure factor – the ISO setting. ISO 200 is half as sensitive to light as ISO 400 and needs double the exposure. This photo was taken at 1/250 at f/5.6 with a 200 ISO setting. Had that setting been 100 ISO, the necessary exposure would have been 1/125 at f/5.6 or 1/250 at f/4 (i.e. half the shutter speed or one stop more exposure).

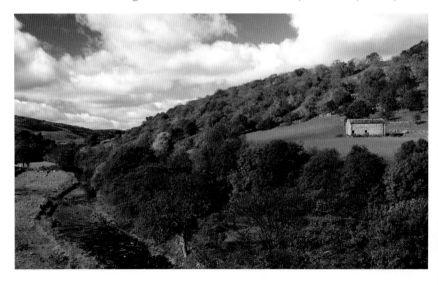

A light meter is simply a gadget that measures the quantity of light falling on it (known as an incident reading) or how much light is reflected by the subject (a reflected reading). Through-the-lens (TTL) metering makes use of reflected light readings, which means that they are more likely to be fooled by highly reflective surfaces in your shot.

How helpful a meter reading is depends on how you, or your camera, interprets the result. Any light-meter reading – from Canon's 35-zone full-frame evaluative system to that of a simple 1° spot meter – averages the readings it has taken and provides a recommended shutter speed and aperture (for a given ISO setting) that would give the correct exposure for an 18% grey card. The metering process works as follows:

1) The extent of the area to be metered is determined by the selected metering mode.

2) The camera's light meter 'sees' this scene in black and white and takes the meter reading.

3) The meter suggests an exposure which would give an overall tone of 18% grey.

4) The camera user adjusts the suggested reading to account for highlight and shadow preferences.

FAVERSHAM, KENT, UK
Your camera's light meter works by 'seeing' the selected scene in black and white (left) and then calculating the correct exposure for an overall tone of 18% grey. The result is a range of accurately represented colours (right).

The AE Lock (auto exposure lock) function is used when there is a difference between the area of the image that is to be metered and the area used to achieve focus, or when multiple frames will be taken using the same exposure.

1) Focus on the subject by partially depressing the shutter-release button.

2) Press the ✱/❐• ⊖ button (☉⁴). The ✱ icon is displayed in the viewfinder, indicating exposure lock. The setting will be overridden by pressing the ✱/❐• ⊖ button again.

3) Recompose the picture and depress the shutter-release button. To take multiple shots at the locked exposure, continue to depress the ✱/❐• ⊖ button.

There are two techniques which can be employed here to make life a little more certain: the first is to learn to recognize common elements or colours which equate to 18% grey (see page 51) so that you can meter from them. The second is to be aware of constantly changing ambient light and to adjust your camera settings while you are walking around – so that when an opportunity presents itself, the camera is already set up to achieve the correct exposure. The latter method works best of all in Manual Exposure mode.

Tips

In Partial metering, Spot metering and Centre-weighted metering modes, AE Lock is applied at the centre AF point.

When the lens is switched to MF (manual focus), AE Lock is also applied to the centre AF point.

In Evaluative Metering mode, AE Lock depends upon the AF point selection settings: with automatic AF point selection, AE Lock is applied to the AF point(s) which achieved focus; with manual AF point selection, AE Lock is applied to the selected AF point.

Common errors

One of the most frequent causes of badly exposed images is the tendency to shoot first and ask questions later. Often, you have a lot more time to get the shot than you think – enough to consider which metering mode is most likely to give the best result.

In most instances the exposure suggested by the camera will be quite adequate provided there are no bright highlights and deep shadows which contain detail that you want to retain. In these cases you can use exposure compensation to shift the overall exposure and pull in additional detail. This makes all the tones darker or lighter, depending on the option chosen.

If you have essential detail in both the bright highlights and the deep shadows, it may be beyond the capacity of the sensor to retain the necessary detail. In this case you may wish to consider an average exposure or bracketing and some work on the computer afterwards using HDR (High Dynamic Range) software.

Exposure compensation of up to +/-2 stops in ⅓- or ½-stop increments can be set regardless of which metering mode has been selected, except in Full Auto (the exposure increment is set in C.Fn I-1). Creative Auto also offers an exposure compensation mode but it is less precise.

1) Turn the Mode Dial to any setting except **M** Manual, ☐ Full Auto or **CA** Creative Auto.

2) Turn the power switch to ⏻.

3) Frame your shot and partially depress the shutter-release button to obtain an exposure reading. Consider the balance between highlight and shadow and assess the likely level of compensation needed.

4) Check the exposure level indicator ▇▁▁▂▁▁▂▁▁▂ at the bottom of the viewfinder or in the LCD top panel to make sure that it is at the centre of the exposure scale.

5) To set the level of compensation, turn the ⊙ Quick Control Dial while partially depressing the shutter-release button. One direction will increase the exposure and the opposite direction will decrease it, one increment at a time. The exposure level indicator ▇▁▁▂▁▁▂▁▁▂ will show the extent of the compensation.

6) Take the photograph and review the result. You may wish to increase or decrease the compensation and take further exposures.

7) To cancel the exposure compensation, repeat step 5 and return the indicator ▇▁▁▂▁▁▂▁▁▂ to the centre point of the scale.

1) In the desired exposure mode, press the ❊ Multi-controller to open the Quick Control Screen. One of the selectable functions will be highlighted in green.

2) Push the ❊ Multi-controller up/down or left/right as necessary to select the exposure level indicator.

3) Rotate the ◯ Quick Control Dial to adjust the exposure compensation. (The ⚙ Main Dial can also be used to set auto exposure bracketing. Both dials can be used in combination.)

Tips

Once set, the level of exposure compensation will be retained if you change the metering mode to Aperture Priority, Shutter Priority or Program mode, if you turn the power setting to **OFF**, or if the camera powers-off automatically after a preset period.

If you switch to one of the three Camera User modes, the level of exposure compensation will be reset to zero 2..1..■..1.:2 until you return to Aperture Priority, Shutter Priority or Program mode, which will have retained the compensation setting.

Setting exposure compensation using menus

1) Press **MENU** and select Shooting Menu 2.

2) Select **Exposure comp./AEB setting** and press **SET**.

3) Rotate the ◯ Quick Control Dial to adjust the exposure compensation. (The ⚙ Main Dial can also be used to set auto exposure bracketing. Both dials can be used in combination.)

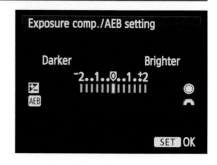

54

Not to be confused with exposure compensation, which adjusts all tones by the same degree, Highlight Tone Priority expands the dynamic range of the highlights only. This ensures the retention of highlight detail without sacrificing existing shadow detail. A classic example of the type of image this might assist with would be a typical bride-and-groom shot with the bride in white and the groom in a dark suit. This mode is only available in the ISO 200–6400 range.

To select Highlight Tone Priority:

1) Press the **MENU** button and select 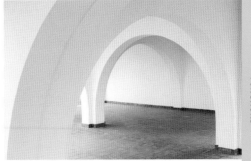 Custom Functions menu.

2) Highlight the **C.Fn. II Image** option and press **SET**.

3) Rotate the ◯ Quick Control Dial to show **Highlight Tone Priority**.

4) Press **SET** to highlight the existing setting.

5) Rotate the ◯ Quick Control Dial to change to the alternative setting.

6) Press **SET** again to save the setting, then press **MENU** to exit.

SHADES OF WHITE
These arches were captured using the Highlight Tone Priority function, which automatically resets ISO 100, if selected, to ISO 200 in order to soften contrast slightly.

Tip
To show that Highlight Tone Priority has been enabled, **D+** is shown alongside the ISO setting in the viewfinder, on the LCD top panel and in the Quick Display screen.

The Highlight Tone Priority function can also be combined with exposure compensation.

FUNCTIONS

The EOS 5D Mk II covers a vast ISO range, from ISO 50 up to an astonishing ISO 25,600. Under normal circumstances the range is confined to 100–6400 but it can be expanded to L (50), H1 (12,800) or H2 (25,600) by enabling **ISO expansion** in Custom Function I-3. The ISO speed increment can be toggled between 1-stop and ⅓-stop using Custom Function I-2.

You can also adjust the **High ISO speed noise reduction** in Custom Function II-2. The four settings are Disabled, Low, Standard and Strong. Note that the default setting is Standard, not Disabled – this is suprising because noise reduction, when it is enabled, is applied at all ISO speeds and does slow the camera down marginally. If Strong is selected, the maximum available burst will also be reduced noticeably.

Tip

With Highlight Tone Priority enabled, the ISO range will be restricted to ISO 200–6400, regardless of the ISO expansion setting.

MOORISH CAFE
At ISO 1600, noise is barely noticeable unless the image is viewed at pixel level.

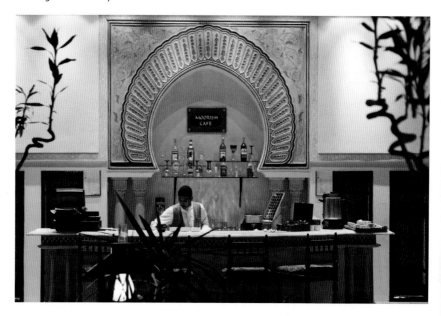

PTOLEMAIC TEMPLE, EGYPT

Noise is most obvious in parts of an image where there is a consistent tone, typically areas of sky or shadow. In an image like this, it is much harder to detect. By being selective with your subject matter, you can capture stunning high ISO images without being plagued by noise artefacts.

Settings
Aperture Priority (Av)
ISO 3200
1/25 sec at f/4 handheld
EF 24–105mm L using IS
Evaluative metering
High ISO noise reduction: Standard
White balance: Daylight
One Shot AF

Selecting the AF point

Automatic AF point selection will take place in both Full Auto and Creative Auto modes and cannot be overridden. In the other modes, it is possible to select any one of the nine AF points or automatic AF point selection using all nine AF points.

Custom Function III-3 allows three different methods for selecting the AF point while shooting: Normal (default), Multi-controller, or Quick Control Dial. Each method is examined in detail below:

Normal

Press the ⊡/🔍 button (⚙⁶). The currently selected AF point or points will be displayed in the viewfinder and in the LCD screen's top panel. If all nine AF points are indicated, automatic AF point selection is the current setting. To select an AF point, scroll through the choices by turning either the ⊙ Quick Control Dial or the ⌒> Main Dial. Alternatively, tilt the ✳ Multi-controller in the appropriate direction.

Multi-controller direct

With this method there is no need to press the ⊡/🔍 button first – just press the ✳ Multi-controller in the desired direction. The AF point selected will change according to

the direction in which you tilt the ✳ Multi-controller. Pressing ⊡/🔍 at any time will select automatic AF point selection. Pressing the ✳ Multi-controller at any time will revert to single AF point selection. With this method, no display is shown in the LCD top panel.

Quick Control Dial direct

Again, there is no need to press the ⊡/🔍 button first. When you rotate the ⊙ Quick Control Dial, the AF point selected will change as you scroll through the choices. All nine AF points shown together indicate automatic AF point selection. With this selection method no display is shown in the LCD top panel.

Common errors

These options permit a great deal of choice. However, there is a very real danger of confusing the Normal and Quick Control Dial direct methods, and rotating the Main Dial in Quick Control Dial direct mode will alter the exposure settings. Experiment with each method to find the one that feels most intuitive.

AF lock

Maintaining light pressure on the shutter-release button will lock focus so that you can recompose the image, safe in the knowledge that your main subject will be sharply focused. However, this is not the only mechanism for locking focus.

Using Custom Function IV-1 it is possible to select a number of different permutations for using the shutter-release button in conjunction with the **AF•ON** button. For example, if you select option 3, the shutter-release button will operate only the metering, with the **AF•ON** button used to initiate autofocus and also to lock focus if pressure is maintained on the button.

AF-assist beam

An attached Speedlite can fire a brief burst of flash to illuminate the subject to aid focusing prior to actually taking the picture. This can be enabled/disabled using Custom Function III-5.

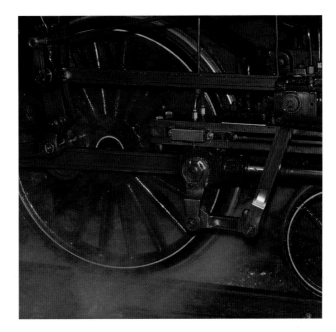

STEAM LOCOMOTIVE
This loco was in near darkness in its shed. It was shot using a 550 EX Speedlite, making use of the camera's AF-assist beam.

(P) Program AE mode

Program mode automatically sets the shutter speed and aperture. The combination can be adjusted, but only as a combination and not individually. You could change 1/250 at f/8, for example, to 1/1000 at f/4 or another combination giving the same effective exposure. This is called Program Shift. However, full control is available over AF mode, drive mode, built-in flash and other functions, so it is still a quite flexible mode and the next stage in the learning curve after Full Auto mode.

CHURCH SQUARE, RYE, UK
Program mode is perfect for walking around town, especially in conjunction with a wide-ranging zoom lens. Select a narrow aperture and a wide-angle setting for maximum depth of field, as in this image, or zoom into an interesting detail using a telephoto zoom setting, selecting a faster speed to combat possible camera shake by simply rotating the Main Dial.

Program mode

Quality settings	All settings are selectable using any one of RAW, sRAW 1, sRAW 2 or six levels of JPEG on their own, or in any combination of JPEG plus one of RAW, sRAW 1 or sRAW 2
Exposure settings	Evaluative metering using 35 different zones; Partial metering; Centre-weighted metering; Spot metering; exposure compensation; auto-exposure bracketing; Auto Lighting Optimizer (JPEG only; ALO can be applied to RAW images in Digital Photo Professional); Highlight Tone Priority; Long exposure noise reduction; High ISO noise reduction; ISO expansion; External flash exposure compensation
Focus settings	One Shot; AI Servo; AI Focus; automatic or manual AF point selection
Frame advance	Single frame; continuous; self-timer (10 sec or 2 sec)
Notes	In many ways a more logical step up from Full Auto than Creative Auto. All settings are fully selectable apart from the relationship between aperture and shutter speed

Using Program AF mode

1) Turn the Mode Dial to **P**.

2) Aim the camera at the subject. Lightly press the shutter button to achieve focus. The focus confirmation symbol ● and selected AF points will be illuminated in the viewfinder.

3) The automatically selected shutter speed and aperture combination will be visible at the bottom of the viewfinder. To change these settings using Program Shift, rotate either the 🖐 Main Dial or the ◯ Quick Control Dial until the desired exposure combination is displayed in the viewfinder.

4) Retain light pressure on the shutter button to keep the focus locked and recompose the picture before depressing the button fully to take the photograph.

5) After a very brief delay, the captured image will display on the LCD monitor for 2 seconds, unless the review function has been adjusted or switched off.

(Tv) Shutter Priority mode

Shutter Priority mode gives the photographer the opportunity to decide on shutter speed as the single most important function. This may be in order to capture a fast-moving subject or to deliberately blur movement for pictorial effect. For the record, Tv stands for Time Value.

The key factor in determining a suitable shutter speed is not the absolute speed at which the subject is travelling. What is important is the speed at which the subject is moving across the frame, and its size in

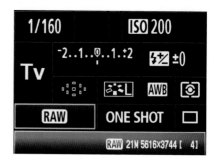

relation to the area of the frame. For example, a 1:1 magnification of a flower moving gently in the breeze is more likely to blur than an express train some distance away taken with a wide-angle lens.

1954 MV AGUSTA 500/4
Panning is usually necessary for fast-moving subjects. Try to ensure a plain and uncluttered background and one which is significantly lighter for a dark subject, and vice versa.

Tips

The lower the ISO setting the better, generally speaking, but the EOS 5D Mk II produces virtually noise-free images at 400 ISO, and even 800 ISO with some subjects. If your subject matter will be varied but will include some high-speed shots, try selecting Auto ISO.

Using Custom Function I-6 you can enable the 5D Mk II's **Safety shift** feature, which will override your choice of shutter speed when light levels are very high or very low. This feature also works in Av mode.

Shutter Priority mode

Quality settings	All settings are selectable using any one of RAW, sRAW 1, sRAW 2 or six levels of JPEG on their own, or in any combination of JPEG plus one of RAW, sRAW 1 or sRAW 2.
Exposure settings	Evaluative metering using 35 different zones; Partial metering; Centre-weighted metering; Spot metering; exposure compensation; auto-exposure bracketing; Auto Lighting Optimizer (JPEG only; ALO can be applied to RAW images in Digital Photo Professional); Highlight Tone Priority; Long exposure noise reduction; ISO noise reduction; ISO expansion; Safety shift; External flash exposure compensation
Focus settings	One Shot; AI Servo; AI Focus; automatic or manual AF point selection
Frame advance	Single frame; continuous; self-timer (10 sec or 2 sec)
Notes	The user sets the shutter speed and the camera automatically selects a suitable aperture. Also useful in changing light conditions to avoid camera shake

Using Shutter Priority mode

1) Turn the Mode Dial to **Tv** and set the desired shutter speed.

2) Aim the camera at the subject and lightly press the shutter button to achieve focus. The focus confirmation symbol ● and selected AF points will be illuminated in the viewfinder, unless you are using AI Servo focusing mode.

3) The shutter speed and automatically selected aperture will be visible at the bottom of the viewfinder.

4) Retain light pressure on the shutter button to keep the focus locked and recompose the picture before depressing the button fully to take the photograph.

5) After a very brief delay, the captured image will display on the LCD monitor for 2 seconds, unless the review function has been adjusted or switched off.

(Av) Aperture Priority mode

This is the mode to use when you want to ensure that everything from the foreground to the background is in focus. Conversely, you can opt to use differential focus to make your subject stand out against an out-of-focus background. A wide aperture ensures narrower depth of field and a narrow aperture (larger f-number) will provide greater depth of field.

Many landscape photographers switch off autofocus on their lens when using this mode with a very narrow aperture. Instead, they focus manually on a point about a third of the way into the zone they want in focus. They may also use the depth-of-field scale on the lens, but these are less common on newer lenses.

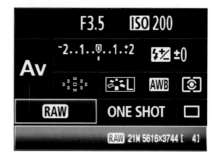

Common errors

If the shutter speed is flashing, the selected aperture is too low or too high for the current ISO rating and a correct exposure cannot be achieved unless it is adjusted. Nevertheless, the camera will still take the picture. Enable **Safety shift** in Custom Function I-6 and/or set Auto ISO to avoid this problem.

HOOPOE
The early bird catches the worm – and both are captured in this image at f/4, providing just enough depth of focus to record the bird's elegant plumage.

Aperture Priority mode

Quality settings	All settings are selectable using any one of RAW, sRAW 1, sRAW 2 or six levels of JPEG on their own, or in any combination of JPEG plus one of RAW, sRAW 1 or sRAW 2.
Exposure settings	Evaluative metering using 35 different zones; Partial metering; Centre-weighted metering; Spot metering; exposure compensation; auto-exposure bracketing; Auto Lighting Optimizer (JPEG only; ALO can be applied to RAW images in Digital Photo Professional); Highlight Tone Priority; Long exposure noise reduction; manual or auto ISO; High ISO noise reduction; ISO expansion; Safety shift; 3 flash sync. settings; External flash exposure compensation
Focus settings	One Shot; AI Servo; AI Focus; automatic or manual AF point selection
Frame advance	Single frame; continuous; self-timer (10 sec or 2 sec)
Notes	The user sets the aperture and the camera automatically selects a suitable shutter speed. Normally selected when depth of focus is the key issue

Using Aperture Priority AE mode

1) Turn the Mode Dial to **Av** and set the desired aperture. Aim the camera at the subject and lightly press the shutter button to achieve focus. The focus confirmation symbol ● and selected AF points will be illuminated in the viewfinder.

2) The aperture and automatically selected shutter speed will be visible in the bottom left of the viewfinder.

3) Retain light pressure on the shutter button to keep the focus locked and recompose the picture before depressing

Tips

For very wide depth of field using slow ISO settings you will probably need a tripod. If you do not have a remote release, use the self-timer at its 10 sec setting in order to minimize camera shake.

the button fully to take the photograph. The captured image will display on the LCD monitor for 2 seconds, unless the review function has been adjusted.

(M) Manual exposure mode

This mode provides ultimate control over exposure, as the shutter speed and aperture are set independently – the camera does not choose one to fit the other. This is particularly useful in awkward lighting situations at times when the camera's light meter may be fooled by the luminosity or reflectivity of the subject matter and when the desired effect is other than an averagely toned scene.

Sometimes a very bright high-key image is required – a soft-focus portrait of a bride in her wedding dress, for example. There are also times when what might normally be deemed an under-exposed result is required, typically for reportage images (*National Geographic* magazine, for example, nearly always uses 'heavy' images).

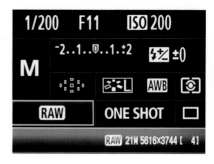

Another factor to bear in mind with the EOS 5D Mk II is that it offers a monochrome option, including the simulated use of black-and-white filters. Traditionally, metering for slide film has always been based on the highlights, while metering for black-and-white photography was based on the shadows. With the 5D Mk II in Manual mode you can adopt different mid-tones to suit different styles of photography. You also have the benefits of Picture Styles to fine-tune your way of working, and the Highlight Tone Priority feature – though the latter restricts your minimum ISO to 200.

TIMEPIECE
This lady in period costume was photographed for a tourist board publication on a very bright day and had to be positioned in shade so that her white clothing didn't burn out. Spot metering and Manual mode ensured a perfect exposure.

Manual exposure mode

Quality settings	All settings are selectable using any one of RAW, sRAW 1, sRAW 2 or six levels of JPEG on their own, or in any combination of JPEG plus one of RAW, sRAW 1 or sRAW 2.)
Exposure settings	Evaluative metering using 35 different zones; Partial metering; Centre-weighted metering; Spot metering; auto-exposure bracketing; Auto Lighting Optimizer (JPEG only; ALO can be applied to RAW images in Digital Photo Professional); Highlight Tone Priority; Long exposure noise reduction; manual or auto ISO; High ISO noise reduction; ISO expansion; External flash exposure compensation
Focus settings	One Shot; AI Servo; AI Focus; automatic or manual AF point selection
Frame advance	Single frame; continuous; self-timer (10 sec or 2 sec)
Notes	The user sets both the aperture and the shutter speed independently of one another. Used for ultimate control of all the camera's functions but requires the greatest understanding of photographic principles

Using Manual Exposure mode

1) Ensure that the power switch is set to ⏻ rather than just **ON**. Turn the Mode Dial to **M** and set the desired metering mode.

2) Aim the camera at the subject and lightly press the shutter button to achieve focus. The ● focus confirmation symbol and selected AF points will be illuminated unless using AI Servo focusing mode.

3) Rotate the 🖬 Main Dial to adjust the shutter speed and the ◯ Quick Control Dial to adjust the aperture until the exposure level indicator is centred.

4) If you are metering from a selected area, take the reading and make the necessary adjustment to centre the exposure level indicator.

5) Retain light pressure on the shutter button to keep the focus locked and recompose the picture before depressing the button fully to take the photograph.

6) After a very brief delay, the captured image will display on the LCD monitor for 2 seconds, unless the review function has been adjusted or switched off.

(B) Bulb mode

This mode is used when the required exposure is longer than the EOS 5D Mk II's maximum of 30 seconds. The camera user sets the aperture by rotating either the 🖼 Main Dial or the ⭕ Quick Control Dial and retains manual control (literally) of the shutter speed by depressing the shutter and only releasing it when the required exposure is completed. It is advisable to use the RS-80N3 remote release or the TC-80N3 timer/remote control in order to avoid camera shake.

CHAMBÉRY, FRENCH ALPS
This night shot of a château in central Chambéry required a Bulb exposure of six seconds using Manual shooting mode, with the camera mounted on a sturdy tripod.

Bulb mode	
Quality settings	All settings are selectable using any one of RAW, sRAW 1, sRAW 2 or six levels of JPEG on their own, or in any combination of JPEG plus one of RAW, sRAW 1 or sRAW 2
Exposure settings	Evaluative metering using 35 different zones; Partial metering; Centre-weighted metering; Spot metering; Auto Lighting Optimizer (JPEG only; ALO can be applied to RAW images in Digital Photo Professional); Highlight Tone Priority; Long exposure noise reduction; manual or auto ISO (Note: if Auto ISO is selected in Bulb mode, the ISO will be fixed at ISO 400); High ISO noise reduction; ISO expansion; External flash exposure compensation
Focus settings	One Shot; AI Servo; AI Focus; automatic or manual AF point selection
Frame advance	Single frame; continuous (low); continuous (high); self-timer (10 or 2 sec)
Notes	The elapsed time is displayed on the LCD top panel but this necessitates pressing the LCD top panel illumination button, which may contribute to camera shake and, in any case, will only remain illuminated for six seconds.

FUNCTIONS

(C1,C2,C3) Camera user modes

There are three settings on the Mode Dial – **C1**, **C2** and **C3** – which allow the user to define three complex combinations of settings to suit individual circumstances. These Camera user modes are set using Set-up menu 3 (see page 103).

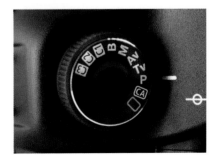

Menu options

The EOS 5D Mk II's menu screens are displayed on the LCD monitor on the back of the camera. The nine tabs consist of two Shooting menus, two Playback menus, three Set-up menus, a Custom Functions menu and, finally, the customizable My Menu for easy access to your most frequently changed options. Each menu category is represented by a symbol and is colour-coded to make identification easier. The currently selected item on a menu is highlighted in the same colour as the type of menu. For example, the Playback menu symbol is blue, so its menu items are highlighted in blue. When a menu item is selected, a secondary menu may be displayed; in some cases this is followed by another submenu or a Cancel/OK dialogue box.

Selecting menu options

The general procedure described here for selecting menu options applies to all the menus which follow.

1) Select ⏻ on the camera power switch.

2) Press the **MENU** button and use the ⬚ Main Dial to scroll through the nine menus until you reach the one you require.

3) To highlight a different item on the menu, rotate the ⬚ Quick Control Dial.

4) When an item is highlighted, select it by pressing the **SET** button.

5) If secondary menus or confirmation dialogue boxes are displayed, use the ⬚ Quick Control Dial and the **SET** button as described in step 4.

6) When a setting has been changed, press **SET** to save the new setting.

7) To exit at any stage, press the **MENU** button to go back one level, and repeat if necessary.

Menu summary

📷 Shooting menu 1 (Red)	Options
Quality	Any RAW or any JPEG setting on its own or any combination of RAW and JPEG
Beep	On / Off
Shoot w/o card	On / Off
Review time	Off / 2 sec / 4 sec / 8 sec / Hold
Peripheral illumination correction	Enable / Disable

📷 Shooting menu 2 (Red)	Options
Exposure compensation/AEB	Compensation or bracketing- in ⅓- or ½-stop increments, +/-2 stops
White balance	AWB / ☀ / ⌂ / ☁ / ☀ / ▦ / ⚡ / ⊿ / K (2,500–10,000°K)
Custom WB	Manual setting of white balance
WB SHIFT/BKT	White-balance correction White-balance bracketing
Colour space	sRGB / Adobe RGB
Picture Style	Standard / Portrait / Landscape / Neutral / Faithful / Monochrome / User Def. 1,2,3
Dust Delete Data	Obtains data to be used to erase dust spots

▶ Playback menu 1 (Blue)	Options
Protect images	Prevent deletion of highlighted image(s)
Rotate	Rotate highlighted image(s)
Erase images	Erase highlighted image(s)
Print order	Specify images to be printed
Transfer order	Specify images to be transferred to computer

▶ Playback menu 2 (Blue)	Options
Highlight alert	Disable / Enable
AF point disp.	Disable / Enable
Histogram	Brightness / RGB
Slide show	Auto playback of movies or still images by folder or date or all on card
Image jump with 🌀	Allows quick search of recorded images by jumping 1, 10 or 100 images at a time or by date or folder

𝖸𝖳 Set-up menu 1 (Yellow)	Options
Auto power-off	1 min / 2 min / 4 min / 8 min / 15 min / 30 min / Off
Auto rotate	On 📷🖥 / On 🖥 / Off
Format	Initialize and erase data on the card
File numbering	Continuous / Auto reset / Manual reset
Select folder	Select existing or create new folder

72

ᵞᵀᶦ Set-up menu 2 (Yellow)	Options
LCD brightness	Auto or manual (7 levels of brightness)
Date / Time	Set date and time
Language	25 languages to select from
Video system	NTSC / PAL
Sensor cleaning	Auto cleaning / Clean now / Clean manually
Live View / Movie function settings	Enable / disable stills or movie or combined modes, grid display, silent shooting, metering timer, AF modes, movie quality, sound recording, exposure simulation

ᵞᵀᶦ Set-up menu 3 (Yellow)	Options
Battery information	Register individual batteries Monitor battery in use
INFO button	Normal display / Camera settings / Shooting functions
External Speedlite control	Set flash functions or flash custom functions depending on model attached
Camera user setting	Register current camera settings to C1, C2 or C3
Clear settings	Resets the camera to default settings
Firmware version	Updated firmware from Canon website

⚙ Custom Functions menu (Orange) Options

C.Fn. I: Exposure C.Fn. II: Image C.Fn. III: Autofocus / Drive C.Fn. IV: Operation / other	Fully customize the camera settings within these groups
Clear all Custom Functions	Resets camera to default C.Fn. settings

⚙ My Menu (Green)	Options
My Menu settings	Register frequently used menu items and Custom Functions

My Menu

With My Menu, you can register up to six menus and Custom Functions that you use on a frequent basis.

1) Press the **MENU** button and select ⚙ My Menu. Choose **My Menu settings** and press **SET**. Then rotate the ⊙ Quick Control Dial to select **Register** and press **SET** again.

2) Rotate the ⊙ Quick Control Dial to select an item to include. Press **SET**, then **OK** when the dialogue box is displayed.

3) Repeat for up to six items and press the **MENU** button to exit.

4) To sort the order in which items are displayed, select **My Menu settings**.

Choose **Sort**, then the item you wish to move, and rotate the ⊙ Quick Control Dial to move the item up or down the list. Press **SET** to finalize the setting.

5) To delete an item from the My Menu display, select **My Menu settings**. Choose **Delete** and select the item you wish to delete, then press **SET** again. Select **OK** and press **SET** again.

Shooting menu 1

There are two Shooting menus, which are both colour-coded red. Between them, these two menus control all the basic shooting-related functions, including the quality of the files recorded, auto exposure bracketing, white balance and colour options, and Picture Styles.

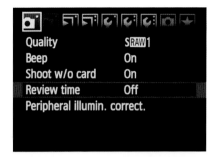

FUNCTIONS

Quality

There are 27 different settings for image quality, using various combinations of JPEG, RAW and sRAW files. The inclusion of two sRAW settings will be welcomed by many photographers, as they provide all the advantages of RAW quality and workflow but with much smaller file sizes than full RAW files.

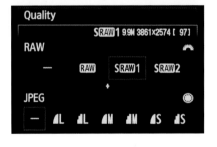

When JPEG format alone is selected, file sizes are smaller and will take up much less space on your memory card, even if you choose the Large/fine setting. They will also write faster and you are far less likely to need to wait while the buffer empties. The burst size (the maximum number of shots you can take before the buffer is full) is also significantly increased.

As the camera performs a number of processing tasks on JPEGs compared with RAW files, there is far less post-processing

required. The disadvantage of shooting JPEGs is that you have far less control over the recorded image than is the case with a RAW or sRAW file. JPEG is a compressed format, which means that there is some loss of quality involved. The smaller the file, the greater the compression and the greater the loss of picture quality.

Using RAW or sRAW files suits those who require the highest quality images and are prepared to use computer software to bring those images to fruition. With the

advent of Picture Styles, however, some of this can be avoided, making RAW and sRAW a much more viable option for those who are less interested or less skilled in post-processing. One final advantage of shooting RAW or sRAW files is that you can easily rescue images that are under- or over-exposed by at least a couple of stops.

File-quality settings

Quality		Pixels (approx)	File size	Shots per 2Gb card (approx)	Max Burst (CF)	Max Burst (UDMA)
JPEG	◢L	21Mp	6.1MB	310	78	310
	◢L		3.0MB	610	610	610
	◢M	11.1Mp	3.6MB	510	330	510
	◢M		1.9MB	990	990	990
	◢S	5.2Mp	2.1MB	910	910	910
	◢S		1.0MB	1680	1680	1680
RAW	RAW	21Mp	25.8MB	72	13	14
	sRAW1	10Mp	14.8MB	120	15	15
	sRAW2	5.2Mp	10.8MB	170	20	20
RAW +JPEG*	◢L + RAW	21Mp 21Mp	6.1MB+ 25.8MB	57	8	8
	◢L+ sRAW1	21Mp 10Mp	6.1MB+ 14.8MB	89	8	8
	◢L+ sRAW2	21Mp 5.2Mp	6.1MB+ 10.8MB	110	8	8

*Both file types will be saved in the same folder with the same file name, but with different extensions (.JPG and .CR2 for the RAW file).
The above figures will vary depending on camera settings and brand of memory card.

Beep

The beep is very useful to confirm focus, especially if you wear spectacles and have difficulty getting your eye right up to the viewfinder. However, it can also be an unwelcome distraction in situations like a church or museum, so it is possible to turn it off.

76

Shoot without card

With this function you can choose whether or not you want to allow the camera to function without a memory card installed. This facility might be used when capturing a large number of images direct to computer via USB or WFT.

Review time

After shooting, the camera will display the image on the monitor for 2, 4 or 8 seconds, or for as long as you like if you have selected **Hold**. Alternatively, if want to conserve battery power and review images at a later time, you can turn the review function off.

Peripheral illumination correction

In some circumstances, there may be a slight loss of brightness in the corners of the image. This function corrects this issue in-camera when shooting JPEG files; RAW shooters need to make the correction later in Digital Photo Professional.

The EOS 5D Mk II comes programmed with correction data for over 24 lenses, the list of which can be checked in the EOS Utility software. This list also includes combinations of certain lenses and extenders. The correction data for

lenses that are not already registered in the EOS 5D Mk II's memory can be added to the camera later.

Shooting menu 2

The 5D Mk II's second Shooting menu gives you access to settings which control exposure, colour, contrast and sharpness. As with Shooting menu 1, selected items are highlighted in red. Exactly the same process is used to select a menu, highlight an item, and make further choices about your settings.

Exposure compensation

The 5D Mk II's various metering modes cover most situations, but occasions will arise when you wish to adjust exposure settings to compensate for unusual circumstances, such as back-lighting or a highly reflective subject. This is the time to dial in some exposure compensation, to a maximum of +/- 2 stops. The exposure scale in the settings screen will show either ½- or ⅓-stop increments, according to the setting in C.Fn I-1.

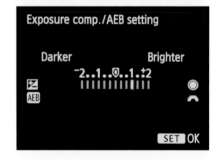

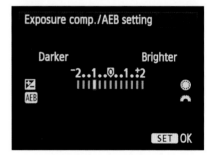

Auto-exposure bracketing

The Canon EOS 5D Mk II's auto exposure bracketing (AEB) facility is useful when you're not sure how the balance between highlights and shadows will work out. Three exposures are recorded, with one either side of the nominal setting. Additional indicator marks on either side of the central indicator show the level of over- and under-exposure. The exposure scale in the settings screen will show either ½- or ⅓-stop increments, according to the setting in C.Fn I-1.

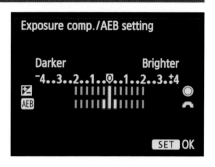

Auto exposure bracketing can also be combined with Exposure compensation.

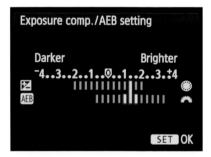

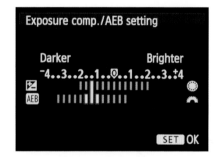

FUNCTIONS

Tips

If **Bracketing auto cancel** is not enabled in C.Fn I-4, the camera will retain the bracketing setting even when it is turned off.

Auto exposure bracketing can be combined with white-balance bracketing (see page 83).

When using auto exposure bracketing, the order in which the under-exposed, normal and over-exposed pictures are taken can be set to **0,-,+** (default) or **-,0,+**. This option is set using Custom Function I-5.

White balance

In order for other colours to be rendered accurately, white must be represented correctly. This usually means obtaining a pure white, without the colour cast that comes from artificial light sources, and from natural lighting at different times of the day or in shade. These variations are measured according to their colour temperature, measured in degrees Kelvin. The EOS 5D Mk II allows you to specify an exact colour temperature in the range 2500–10,000° K where this is known,

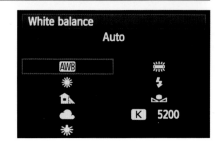

or to use the camera's pre-programmed shortcuts. A Custom white-balance setting can also be created.

AWB	Auto white balance: camera chooses a setting in the range 3000–7000°K		Cloudy, twilight, sunset: 6000°K
	Daylight: 5200°K		Tungsten lighting: 3200°K
			White fluorescent light: 4000°K
	Shade: 7000°K		Flash: 6000°K

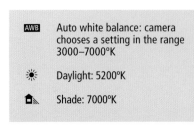

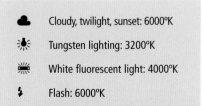

Custom White Balance

Using the same menu, it is possible to determine a Custom white-balance setting in the range 2000–10,000°K to suit a particular shooting situation.

1) Photograph a white object, ensuring that it fills the spot-metering circle. Any white-balance setting can be used at this stage.

2) Using Shooting menu 2, highlight **Custom White Balance** and press **SET**. An image will be captured on the monitor.

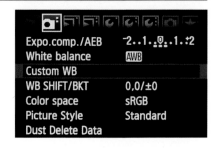

3) Turn either the Quick Control Dial or Main Dial until the image you wish to use as a basis for your Custom WB

80

setting appears, then press **SET**. Note: the ⌇ Quick Control Dial will scroll through images one at a time; the 🔄 Main Dial will scroll through images according to the setting in **Image jump w/** 🔄 in Payback Menu 2. Press **SET**.

Common problems

If the exposure obtained in step 1 above is significantly under-exposed or over-exposed, a correct white balance may not be obtained.

If the image captured in step 1 is taken with the Picture Style set to Monochrome, it cannot be selected in step 3.

4) You will be presented with a dialogue box reading **Use WB data from this image for Custom WB**. Select **OK** and the data will be imported.

5) Exit the menu and press the ⊡•**WB** button. Rotate the ⌇ Quick Control Dial to select ⤴ Custom White Balance.

Tips
If you have registered a personal white-balance setting using the software provided with the camera, it will be replaced by any new Custom white-balance setting under ⤴ Custom WB.

White-balance shift and bracketing

White-balance shift is incorporated into the same **WB SHIFT/BKT** screen as White-balance bracketing. Adjusting the colour settings is not unlike using colour-correction filters, except that here, nine levels of correction are possible. Each increment is equivalent to a 5 mired shift. This facility can be applied to any white-balance setting including Custom, °K and white-balance shortcut settings.

1) In 📷² Shooting menu 2, highlight **WB SHIFT/BKT** and press **SET**. Use the ✳ Multi-controller to move the cursor ■ from its central position to the new setting. The bias can be towards Blue/

Amber and/or Magenta/Green. The blue panel at the top right displays the new co-ordinates.

2) Press **INFO** at any time to reset the bias to **0,0**. Press **SET** to finalize the setting.

White-balance bracketing

White-balance bracketing can be used in conjunction with White-balance shift to capture three versions of the same image, each with a different colour tone. The primary image will use the cursor location set in the previous section (see page 81). Either side of this, two further images will be captured with a difference of up to three levels in single-level increments, each increment being 5 mireds. You can bracket with either a Blue/Amber bias or a Magenta/Green bias.

1) Rotate the ⊙ Quick Control Dial clockwise to set a Blue/Amber bias with one, two or three levels' difference. The increments will be shown in the blue panel at the bottom right. Alternatively, rotate the ⊙ Quick Control Dial anti-clockwise to set a Magenta/Green bias with one, two or three levels' difference.

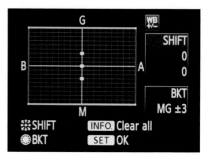

Blue/Amber bias

Magenta/Green bias

Tip
It is only necessary to press the shutter release once with White-balance bracketing selected in order to capture the three images. However, both the total number of shots available on the memory card and the number of burst images available will be reduced by three.

Note
Press **INFO** at any time during this procedure to cancel White-balance bracketing. This will also reset the cursor to **0,0**.

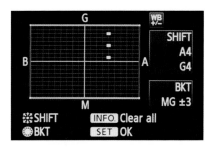

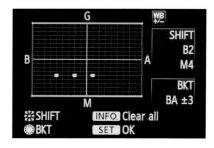

2) When bracketing has been selected (without having pressed **SET**), it is still possible to use the � Multi-controller to move the cursor (now showing as ■ ■ ■) around the screen in order to adjust the colour bias.

3) Press **SET** to finalize your settings and return to 📷 Shooting menu 2.

WB Shift plus AE-bracketing

White-balance bracketing can also be combined with auto exposure bracketing, in which case pressing the shutter release three times will result in nine images being captured. The bracketing sequence will be as follows: Standard white balance, Blue bias, Amber bias or Standard white balance, Magenta bias, Green bias.

Colour space

The term 'colour space' is used to describe the range of colours that can be reproduced within a given system. The EOS 5D Mk II provides two such colour spaces: sRGB and Adobe RGB. The latter offers a more extensive range and is likely to be used by those for whom the final image is intended for conversion to the CMYK colour space for commercial printing in books, magazines or catalogues. Canon recommend sRGB for what they classify as 'normal use'.

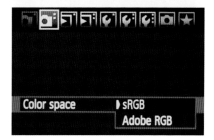

Picture Style

In Full Auto mode, the Standard Picture Style is selected automatically. In Creative Auto mode, a limited choice is given between Standard, Portrait, Landscape and Monochrome styles. In both of these shooting modes the Picture Style parameters are fixed and cannot be adjusted. In all other modes any Picture Style can be selected and can then be tailored to individual requirements. They can also be incorporated into the **C1**, **C2** and **C3** Camera User modes. The Picture Style menu can be accessed quickly and easily from ⚄ My Menu if desired. In addition, three User Defined Picture Style settings can be created.

Picture Style	◑,◐,⚬,◔
⬛S Standard	3 , 0 , 0 , 0
⬛P Portrait	2 , 0 , 0 , 0
⬛L Landscape	4 , 0 , 0 , 0
⬛N Neutral	0 , 0 , 0 , 0
⬛F Faithful	0 , 0 , 0 , 0
⬛M Monochrome	3 , 0 , N , N
INFO Detail set.	SET OK

All the following options apply equally to JPEG and RAW files (including Sharpness) but RAW file users also have the option of resetting or changing the parameters afterwards on the computer.

Colour parameters

For each style there are four sets of parameters: ◑ Sharpness, ◐ Contrast, ⚬ Saturation and ◔ Colour tone. With the exception of ◐ Sharpness, the settings for which range from 0 to +7, all the other settings range from -4 to +4. Their effects are self-explanatory, apart from Colour tone. With the Colour tone parameter, a lower setting (-4, for example) produces a reddish skin tone, while a higher setting (such as +4) produces a yellower skin tone.

If you change a setting, you will see that the new setting is indicated by a white marker, but the original setting remains

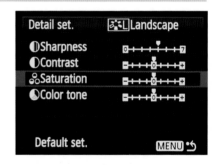

in view as a grey marker. This makes it easy to return to the default settings, so don't be afraid to experiment. This applies to both the Colour and the Monochrome parameters (see opposite).

84

Monochrome parameters

In addition to ◑ Sharpness and ◑ Contrast, there are two monochrome-only settings: ◔ Filter effect and ⊘ Toning effect. The symbols for these settings replace those for Saturation and Colour Tone as soon as Monochrome is selected.

Picture Style default settings

	◑ Sharpness	◑ Contrast	⊗ Saturation	◑ Colour tone
Standard	3	0	0	0
Portrait	2	0	0	0
Landscape	4	0	0	0
Neutral	0	0	0	0
Faithful	0	0	0	0
	◑ Sharpness	◑ Contrast	◔ Filter effect	⊘ Toning effect
Monochrome	3	0	None	None

The three User Defined sets of parameters are all set to 0.

To set a Picture Style (Method A)

1) Using ◘ Shooting menu 2, rotate the ◌ Quick Control Dial to highlight **Picture Style** and press **SET**.

2) Rotate the ◌ Quick Control Dial to highlight the desired Picture Style.

3) To change the parameters of the Picture Style, press the **INFO** button to go to the **Detail set.** screen. To accept the existing parameters, press **SET** or **MENU**.

4) Rotate the ◌ Quick Control Dial to highlight the parameter you wish to change and press **SET**.

5) The selected parameter will now appear on a screen on its own. Rotate the ◌ Quick Control Dial clockwise to increase the setting or anti-clockwise to decrease it. The white indicator will move along the scale accordingly, leaving a grey indicator showing the default setting.

6) Press **SET** to finalize the parameters. The **Default set.** screen appears. Press **MENU** once to return to the Picture Style screen, then press **SET** to finalize your choice of Picture Style and to return automatically to the Shooting Menu.

To set a Picture Style (Method B)

1) Press the ⊹ Picture Style selection button and rotate either the 🔄 Main Dial or ◯ Quick Control Dial to highlight the desired Picture Style.

2) To retain the existing parameters, press **SET**. The monitor will turn off.

3) To change the parameters of the Picture Style, press the **INFO** button to change to the **Detail set.** screen.

4) Rotate the ◯ Quick Control Dial to highlight the parameter you wish to change and press **SET**.

5) That parameter will now appear on a screen on its own. Rotate the ◯ Quick Control Dial clockwise to increase the setting or anti-clockwise to decrease it. The white indicator will move along the scale accordingly, leaving a grey indicator showing the default setting.

6) Press **SET** again to finalize the Picture Style parameters. The **Default set.** screen appears. Press **MENU** once to return to the Picture Style screen, then press **SET** to finalize your choice of Picture Style.

To set a Picture Style (Method C)

1) In the desired shooting mode, press directly on the ⊹ Multi-controller. One of the selectable settings will be highlighted.

2) Push the ⊹ Multi-controller up/down/left/right to highlight the Picture Style setting. Press **SET**.

3) Rotate the ◯ Quick Control Dial to highlight the parameter you wish to change and press **SET**.

4) That parameter will now appear on a screen on its own. Rotate the ◯ Quick Control Dial clockwise to increase the setting or anti-clockwise to decrease it. The white indicator will move along the

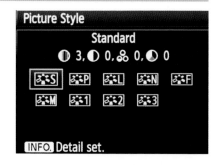

scale accordingly, leaving a grey indicator showing the default setting.

5) Press **SET** to finalize the parameters. The **Default set.** screen appears. Press **MENU** once to return to the Picture Style screen, then press **SET**.

86

Monochrome Picture Style settings

The procedure for setting or adjusting the parameters for Sharpness and Contrast are exactly as outlined on pages 85–6. The procedure for setting Filter or Toning effects is the same up to the point where a single parameter is shown on screen.

Instead you are presented with a menu from which to choose. The Filter effects menu offers a choice of yellow, orange, red or green filter effects or none at all. The Toning effects menu offers a choice of sepia, blue, purple or green or none at all.

Monochrome Filter effects

Yellow Blue sky will look less washed out and clouds will appear crisper.

Orange Blue sky will be darker and clouds more distinct. Good for stonework.

Red Blue sky will appear extremely dark, clouds very white, high contrast.

Green Good for lips and skin tones. Foliage will look crisper.

Registering User-Defined Picture Styles

You can adjust the parameters of a Picture Style and register it as one of three User Defined styles, while keeping the default settings for the base style.

1) Press the ✂ Picture Style selection button and rotate the ◯ Quick Control Dial to highlight User Defined 1/2/3, then press the **INFO** button to bring up the **Detail set.** screen.

2) Press **SET** and Picture Style will appear on its own with a scroll bar on the right. Use the ◯ Quick Control Dial to scroll through the base styles. (To exit without proceeding, press **MENU**.) Press **SET** to select your base Picture Style.

3) The **Detail set.** screen will appear with your desired base Picture Style indicated. Use the ◯ Quick Control Dial to highlight a parameter and press **SET**.

4) That parameter appears on a screen on its own. Rotate the ◯ Quick Control Dial clockwise to increase the setting or anti-clockwise to decrease it. The white indicator moves along the scale and a grey indicator shows the default setting.

5) Press **SET** to finalize the parameters. The **Detail set.** screen appears. Press **MENU** once to return to the Picture Style screen, then press **SET** to finalize your choice of Picture Style.

Under normal circumstances the Self-Cleaning Sensor Unit will eliminate most of the dust specks that show up on your images. When visible traces remain, however, you can append the Dust Delete Data to the images to erase the dust spots automatically at a later stage in the Digital Photo Professional software provided. Once obtained, the data is appended to all JPEG, RAW and sRAW images captured after this point, but has no significant impact on file size.

To obtain the Dust Delete Data:

1) Using a solid-white subject, set the lens focal length to 50mm or longer.

2) Set the lens to **MF** manual focus and rotate the focusing ring to the infinity setting.

3) In 📷 Shooting menu 2, select **Dust Delete Data** and press **SET**.

> **Tip**
> Update the Dust Delete Data before an important shoot – especially if you will be working with narrow apertures, which show up dust spots more clearly.

4) Select **OK** and press **SET**.

5) After automatic sensor cleaning is completed, the following message will appear: 'Press the shutter button completely when ready for shooting'.

6) Photograph the solid-white subject at a distance of 8–12in (20–30cm). Ensure that the subject fills the viewfinder.

7) The resulting image will be captured automatically in **Av** Aperture Priority mode at an aperture of f/22. This image will not be saved, but the Dust Delete Data derived from it will be retained by the camera. A message screen appears that reads 'Data obtained'. Press **OK**.

8) If the data was not obtained, another message will advise you of this. Make sure you follow the preparatory steps carefully and try again.

Playback menu 1

This is the first of two Playback menus, both identified by their blue highlighting. They cover the protection, deletion and rotation of selected images, together with your choice of images for the purpose of printing or transferring to computer.

Protect images

Selected images can be protected to avoid accidental deletion. Protected images will display the ⊙ key symbol. A key symbol with the word **SET** is displayed in the top-left corner of the LCD monitor. This is an instruction, not an indication that an image is protected.

1) Select ⏻ on the camera power switch. Press the **MENU** button and use the ⌒ Main Dial to scroll through the nine menus to ▶ Playback menu 1. Rotate the ○ Quick Control Dial to select **Protect images** and press **SET**.

2) Rotate the ○ Quick Control Dial or ⌒ Main Dial to select an image and press **SET**. (The ⌒ Main Dial will scroll according to the setting of **Image jump w/⌒** in Playback menu 2.) The ⊙ key icon is shown next to the folder number.

3) To cancel protection for an image, highlight it and press **SET**. The ⊙ key icon will disappear.

4) To protect another image, repeat step 2. To exit image protection, press the **MENU** button.

Warning!
Protected images will still be deleted when you format a memory card.

Note
To delete protected images, you must cancel the protection individually for each image.

Rotate images

This facility enables you to rotate individual images, as opposed to the Auto Rotate function(see page 96) which automatically rotates all portrait-format images to the correct orientation.

1) Select ⌿ on the camera power switch.

2) Press the **MENU** button and use the ⚙ Main Dial to scroll through the menus until you reach ▶ Playback menu 1.

3) Rotate the ◯ Quick Control Dial to select **Rotate** and press **SET**.

4) Rotate either the ◯ Quick Control Dial or ⚙ Main Dial to select the image to be rotated and press **SET**. (The ⚙

Main Dial will scroll through the images according to the setting of **Image jump w/**⚙ in Playback menu 2.)

5) To rotate another image, repeat step 4.

6) To exit, press the **MENU** button.

> **Tip**
> Using the ✳/�• ⊖ and ⊟/⊕ buttons you can toggle between a single image, four images or nine images displayed on the monitor. This applies equally to the Protect, Rotate and Erase functions.

Erase images

The Erase menu enables you to delete selected individual images, all images in a selected folder, or all images on the memory card – with the exception of any protected images in each case.

The advantage of erasing individual images via this menu, as opposed to using the 🗑 button during review, is that images are selected for deletion (marked with a tick) but not actually deleted until you finally press the 🗑 button to delete all the selected images at once. As a result,

you can scroll backwards and forwards to compare similar images and uncheck an image if necessary.

90

To select and erase individual images:

1) Select ⏻ on the camera power switch. Press **MENU** and use the 🎛 Main Dial to scroll through the menus until you reach ▶️ Playback menu 1.

2) Rotate the ◌ Quick Control Dial to select **Erase images** and press **SET**.

3) Highlight **Select and erase images** and press **SET**.

4) Rotate the ◌ Quick Control Dial or 🎛 Main Dial to select the image to be erased, and press **SET**. The ✓ check mark will appear above the image.

5) To cancel deletion, highlight the image and press **SET**. The ✓ icon will disappear. To select another image, repeat step 4.

6) To delete all images marked with ✓, press 🗑. A dialogue box will appear. Highlight **OK** and press **SET**. The selected images will be deleted.

7) To exit at any stage, press the **MENU** button to go back one level.

To erase all images in a folder:

1) Select ⏻ on the camera power switch.

2) Press **MENU** and use the 🎛 Main Dial to scroll through the nine menus until you reach ▶️ Playback menu 1.

3) Rotate the ◌ Quick Control Dial to select **Erase images** and press **SET**.

4) Highlight **All images in folder** and press **SET**.

5) Select the desired folder and press **SET**. A Cancel/OK dialogue box is displayed. Rotate the ◌ Quick Control Dial to select **OK** and press **SET**.

6) All unprotected images will be erased.

To erase all images:

1) Select ⏻ on the camera power switch.

2) Press **MENU** and use the 🎛 Main Dial to scroll through the nine menus until you reach ▶️ Playback menu 1.

3) Rotate the ◌ Quick Control Dial to select **Erase images** and press **SET**.

4) Highlight **All images on card** and press **SET**.

5) Rotate the ◌ Quick Control Dial to select **OK** and press **SET**.

6) All unprotected images will be erased.

Print order & Transfer order

For **Print order** and **Transfer order** options in Playback menu 1, see Chapter 8.

Playback menu 2

The second of the two Playback menus covers specific information relating to exposure and focus that can be included with the image being reviewed, together with the Slide show option which initiates a continuous display of recorded images.

Highlight alert

The Highlight Alert function is a valuable tool that warns you about over-exposed highlight areas in an image you are about to capture.

To enable the Highlight Alert function:

1) Select ⏻ on the power switch.

2) Press **MENU** and use the ⚙ Main Dial to scroll through the nine menus until you reach ▶' Playback menu 2.

3) Rotate the ◌ Quick Control Dial to select **Highlight alert** and press **SET**.

4) Select **Enable** and press **SET**.

5) When you play an image back, any areas of the image that contain highlights which the sensor may not record with sufficient detail at the selected exposure will flash on and off.

6) To disable Highlight Alert, select **Disable** in step 4 and press **SET**.

AF point display

This function enables the superimposed display of AF points on the image being reviewed. If only one AF point was selected, this is all that will be displayed. If automatic AF point selection was in operation, all the focus points which were engaged when the image was captured will be displayed. Selection is by the same process as described above for enabling Highlight Alert.

Histogram

When you're reviewing an image, pressing the **INFO** button brings up alternative screens that show the image at a smaller size but with useful shooting information, including a histogram. The Histogram menu allows you to choose between an overall Brightness histogram or an RGB histogram which shows the relative brightness of the Red, Blue and Green colour channels. The histogram is enabled

in the same way as the Highlight Alert option (see opposite).

Using the Brightness histogram

The Brightness histogram shows the overall exposure level, the distribution of brightness and the tonal gradation. It enables you to assess the exposure as a whole and to judge the richness of the tonal range. With the ability to interpret these histograms comes the skill needed to fine-tune the exposure.

The horizontal axis on the histogram shows the overall brightness level of the image. If the majority of the peaks appear on the left, it indicates that the image may be too dark. Conversely, if the peaks are largely on the right, the image may be too bright. Why 'may be' as opposed to 'will be'? The reason I have qualified the wording is that the answer all depends on the result you are seeking. You might actually want a very 'heavy' result, or perhaps a high-key, soft-focus image which is bright and ethereal in quality.

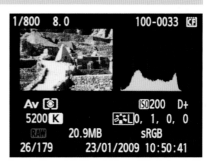

The vertical axis shows how many pixels there are for each level of brightness. Too many pixels on the far left suggests that shadow detail will be lost. Too many on the right suggests that highlight detail will be lost. If Highlight Alert is enabled, the latter areas will quickly become apparent. In particularly contrasty situations you may be in danger of losing both shadow and highlight detail from the image, in which case you will have to judge which of the two to sacrifice in favour of the other.

Using the RGB histogram

The RGB histogram is a graph showing the distribution of brightness in terms of each of the primary colours – Red, Green and Blue. The horizontal axis shows each colour's brightness level (darker on the left and lighter on the right). The vertical axis shows how many pixels exist for each level of brightness in that particular colour.

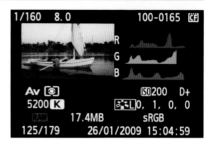

The greater the number of pixels on the left of the histogram, the darker and less emphatic that particular colour will appear in the image. Conversely, the greater the number of pixels shown on the right, the brighter that colour will be, possibly to such an extent that the colour is far too saturated and won't hold detail.

Slide show

Slide show initiates continuous playback of your images, with or without the shooting information and histograms described above. You can press **INFO** during the slide show to change the display to include shooting information and histograms. By selecting **All images** and pressing **SET**, a scroll menu offers the choice of displaying all images on the card, images shot on a specific date, or images in a specific folder. By selecting **Set up** you can display each image for 1, 2, 3, 4 or 5 seconds.

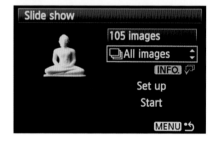

Image jump with ☼

This function provides different options for scrolling through images on the memory card using the ☼ Main Dial. When this facility is in use, the ○ Quick Control Dial can also be used to scroll through images one at a time. Using both dials in combination is a fast and efficient way to navigate through large numbers of images.

94

Set-up menu 1

This is the first of three menus that cover settings which, in most cases, you will determine once and need not return to often, except in special circumstances. Highlighting for all Set-up menus is in yellow.

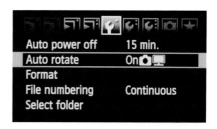

To set options in ⚙ Set-up menu 1:

1) Select ⏻ on the power switch.

2) Press the **MENU** button and then use the ⌚ Main Dial to scroll through the nine menus until you reach ⚙ Set-up Menu 1.

3) To highlight a different item on the menu, rotate the ◯ Quick Control Dial in either direction.

4) To select an item once it is highlighted, press the **SET** button.

5) When secondary menus or confirmation dialogue boxes are displayed, use the ◯ Quick Control Dial to highlight your selection and press the **SET** button to save.

6) To exit at any stage, press the **MENU** button to go back one level and repeat if necessary.

Auto power-off

With this setting, you can save battery power while keeping the camera ready for action. You can instruct the camera to turn itself off after a set interval ranging from 1–30 minutes of non-operation, but power will be restored immediately as soon as you depress the shutter-release button (or any other button). If you wish the camera to remain switched on at all times, you should select the **Off** option from the menu. The LCD monitor will always turn itself off after 30 minutes, whatever the setting.

Auto rotate

If Auto rotate is enabled, all vertical images are rotated automatically so that they are displayed with the correct orientation. This can be applied to either the camera monitor and computer ⬛🖥, just the computer 🖥, or it can be disabled altogether.

Format

If the memory card is new or has been in use in a different camera, the Format function will initialize the card ready for use in the current camera. Formatting a card removes all images and data stored on that card. The format function can also be used to reset the file-numbering sequence (see below).

File numbering

Each time you record an image, the camera allocates a file number to it and places it in a folder. The file numbers and folder names can be changed once they are on your computer, but not in camera.

Images are assigned a sequential file number from 0001 to 9999 – for example, IMG_0001.JPG – and are saved in one folder. The prefix IMG_ is used regardless of file type but the suffix will be either .JPG or .CR2 (.CR2 is used for both RAW and sRAW files). Movie files are stored in the same way but with the prefix MVI_ and the suffix .MOV.

When a folder is full and contains 9999 images, the 5D Mk II will automatically create a new folder. The first image in the new folder will revert to 0001, even if **Continuous** is selected. The camera can create up to 999 folders.

Continuous

If you select this option, when you change a memory card, the file number of the first image recorded on the new card will continue from the last image on the card you removed. So, if the last shot taken on a card was IMG_0673.JPG, the first shot on the new card will be IMG_0674.JPG. Normally, the same applies when you start a new folder but as soon as the file number reaches 9999, a new folder will still be created and the file number will revert to 0001.

Auto reset

Each time you replace a memory card or create a new folder, the file numbering automatically starts from 0001.

Manual reset

When you reset the file numbering manually, the camera creates a new folder immediately and starts the file numbering in that folder from 0001. This is convenient if you are shooting similar images in a variety of different locations or at different times and want to keep each set of images separate. This can be helpful when renaming files or adding captions at a later date. After a manual reset, the file-numbering sequence will return to Continuous or Auto reset.

Common problems

Continuous file numbering is sometimes assumed to be a mechanism for counting the number of shutter actuations. This is not the case. 'Continuous' in this context refers only to the continuation of the file-numbering sequence when you replace the memory card or start a new folder. With both Continuous file numbering and Auto reset, if you switch to a replacement card, or an existing folder, which already contains images, file numbering may continue from the last image in that sequence, not from the card or folder which you have just moved from. Always create a new folder or use a freshly formatted card.

This menu allows you to select an existing folder into which subsequent images will be saved. It also allows you to manually create a new one. If you select **Create folder** the folder name will follow the standard sequence. If your highest numbered existing folder is 106, for example, the new one will be 107.

In order for continuous file numbering to be applied when you create a new

folder, the last image recorded in the previous folder must have been taken with Continuous file numbering selected (see page 97), otherwise the first image in the new folder will start from 0001.

Set-up menu 2

As with Set-up menu 1, you will visit most of the settings in Set-up menu 2 when you first acquire the camera, but rarely afterwards – with the possible exceptions of the Live View functions (see page 118–31).

To set options in ¶Ť Set-up menu 2:

1) Select ⏻ on the camera power switch.

2) Press the **MENU** button and use the Main Dial to scroll through the nine menus until you reach ¶Ť Set-up menu 2.

3) To highlight a different item on the menu, rotate the ⊙ Quick Control Dial.

4) To select an item once it is highlighted, press the **SET** button.

5) When secondary menus or dialogue boxes are displayed, use the ⊙ Quick Control Dial to highlight your selection and press the **SET** button to save the setting.

6) To exit at any stage, press the **MENU** button to go back one level and repeat if necessary.

LCD brightness

When this function is selected, three items are displayed on the monitor: the last image recorded, a greyscale and a slider control. Rotate the ⊙ Quick Control Dial in either direction to change the setting. The arrow on the slider will move along the scale and all the bands of the greyscale graphic will become darker or lighter, as will the displayed image.

Date / Time

To set or amend the Date/Time:

1) Rotate the ⊙ Quick Control Dial to scroll through the different settings.

2) To change a setting, highlight it and press **SET**.

3) Rotate the ⊙ Quick Control Dial again in either direction to change to the desired setting, then save it by pressing **SET**.

4) Repeat the process for each setting you wish to change.

Common problems

Changes may appear to have been made on the selected menu screen, but make sure you highlight OK and press SET after making any changes. If you don't, the changes will not be registered, even if you pressed SET after each individual change.

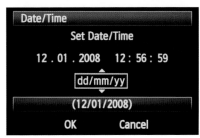

5) To save all changes, highlight **OK** and press **SET**.

Language

Twenty-five separate languages are
programmed into the EOS 5D Mk II.
If, just for fun, you select a different
language – particuarly one which uses
a different alphabet – you may find it
difficult to restore your own language.

Video System

You can connect the camera to a TV set
using the cable provided (see page 233).
However, you must first use the Video
System menu to establish the correct video
format. The choice of settings is between
NTSC (more common in North America)
and PAL (more common in Europe).

Sensor cleaning

Dust specks on the sensor are one of
digital photography's major irritations,
and they are virtually impossible to avoid.
They show up particularly in areas of plain
colour, such as expanses of blue sky, and
when using narrow apertures – assuming
the image is magnified sufficiently for
them to be noticeable. To minimize the
problem, try to avoid changing lenses
frequently if possible, especially in a dusty
or windy environment, and don't use f/22
when f/8 will do!

While it may occasionally be necessary to
have your camera's sensor professionally
cleaned by an authorized Canon service
centre, the 5D Mk II's Integrated Cleaning
System is designed to shake off particles
of dust during routine use.

100

If you enable **Auto cleaning** in this menu, the Self Cleaning Sensor Unit, which is attached to the sensor's front layer, will operate for approximately one second each time you set the power switch to **ON**, ⏻ or **OFF**. During this brief period the LCD monitor displays a message indicating that the operation is taking place. Auto cleaning can also be disabled using this menu. The **Clean manually** setting is for use by service technicians.

It is also possible to instruct the camera to operate the sensor cleaning operation immediately by selecting the **Clean now** option in the Sensor cleaning menu. This will initiate a single cleaning cycle.

To select the Clean now function:

1) Rotate the ⌬ Quick Control Dial to select **Clean now** and press **SET**.

2) Select **OK** and press **SET**.

3) The LCD monitor displays the sensor-cleaning message. You hear the sound of the shutter but no picture is taken.

4) Remember that the manually selected sensor-cleaning operation takes slightly longer than the automatic cleaning operation (approximately 2.5 sec).

Live View functions

For full details of the 5D Mk II's Live View and Movie settings, see pages 118–31.

Live View/Movie func. set.	
LV func. setting	Disable
Grid display	Grid 1 ⊞
Silent shoot.	Disable
Metering timer	16 sec.
AF mode	Live mode
Movie rec. size	1920x1080
Sound recording	Off

Set-up menu 3

This menu is used for registering the settings for the Camera User modes **C1**, **C2** and **C3** and settings for an external Speedlite. It is also used to clear all camera settings back to their default values, so care needs to be taken not to use this function accidentally. This menu also identifies the current firmware installed on the camera.

Battery info

A vast improvement on the usual simplistic scale showing the level of charge, the Battery info menu allows you to register individual batteries and monitor their efficiency. Remaining capacity is indicated in 1% increments, the number of shots recorded with the selected battery since recharging is shown, and its recharging performance is displayed as a three-bar indicator in green. This changes to a single red bar when the battery should be discarded and a new one purchased.

INFO button

The **INFO** button can be used to display a summary of information in addition to that provided by the LCD top panel. This menu setting can be used to determine which of two displays will normally be shown: Camera Settings or Shooting Functions.

External Speedlite control

When a Canon EX-series Speedlite is attached, its functions and Custom Functions can be accessed from this menu. The options displayed will depend upon the model of Speedlite and metering mode selected.

For normal situations, evaluative ETTL-II metering is recommended.

Camera user settings

These are the three custom modes **C1**, **C2** and **C3** found on the Mode Dial. They can be set up to incorporate three groups of camera settings which you might use in combination on a frequent basis.

To register Camera user settings:

1) Turn the power switch to the ◢ position and choose the desired settings.

2) Go to Set-up menu 3 and highlight **Camera user setting** and press **SET**.

3) On the next menu, highlight **Register** and press **SET** again.

4) On the third menu, rotate the ◌ Quick Control Dial to select **C1**, **C2** or **C3** and press **SET** again.

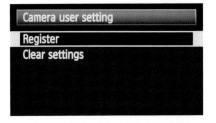

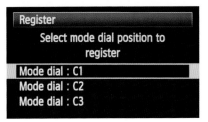

5) When the confirmation box appears, select **OK** and press **SET** for the last time. Your settings will now be registered.

To clear Camera User settings:

1) Go to 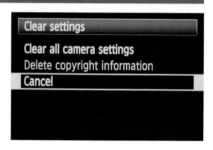 Set-up menu 3 and highlight **Camera user setting**. Press **SET**. Rotate the ◎ Quick Control Dial to select **Clear settings** and press **SET**. Then select the group of settings you wish to clear – **C1, C2** or **C3** – and press **SET** again.

2) Select **OK** in the confirmation box and press **SET** for the last time. Your settings for the Camera User mode dial setting selected will now be deregistered. Follow the same procedure to cancel the settings for the other Camera user modes.

Clear settings

1) To clear all the camera settings and restore them to their default values, switch the camera on using the ┘ setting. (Note that When the Mode Dial is set to **C1, C2** or **C3**, the **Clear all camera settings** option in Set-up menu 3 and the **Clear all Custom Functions** option in Custom Functions Menu will not operate.)

2) Select Set-up menu 3. Highlight **Clear all camera settings** and press **SET**.

3) When the confirmation dialogue box appears, select **OK** and press **SET**.

Firmware version

Canon periodically update the camera's firmware; check their website (see page 237) to see when a new version is available and for full installation instructions. You can also have the firmware installed for you at a Canon Service Centre.

Common problems

Early production models suffered from a 'black dot' issue, with pixels immediately to the right of a point of light rendered as black. Firmware update v1.1.0 will correct this, and also fix the vertical banding noise issue in sRAW 1. Updates to Digital Photo Professional and Picture Style software should also be downloaded.

104

Custom Functions menu

This menu alone provides 25 options for fine-tuning your camera usage and it is well worth familiarizing yourself with the choices available.

Custom Functions are divided into four groups primarily concerned with Exposure, Image, Autofocus and Drive, with a final group, called Operation/Others, for additional options that don't fall into any of the above categories. These groups are abbreviated to C.Fn I, C.Fn II, and so on, using Roman numerals. Choices within each group are referred to by

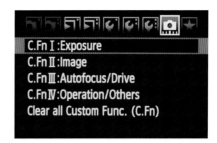

their position in the respective menu, eg. C.Fn IV-3. There are many different menus, but the procedure for accessing each menu item is the same, and is shown below.

1) Select ⌣ on the camera power switch.

2) Press the **MENU** button and use the Main Dial to locate the 📷 Custom Functions menu.

3) To change the highlighting to one of C.Fn I, C.Fn II, C.Fn III or C.Fn IV, rotate the ⏥ Quick Control Dial. To select it, press **SET**.

4) When a Custom Functions category has been selected, it does not display a secondary menu of its own. Instead, the last-viewed sub-menu from within that category is displayed. Rotate the ⏥ Quick Control Dial to scroll through the sub-menus for that category. The number for each sub-menu is displayed in the top right corner of the screen.

5) Press **SET** to make this menu active and the current selection will be highlighted.

6) Rotate the ⏥ Quick Control Dial to highlight the desired function setting and press **SET**.

7) Press **MENU** to exit to the main Custom Functions menu.

> **Tip**
> In each Custom Function category's sub-menu, the current settings for all the sub-menus in that Custom Function category are displayed numerically at the bottom of the display, with each default setting represented by a zero.

C.Fn I-1 Exposure level increments

This provides a choice between ⅓- or ½-stop increments for both normal and flash exposure settings.

C.Fn I-2 ISO speed setting increments

This provides a choice between ⅓- or 1-stop increments for ISO speed settings.

C.Fn I-3 ISO expansion

The normal ISO range is from 100–6400 (100–3200 in Auto ISO and 200–6400 in Highlight Tone Priority) but can be expanded to 50 (L), 12,800 (H1) or 25,600 (H2). Remember that a high ISO will significantly increase noise in your images, but you can increase the level of noise reduction in C.Fn II-2 (see page 109).

106

C.Fn I-4 Bracketing auto cancel

With this feature set to **On**, both Auto exposure bracketing and White-balance bracketing will be cancelled if the camera's power switch is turned to **OFF** (this does not apply to Auto power-off, which can be interpreted as a standby setting). Auto exposure bracketing will also be cancelled before a flash is fired.

With this function switched off, both AEB and WB-BKT settings will be retained even when the power switch is set to **OFF**,

though AEB will still be cancelled before a flash is fired.

C.Fn I-5 Bracketing sequence

This function offers a choice between having the bracketing sequence with the nominally correct exposure first, followed by the under- and over-exposed images, or having them in order of exposure value.

C.Fn I-6 Safety shift

This function applies solely to Aperture Priority (Av) and Shutter Priority (Tv) modes and enables an automatic adjustment to the exposure if there is a last-moment shift in lighting conditions.

FUNCTIONS

C.Fn I-7 Flash sync. speed in Av mode

This function applies solely to Aperture Priority (Av) mode and the use of flash. The flash sync speed can be set to a fixed 1/200 sec or can be left on **Auto** when it will set a suitable speed to match the ambient light, up to a maximum of 1/200 sec. A third option allows you to select 1/200–1/60 sec auto, which allows some flexibility without the risks of blur associated with a very slow shutter speed.

You must also select **Auto** if you intend to use high-speed flash sync.

C.Fn II: Image

C.Fn II-1 Long exposure noise reduction

The default setting for this function is **OFF**. When changed to **Auto**, the camera will automatically apply noise reduction to exposures of 1 sec or longer provided it detects noise in the image just captured. When switched to **On**, this function will apply noise reduction to all exposures of 1 sec or longer.

Tips

The noise-reduction process is applied after the image is captured and will effectively double the time it takes to record the image.

If noise-reduction is set to **On** when shooting with Live View, the LCD display will be disabled while the noise-reduction process is applied.

The size of the maximum burst for continuous shooting will be drastically reduced when noise reduction is applied.

C.Fn II-2 High ISO speed noise reduction

This function will reduce noise at all ISO settings, not just high ISO speeds as it seems to suggest. When **2: Strong** is selected, the size of the maximum burst for continuous shooting will be dramatically reduced.

C.Fn II-3 Highlight Tone Priority

This function expands the dynamic range of the highlights to ensure the retention of highlight detail without sacrificing existing shadow detail (though noise may increase in the shadows). It only operates in the ISO 200–6400 range. The additional symbol **D+** will be displayed with the ISO setting. Highlight Tone Priority can be combined with exposure compensation.

C.Fn II-4 Auto Lighting Optimizer

This function will automatically correct the balance of contrast and brightness when the selected exposure will produce an unbalanced image. In ⬭ Full Auto and **CA** Creative Auto modes the Auto Lighting Optimizer will be applied automatically

> **Tip**
> Auto Lighting Optimizer can only be applied to JPEG images in-camera. However, it can be applied retrospectively to RAW and sRAW images using Canon's Digital Photo Professional software.

using the **Standard** setting. In **P, Tv** and **Av** modes the Standard setting is enabled by default but can be adjusted. During exposures made in **M** or **B** modes this feature is disabled.

C.Fn III: Auto focus/Drive

C.Fn III-1 Lens drive when AF impossible

Although the especially sensitive '+' type centre AF point on the EOS 5D Mk II improves focus acquisition, there are still circumstances when AF will struggle to achieve focus. In these conditions the lens will continue to 'hunt' for focus and it can be quicker to focus manually. (Many EF lenses provide full-time manual focus which can be safely employed even when the lens is switched to **AF**.) This function allows the camera to disengage AF when the lens is unable to achieve focus using AF so that it will not continue to 'hunt'.

110

C.Fn III-2 Lens AF stop button function

The AF stop button is only provided on super-telephoto IS lenses. This function allows you to designate different functions for the AF stop button. For a detailed explanation of any of these settings, refer to Canon's instruction manual.

C.Fn III : Autofocus/Drive 2

Lens AF stop button function

0:AF stop

1:AF start

2:AE lock

3:AF point:M->Auto/Auto->Ctr

4:ONE SHOT ⇄ AI SERVO

1 2 3 4 5 6 7 8
0 0 0 0 0 0 0 0

C.Fn III-3 AF point selection method

The ability to change a specific autofocus point quickly is a feature which many photographers find invaluable. There are three options available on the 5D Mk II. The **Normal** setting makes use of the ⊡ / ⊕ AF point selection button which is pressed once to light up the current AF point in the viewfinder, then either the ⛭ Main Dial or the ◯ Quick Control Dial is rotated to scroll through the different AF points and the Auto setting.

Alternatively, the ✳ Multi-controller can be used on its own, without pressing the ⊡/⊕ AF point selection button first. However, you can still use the ⊡/⊕ AF point selection button as a shortcut to implement Auto AF point selection.

C.Fn III : Autofocus/Drive 3

AF point selection method

0:Normal

1:Multi-controller direct

2:Quick Control Dial direct

1 2 3 4 5 6 7 8
0 0 0 0 0 0 0 0

The third option is to use just the ◯ Quick Control Dial without pressing the ⊡/⊕ AF point selection button first. With this selection there is an added feature: you can hold down the ⊡/⊕ AF point selection button while rotating the ⛭ Main Dial in order to set exposure compensation.

C.Fn III-4 Superimposed display

This function deals with the AF points in the viewfinder. The **Off** setting stops AF points from lighting up in red in the viewfinder when focusing. AF points will continue to light up when being selected.

C.Fn III-5 AF-assist beam firing

If **Enable** is selected, an attached EX Speedlite can use the AF-assist beam to assist with focusing.

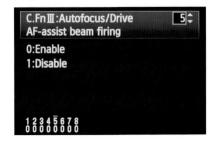

C.Fn III-6 Mirror lock-up

To prevent the slight vibration that can be caused by the reflex mirror operation, the mirror can be locked up as soon as your focusing, framing and exposure-setting procedures have been completed. When this function is enabled, fully depressing the shutter release once swings the mirror up and locks it in place. This operation sounds like shutter actuation but is not. The shutter-release button must be pressed a second time to take the exposure and release the

mirror afterwards. It is recommended that the remote release RS-80N3 is used to further reduce the risk of vibration.

112

C.Fn III-7 AF point area expansion

With AI Servo and the centre AF point selected, enabling the AF point area expansion function brings into play six additional AF-assist points, located within the spot-metering circle. This is useful when tracking a subject which is small in the frame and moving erratically.

C.Fn III-8 AF Microadjustment

All lenses contain many components which are engineered to microscopic tolerances, but minute differences may still occur. This is an issue which is unlikely to trouble the majority of readers, except for those involved with extreme close-ups, studio work, or fine art photography demanding the utmost precision.

It has always been possible to have a lens calibrated at a Canon Service Centre, but the 5D Mk II now has this facility built-in. These adjustments effectively move the focal plane forwards or backwards to ensure absolute precision when focusing. Any adjustments made are applied only within the camera. The lens is not affected in any way, other than responding to the AF commands issued by the camera.

Adjustment may be necessary if the sharpest plane of focus in your images tends to be beyond, or in front of, the subject plane you believe should be

sharpest. This may happen with all lenses, or it may suggest one particular lens that requires compensation. Settings can be applied individually to a maximum of 20 lenses. If a lens is combined with either the EF 1.4× or 2× extender, it will be treated as a separate camera/lens combination.

Adjustments are made in small increments: up to 20 in either direction, forward or backward. You can adjust all the lenses you use by the same amount, or you can adjust one lens at a time – in which case, the camera will store the information and recognize each lens when it is fitted.

Any adjustments made can later be reset to zero, or adjusted further by repeating the AF Microadjustment operation. If adjustments have been made for a particular lens, that lens must be fitted for later adjustments to be implemented.

To perform AF Microadjustment:

1) Carefully review your suspect images at 100% (actual pixel level), looking for a consistent tendency for the sharpest plane of focus to be either in front of or behind where it should be.

2) Set the camera on a tripod, aimed at a target subject at a distance typical of the way you normally use that specific lens. Camera-to-subject distance should be at least 50× focal length. Subject lighting should be even and bright enough for the AF system to acquire focus easily (use the centre AF point). Be sure the subject has some depth, i.e. discernible detail both in front of and behind the point you focus on.

3) If using a zoom lens, start your tests with the lens set at its longest focal length. Evaluate the results before testing the lens at wider settings.

4) Test shots (Canon suggest Large/Fine JPEG) should be taken with the lens set at maximum aperture in Manual or Aperture Priority mode, with One Shot AF and a low ISO selected. Any Image Stabilizer on the lens should be switched off. It is also

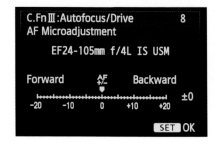

Warning!
Carry out this adjustment only if it is absolutely necessary. If carried out improperly, it may prevent correct focusing from being achieved. AF Microadjustment cannot be performed during Live View shooting in Live and Live 'L' modes. If camera settings are cleared, the microadjustment setting will be retained, though the AF Microadjustment menu will be reset to the default 0:Disable setting.

recommended that you enable mirror lock-up and use either the self-timer or a remote release.

5) Select C.Fn III-8. Highlight either **Adjust all by same amount** or **Adjust by lens** and press **SET**. Press **INFO** to display the adjustment screen. Take a series of test shots at different AF Microadjustment settings (see step 6).

6) For each shot, move the pointer forward on the AF Microadjustment scale if you perceive back-focusing, or backward if

your sharpest plane of focus is too close to the camera. Canon suggest starting with +/-20 and reducing the setting until you feel it is correct.

7) Don't use the camera's LCD monitor to judge AF Microadjustment test results: observe your test images at 100% view on your computer monitor. When you arrive

at an image that comes closest to putting the plane of focus where you feel it should be, try shooting a variety of subjects at that setting and assess the results. Adjust further if necessary.

C.Fn IV: Operation/Other functions

Warning!

The first four functions in this category change the roles performed by different buttons or dials. This is a powerful opportunity to redesign the way in which

you use the EOS 5D Mk II, but there are handling implications for each combination and any reprogramming should be thought through carefully.

C.Fn IV-1 Shutter button / AF-ON button

This menu offers several combinations for the shutter-release button and **AF•ON** button, all of which involve the metering, auto exposure lock and autofocus functions. The default setting uses partial pressure on the shutter release to initiate both autofocus and metering, with the same function also being performed by the **AF•ON** button except in **M** and **B** modes. The other options should be carefully considered alongside other settings and your preferred ways of working.

```
C.Fn IV:Operation/Others          1 ↕
Shutter button/AF-ON button

0:Metering + AF start
1:Metering + AF start/AF stop
2:Metering start/Meter+AF start
3:AE lock/Metering + AF start
4:Metering + AF start/Disable
1 2 3 4 5 6
0 0 0 0 0 0
```

C.Fn IV-2 AF-ON / AE lock button switch

This menu seems to suggest the disabling of these buttons, but, if **Enable** is selected, it actually swaps ('switches') their respective functions.

C.Fn IV-3 Assign SET button

The **SET** button can be programmed to perform various functions, any of which you may like to access quickly. It can be used to bring up either the Image quality selection screen or the Picture Style menu, to access the menu system or to replay the last image captured.

C.Fn IV-4 Dial direction during Tv/Av

This menu appears to relate only to Tv and Av modes, but actually applies to Manual mode as well. In Tv and Av modes, the effect of rotating the Main Dial is reversed. In M mode, the effects of rotating each of the Main Dial and the Quick Control Dial are reversed. In all cases, with **Normal** selected, clockwise rotation decreases the exposure.

C.Fn IV-5 Focusing screen

If you change the type of focusing screen, you should identify the new one being used via this screen. Precision Matte Eg-D is the same as the fitted screen but with a grid. Super Precision Matte Eg-S is designed to make manual focusing easier.

C.Fn IV-6 Add original decision data

When this function is enabled, data is added to each new image you capture to confirm its originality. For anyone to verify originality they must purchase the Original Data Security Kit OSK-E3.

Clear all Custom Functions

This function is different from **Clear settings** in Set-up menu 3 (see page 104) in that only the Custom Function settings will be returned to their default settings.

Live View & Movie Mode

Live View allows you to view the subject on the camera's LCD monitor rather than through the viewfinder, but without the time-lag associated with compact cameras. However, the camera is not suitable for being held at arm's length like a digital compact and Live View is easiest to use when the camera is mounted on a tripod. It is best suited to situations in which the camera-to-subject distance remains constant.

Live View can be used for three types of operation: shooting stills, shooting movie clips, and shooting movie clips but also being able to shoot stills at the same time. Three types of autofocus are possible: Quick Mode, Live Mode, and Live ☺ Face Detection Mode. Using the EOS Utility software provided with the camera, Live View shooting can

Live View/Movie func. set.	
LV func. setting	◯/◯DISP
Grid display	Grid 2 ▦
Silent shoot.	Disable
Metering timer	16 sec.
AF mode	Quick mode
Movie rec. size	1920x1080
Sound recording	Off

be also carried out with the image displayed on a computer screen, with camera functions operated remotely (full details of how to achieve this are contained in the software instruction manual provided with the camera).

The Live View image can also be displayed on a TV using the stereo video cable provided or an HDMI cable (sold separately).

Note
All Live View settings are accessed via **Live View function settings** in ↑↑ Set-up menu 2.

Warning

High camera temperature may degrade image quality and damage internal components. Prolonged Live View shooting will increase the camera's internal temperature. If the ▨ high temperature warning icon is displayed, cease using Live View to allow the internal camera temperature to drop.

Shooting stills

This section deals only with shooting still images in **Stills only** mode. For shooting stills while shooting movie clips, see page 123.

Preparation

Set up the shooting situation with the camera mounted on a tripod. Use the viewfinder in the normal way and align the camera and adjust the lens zoom setting so that the subject is more or less displayed as desired. Position any lighting, flash or wireless flash to be used.

1) Turn the camera's power switch to the ⏻ setting.

2) Select the desired shooting mode from **P**, **Tv**, **Av**, **M**, or **B**.

3) Select ⚙ Set-up menu 2 and **Live View/Movie func. set.** and press **SET**.

4) Select **LV func. setting** and press **SET**. Rotate the ◯ Quick Control Dial to select **Stills only** and press **SET**.

5) Rotate the ◯ Quick Control Dial to select **Stills display** or **Exposure simulation** in the **Screen settings** menu and press **SET** (see box).

6) To display the Live View image, press the 📷 button to the left of the viewfinder. To quit Live View at any time, press 📷 again.

Screen settings

With **Stills display** the image is displayed at a standard brightness level. With **Exposure simulation**, image brightness will approximate the result for the selected exposure value. If the ExpSIM icon is blinking, the image is not being displayed at an appropriate level of brightness due to dark or bright lighting, but the captured image will be recorded correctly provided the exposure settings are correct. If flash is used or **B** mode is selected, the ExpSIM icon will be 'greyed out'. If Auto Lighting Optimizer is not disabled in C.Fn II-4 the image may appear too bright.

1) With the subject displayed on the LCD monitor (see page 119), make final adjustments to the camera position and lens settings and turn on any flash or lighting.

2) Press the **AF•ON** button and the camera will focus using the selected Live View AF mode (see pages 124–6).

3) Fully depress the shutter-release button.

4) The captured image will be displayed on the LCD monitor. When the image review ends, the Live View image will resume.

Live View options

Permissible operations during Live View

a) Camera settings can be changed as normal.

b) Pressing **AF•DRIVE** will bring up the AF/Drive setting screen on the monitor; settings can be changed.

c) Pressing **ISO•⚡** will bring up the ISO/Flash compensation setting screen on the monitor; settings can be changed.

d) Depth-of-field preview functions normally.

e) Pressing the **MENU** button will still provide access to all menus; settings can be changed. However, selecting **Dust delete data, Sensor cleaning, Clear settings** or **Firmware ver.** will cause Live View to terminate.

f) At 23°C (73°F) a fully charged battery will permit approximately 200 images to be shot over a two-hour period. However, note the caution about internal camera temperature on page 118.

g) The **Auto power-off** setting in Set-up menu 1 will apply. If this setting is disabled, Live View will terminate.

h) Live View can make use of a TV using the stereo video cable provided or an HDMI cable (sold separately).

i) The RC-1 or RC-5 Remote Controls (sold separately) can be used with Live View but should not be used in close proximity to fluorescent lighting as this may affect camera operation. If Silent shooting Mode 2 is selected the camera will default to Mode 1 when using these accessories.

Operations not possible during Live View

a) Metering will be set to Evaluative regardless of the current setting.

b) If continuous shooting is selected, the exposure for the first image will be applied to subsequent images in the same burst.

c) Autofocus is not possible using either the RS-80N3 remote switch or TC-80N3 timer/remote controller. (They will trigger the shutter release and can be used when focusing manually.)

d) Silent shooting in Mode 1 or Mode 2 is not possible when using flash. The camera will default to the **Disable** setting.

120

OCEAN RIPPLE

This high-key still life of a group of seashells was shot with a mixture of ambient light and flash. The image was treated to a ripple effect in Photoshop, just for fun.

Settings
Live View stills mode
Aperture priority (Av)
Evaluative ETTL II metering
ISO 100
2 sec at f/22
Manual focus
Off-camera diffused main flash 580EX
Wireless secondary flash 550EX
Flash sync speed: Auto
Photoshop: Filter > Distort > Ocean ripple

Silent shooting

There are two silent shooting modes, plus a **Disable** setting.

The default setting is **Mode 1** which is not 'silent' but is quieter than normal shooting and also permits continuous shooting at approximately 3 fps. No image will be displayed on the monitor while the images are being recorded. If continuous shooting is selected, all images will be recorded using the same exposure as the first shot in the sequence.

With **Mode 2** selected, only one frame can be exposed at a time, regardless of whether continuous shooting is selected or not. Having fully depressed the shutter release to take the photo, maintain full pressure on the shutter release to suspend all other camera activity. When you release pressure sufficiently for the shutter release to return to its halfway position, camera activity will resume and the sound of the reflex mirror will be heard. This allows you to take a single picture with the minimum of intrusion, before moving to a less intrusive position to allow the reflex mirror to return to its previous position.

When **Disable** is selected, Live View works normally and sounds as if two shots are being taken, though it is in fact only one.

Warning!
If you use any extension tube(s) or vertical shift on a TS-E lens in Live View, you should disable **Silent shooting** as exposure is likely to be inaccurate.

Tips
Silent shooting in Mode 1 or Mode 2 is not possible when using flash; the camera will default to the disabled setting.

When using a non-Canon flash unit, select **Disable**.

If Mode 2 is selected and the remote controller RC-1 or RC-5 is used, the camera will default to Mode 1.

Grid display

The grid display can be turned off (default) or can use the **Grid 1** overlay which divides each side of the frame into thirds. **Grid 2** divides the longer side of the frame by six and the shorter side by four. Neither grid is displayed when the captured image is played back.

Metering timer

This function determines how long the current AE lock setting will be retained in the camera's memory. The options range from 4 seconds to 30 minutes.

Shooting stills in Movie mode

You can take a still photo at any time while shooting movies by pressing the shutter-release button. Shutter speed and aperture are set automatically with auto ISO in the range 100–3200.

External flash will be disabled for stills taken during movie recording.

If **Screen settings** is set to ![DISP] Movie display, the depth of field preview button will not function.

When you take a still image during movie recording, the movie itself will record a frozen image for about one second, then continue. This can be an effective device as part of the movie clip but would be unsuitable during, say, a panning sequence.

If either the 10 sec or 2 sec self-timer is currently selected in Drive mode, the camera will behave as if ◯ Full Auto has been selected.

Three AF modes are provided in Live View: Quick mode, Live mode and Live ʔ Face Detection mode. Although AF is functional, Canon still advise manual focusing using a magnified image display for absolute accuracy.

Quick mode AF Quick

The AF system will focus in One Shot mode, just as if you were shooting using the viewfinder in the normal way, and makes use of the normal AF point array. The Live View image display is briefly interrupted during the AF operation. Live View's Quick mode makes use of the camera's normal AF points.

1) Select ʔ Set-up menu 2 and **Live View/Movie func. set.** Press **SET**.

2) Select **AF mode** and press **SET**.

3) Rotate the ○ Quick Control Dial to highlight **Quick mode** and press **SET**.

4) Press the ▭/☐∿ button. The Live View image will be displayed. The tiny rectangle indicates the currently selected AF point. The larger white rectangle shows the magnifying frame which can be moved around the image using the ✳ Multi-controller; this rectangle shows the area of the image which will be magnified (×5 or ×10) when you press the ✳/▣•⊖ and ▦/⊕ buttons.

5) Press **AF•DRIVE** and use the ✳ Multi-controller to select the desired AF point. To select the centre AF point, press directly onto the ✳ Multi-controller; for the other AF points, push the ✳ Multi-controller in the appropriate direction. Pushing the ✳ Multi-controller a second time in the same direction will toggle AF point selection between manual and automatic selection.

6) Position the AF point over the subject and hold down the **AF•ON** button. The Live View image will turn off briefly while the AF operation takes place. You will hear the reflex mirror but this is not the shutter being activated.

7) When focus is achieved, the beep will sound and the Live View image will be displayed on the monitor again (with the active AF point shown in red, provided pressure is retained on the **AF•ON** button).

8) Fully depress the shutter release to take the picture.

Live mode AF Live

This mode makes use of a movable focusing frame, rather than the AF point array, and has the distinct advantage of allowing the focusing frame to be moved anywhere in the image, except right at the edge of the frame. Operation is slower than with Quick mode but more flexible in terms of composition.

1) Select ⚙ Set-up menu 2 and **Live View/Movie func. set.** Press **SET**.

2) Select **AF mode** and press **SET**.

3) Rotate the ◯ Quick Control Dial to highlight **Live mode** and press **SET**.

4) Press the 🗖/🖨~ button. The Live View image will be displayed. A single white rectangle indicates the AF point/focusing frame. (It is vertically orientated to distinguish it from the horizontal magnifying frame in Quick mode.)

5) To move the focusing frame, use the � Multi-controller. Pressing it in will return the focusing frame to the centre.

6) Position the focusing frame over the key part of the subject and hold down the **AF•ON** button to focus. With the focusing frame positioned over the key part of the subject, press the ▣/⊕ button to magnify the image ×5. The focusing frame will change to a square. (Press ▣/⊕ again to achieve 10× magnification or

✱/▣ • ⊖ to reduce magnification by one level.) Return the display to normal magnification before shooting and hold down the **AF•ON** button to focus.

7) When focus is achieved, the beep will sound and the focusing frame will turn green. If AF proves impossible, the focusing frame will turn red.

8) Keep the **AF•ON** button depressed while the focusing frame is green, and fully depress the shutter release to take the picture.

Tip

You can make any changes to the AF points, AF mode and Drive settings on a single screen by pressing the **AF•DRIVE** button and using the 🖴 Main Dial (for AF mode), ◯ Quick Control Dial (for Drive mode) or � Multi-controller (for AF point selection) to adjust the settings.

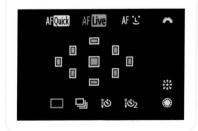

Live Face Detection mode AF ☺

This is the same as Live Mode except that the camera is programmed to recognize a forward-facing human face and to focus on that instead of the nearest part of the subject. This depends upon the extent to which the whole face is visible and its relative prominence in the frame.

1) Select ⛭ Set-up Menu 2 and **Live View/Movie func. set.** Press **SET**.

2) Select **AF mode** and press **SET**.

3) Rotate the ⭕ Quick Control Dial to **Live ☺ mode** and press **SET**.

4) Press the ▣/⎙ button. The Live View image will be displayed without any AF point or magnifying frame.

5) Point the camera at the subject. When a single face is detected, the ⸢⸣ focusing frame will appear, centred on the subject's face. The appearance of the ⸢⸣ focusing frame does not indicate that focus is achieved. The size of the ⸢⸣ focusing frame will vary according to the area occupied by the subject.

6) If more than one face is detected, the ⸢⸣ focusing frame will be displayed instead. Use the ✳ Multi-controller to move the ⸢⸣ focusing frame over the face of the desired subject.

7) Hold down the **AF•ON** button.

8) When focus is achieved, the beep will sound and the focusing frame will turn green. If AF proves impossible, the focusing frame will turn red.

9) Fully depress the shutter release to take the picture.

Tips

The camera may interpret another subject as a 'face' if certain characteristics are present.

Face detection may be affected by a face being very large or very small within the frame, by excessive or poor light, or by tilting the camera.

If the face is too near the edge of the image, the ⸢⸣ focusing frame will be 'greyed out'. Press the **AF•ON** button to focus with the centre AF point.

Toggle between the Live and Live ☺ modes by pressing the ✳ Multi-controller.

Pressing ▦/🔍 in Live ☺ mode will not magnify the image.

Remote Switch RS-80N3 and the Timer Remote Controller TC-80N3 (sold separately) will not activate AF during Live ☺ mode but can be used to release the shutter.

126

Shooting movies

Movie clips can be shot in all shooting modes, including ○ and **CA**. It is also possible to shoot still images either while shooting movies (see page 123) or playing them back. Movies can be played back on a TV. Files are recorded with the .MOV file extension and using the movie equivalent of sRGB colour space.

The ISO speed is set automatically, with ISO 100 as a starting point and increasing to ISO 6400 if necessary. This can be expanded to **H1** 12,800 in extremely low light levels.

Movies are recorded with the currently selected Picture Style applied. If the **Monochrome** Picture Style is selected, both the Live View image displayed during shooting and the recorded footage will be in black and white.

Centre-weighted average metering is always employed by the camera

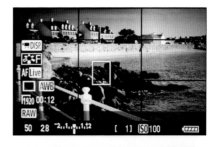

for shooting movies – except when Live ⌣ Face Detection mode (see page 126) is selected, in which case evaluative metering on the detected face is used.

Shooting movies in ○ and CA modes

1) Select ⚏ Set-up Menu 2 and **Live View/Movie func. set.** Press **SET**.

2) Select **Movie recording** and press **SET**.

3) Select **Enable** and press **SET**.

4) Rotate the ○ Quick Control Dial to highlight **Movie rec. size** and press **SET**.

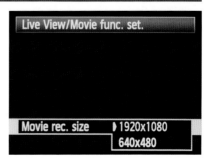

5) Set **1920×1080** for High Definition or **640×480** for 4:3 standard quality and press **SET**.

6) Select the Live View focusing mode you wish to use (see pages 124–6).

7) Press the 📷 button. The Live View movie image will be displayed on the LCD monitor, according to the setting determined in step 5. All the standard AF points will be displayed along with a white rectangular magnifying frame. This frame can be moved around the screen using the

✳ Multi-controller and determines which portion of the image will be displayed if you magnify the image ×5 or ×10 by pressing the [⊡]/🔍 button.

8) Depress the **AF•ON** button to focus. (Make sure you return a magnified image to normal before shooting.)

9) Press **SET** to start shooting. A red circle will be displayed to indicate that recording is taking place.

10) To stop shooting, press **SET** again.

Shooting movies in **P, Tv, Av, M** or **B** modes

1) Select 🔧 Set-up Menu 2 and **Live View/Movie func. set.** Press **SET**.

2) Select **LV func. setting** and press **SET**.

3) Select **Stills+movie** then press **SET**.

4) Select **Movie display** then press **SET**. The screen reverts to the **Live View/Movie func. set.** screen.

5) Rotate the ⬭ Quick Control Dial to highlight **Movie rec. size** and press **SET**.

6) Set **1920×1080** for High Definition or **640×480** for 4:3 standard quality and press **SET**.

7) Select the Live View focusing mode you wish to use (see pages 124–6).

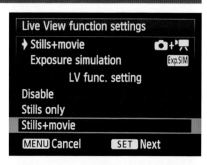

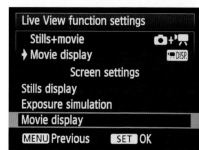

128

8) Press the ⬛ button. The image will be displayed on the LCD monitor. The AF point/magnifying frame display will depend upon the selected Live View AF mode.

9) Depress the **AF•ON** button to focus. (Make sure you return a magnified image to normal before shooting.)

10) Press **SET** to start shooting. A red circle will be displayed to indicate that recording is taking place.

11) To stop shooting, press **SET** again.

Movie playback

The movie playback controls below appear when you press **SET** to start playback, or if you press **SET** again during playback.

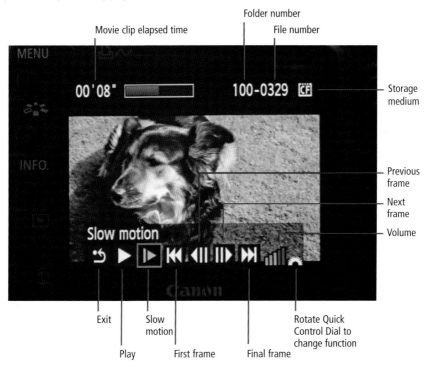

Movie clip elapsed time

Folder number

File number

Storage medium

Previous frame

Next frame

Volume

Exit

Slow motion

Play

First frame

Final frame

Rotate Quick Control Dial to change function

The camera's sound recording capability is turned on or off using the **Live View/Movie func. set.** screen. The sound recorded by the EOS 5D Mk II's built-in microphone is monaural, but stereo sound is possible by connecting an external microphone fitted with a 3.5mm stereo jack to the camera's microphone **IN** terminal. The built-in mic will pick up sounds made by the camera and lens, such as the AF motor and the beep. Using an external microphone can reduce or even eliminate such noises. Sound recording levels are set automatically.

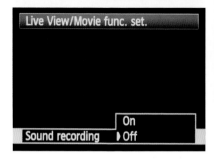

If the Live View image is displayed on a TV while recording is taking place, the TV will not output the soundtrack. This is not an indication that no sound is being recorded.

Hints on shooting movies

In **P**, **Tv**, **Av**, **M** and **B** shooting modes with **Stills+movie** selected, you can still shoot movies by pressing **SET** even if **Screen settings** has been set to **Stills display** or **Exposure simulation**. However, the beginning of a movie clip may display a sudden shift in exposure.

Avoid including bright light sources within the frame.

When shooting movies at 1920 × 1080 full HD quality you are advised to use a large-capacity memory card with a write speed of at least 8MB/sec. As a guide, a

4GB card will provide approximately 12 mins recording time at 1920 × 1280, or 24 mins at 640 × 480. Recording will stop automatically if a file size reaches 4GB or exceeds 29 min 59 sec in length.

If a memory card with a slow writing speed is used, the monitor may display a five-bar graphic indicating how much data has yet to be recorded to the internal buffer. If this reaches the maximum level, movie shooting will be terminated automatically as the buffer cannot cope. You are advised to purchase a faster memory card.

If the memory card's remaining capacity is insufficient, the movie recording size and time remaining will be displayed in red.

At an ambient temperature of 23°C (73°F), a fully charged battery should be able to record up to 90 mins of movie clips.

The **⊞DISP Movie display** mode will show recorded images at a standard level of brightness, but depth of focus will be greater than that used for **Stills display**.

The dimensions of the movie image when played back will correspond to the proportions of the quality setting selected. The semi-transparent mask surrounding the image is a function of playback and will not be included in the recorded movie clip.

You can take still photographs even when **Movie display** is selected. The exposure and ISO settings are determined automatically.

If the lens you are using has image stabilization switched on, it will remain active at all times during shooting, which will significantly increase your battery usage. The IS feature can be switched off if you are using a tripod.

Using AF while recording movies is not recommended. The AF system may 'hunt', throwing the image out of focus temporarily and possibly affecting exposure. With Quick Mode AF selected, the camera will not autofocus while recording even if you press the **AF•ON** button.

Exposure lock can be used in the normal way when shooting movies. Press ✱/⊞• ⊖ to lock the exposure and ⊞/⊕ to cancel AE lock. The metering timer will not operate.

Try to avoid sudden changes in lighting conditions while shooting movies. These may create unsightly breaks in the recording while the camera recalculates exposure.

If you connect the camera to a TV using an HDMI cable to display images while shooting a movie at 1920 × 1080, the images displayed on the TV will be small. This is not an indication that HD quality has not been selected and the movie will be recorded at the selected size.

The RC-1 Remote Control or RC-5 Remote Control can be used but the RC-1 should be set to 2 sec. If immediate shooting is selected, a still image will be recorded. (The RC-5 only offers a 2 sec delay.)

Canon

EOS

Chapter 3

CANON LENS

ULTRASONIC

In the field

Every photograph is a snapshot in so far as it records a moment in time, usually measured in hundredths, if not thousandths, of a second. But not every photograph is worth a thousand words, as the old adage goes. So what makes the difference?

In this age of automation, almost anyone can take a reasonably exposed and in-focus photograph most of the time. But there are four other factors to consider: firstly, the intentions of the photographer, and finally, the impact the image has on the viewer. In between those two factors lie the content of the image and its treatment, both of which have to be considered in the light of what doesn't take place within the frame as much as what does.

The best approach for the aspiring photographer is to visualize the end result before even picking up the camera. Once the end product is envisaged, the other considerations can fall into place quite quickly when one has a degree of experience. But this is an equally valid approach for the novice: how can you judge your degree of success if you don't know what you were setting out to achieve?

The reference to what doesn't take place or appear in the frame is another aspect of photography that professionals deal with instinctively, but beginners rarely consider. It's important to step back and look for distracting elements, whether it's a piece of litter in the foreground or someone with a bright red or yellow jacket in the background.

SPRING FLOWERS
Nothing gets the creative juices flowing like a spring day after a long, drab winter. With a slight breeze, a slower shutter speed was selected here to allow some blur in the tulips while retaining their distinctive shape.

Depth of field

No lens has two clearly defined zones – in focus and out of focus. What a lens does have is a single plane of sharp focus with a gradual transition, both in front of and behind that plane, towards being out of focus. There comes a point in that transition where relative sharpness ceases to be acceptable. This point will occur twice – both in front of and behind the plane of sharp focus – unless the far point is deemed to be so far away that it reaches infinity. The term 'depth of field' is used to identify this zone within the image which is deemed to be in acceptable apparent focus.

Circle of confusion

The term 'acceptable apparent focus' sounds subjective, rather than absolute, and that is indeed true. While a lens on a test bench can have all sorts of tests performed to determine absolute measurements, depth of field is not one of them. Depth of field depends in particular on the intended magnification of the image and on the chosen size of the

circle of confusion, the latter being the size of an area of the image at which a point ceases to be a point and becomes a small circle. For 35mm cameras and their full-frame digital counterparts, this is generally approximately 0.001in (0.035mm) in size and assumes an average magnification of ×5, resulting in a 5 × 7in (13 × 18cm) print.

However, both professional and keen amateur photographers are likely to want enlargements greater than 5 × 7in. Many professionals choose to use an aperture at least one stop smaller than the depth-

DEPTH-OF-FIELD SCALE
Older lenses like this EF 28mm/f2.8 have a longer travel and a much more useful depth-of-field scale than recent designs. Most older EF lenses are compatible with the 5D Mk II.

of-field scale on the lens indicates for the distances required (i.e. the closest and furthest points in focus).

Lens manufacturers always used to mark their lenses with a useful depth-of-field scale which gave an indication of this zone of acceptable sharpness. Now, the depth-of-field scale is often so cramped or lacking in aperture markings that it is almost meaningless (or is omitted entirely). The reason for this appears to be the reduced arc through which the lens travels in order to achieve focus, so that autofocus speeds can be faster.

Serious landscape photographers will always see depth of field as a matter of prime importance, and it is they who most often plead for decent depth-of-field scales to be retained, owing to their frequent use of the hyperfocal distance focusing technique (see below).

Using hyperfocal distance

The hyperfocal distance at a given aperture is the closest point of focus at which infinity falls within the depth of field. For landscape photographers, learning to use hyperfocal distance is one of the

SHEET MUSIC
Detailed examination of the scrolls of sheet music in this still life shows just how limited depth of field can be in close-up situations.

first skills to be acquired. This is the point on which you would focus the lens to ensure that everything from that point to infinity is in focus, along with a significant zone in front of it. You do not even need to look through the viewfinder to do it: simply switch the lens to manual focus and manually turn the focus ring so that the infinity mark is just inside the mark for the selected aperture on the depth-of-field scale. The equivalent mark at the other end of the scale shows the closest point that will be in focus.

EF and EF-S lenses

There is a need to comment briefly here on why EF-S lenses cannot be used on the Canon EOS 5D Mk II. The image projected by the lens onto the sensor is circular rather than rectangular. The 5D Mk II's full-frame sensor (shown far left in the diagram below) is large enough to accommodate the maximum amount of the projected image circle of an EF lens. However, the smaller APS-C sensor (second from left) covers a smaller proportion of the image circle projected by any EF lens, designed for 35mm or a full-frame sensor. However, an EF-S lens, designed solely for use with an APS-C sensor, has a smaller image circle, once again maximizing the sensor area (second from right). Finally, if an EF-S lens could be fitted to the 5D Mk II, its image circle would not be large enough to cover the whole sensor (far right). Consequently, the 5D Mk II's lens mount will not accept EF-S lenses.

SENSOR AREA
Far left: Full-frame sensor plus EF lens
Second left: APS-C sensor plus EF lens
Second right: APS-C sensor plus EF-S lens
Far right: Full-frame sensor plus EF-S lens

Recording motion

Few techniques test your reflexes, and your understanding of basic photographic principles, more than capturing moving subjects, especially when high speeds are involved. You will also need to develop the ability to predict the best vantage point to capture the action.

Freezing the action

In order to capture a pin-sharp image of a fast-moving subject, three factors must be considered: a fast shutter speed, a firmly held or supported camera position, and an

understanding of the nature of what I call 'apparent speed'. Remember that completely freezing the subject isn't always the best approach, because a degree of blur often helps to increase the impression of speed.

With a top speed of 1/8000 sec, the EOS 5D Mk II can easily freeze the action , but you may need to adopt a higher ISO setting in low light. Camera support is a matter of personal choice, but the single most useful tool for action shots is the monopod, which provides support while allowing mobility.

Now to 'apparent speed'. Ignore the actual speed of travel: what matters is the speed of movement across the frame. A moving subject

DELIBERATE BLUR
It would have been easy to freeze the movement of this racing car in the light available. Instead, a shutter speed of only 1/500 sec was selected in order to retain blur in the wheels and to improve the suggestion of speed.

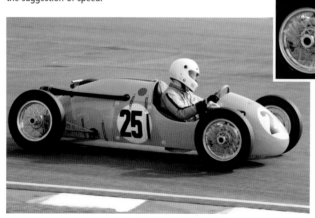

that passes at right angles to the camera position has the highest apparent speed. A subject that is approaching head-on seems to move much more slowly. Very often the best compromise is a vantage point which has the subject moving towards you at an angle of around 45 degrees. Compared with a subject crossing at right angles, you will probably need less than half the shutter speed and can more easily control just the right amount of blur.

Panning

If you stand perfectly still and photograph a fast-moving subject, the likely result is that the subject will be blurred and all the stationary elements of the image will be sharp. Panning the camera – moving the camera through one plane, usually horizontal, while keeping the subject in the viewfinder – can produce the opposite result: the moving object is sharp in the image and the stationary elements are blurred.

The result depends largely on the selected shutter speed. An extremely fast shutter speed may even freeze the background if panning slowly. Conversely, a slow shutter speed may create a blurred background and a blurred subject – this can be quite effective if the degree of blur differs between the subject and the background. The use of flash, especially with second-curtain flash, in conjunction with the latter technique can be very effective.

Blurring for effect

The most popular subject for this technique is undoubtedly water. As with fast-moving subjects, the scale and speed of travel across the frame are the key issues. It is helpful if the water's direction of travel is across the frame – the opposite of fast-moving subjects. To obtain a slow shutter speed in bright conditions, a slow ISO and small aperture will be required. In very bright conditions a neutral density filter or polarizing filter can also be useful in reducing shutter speed by two stops or more. Precise shutter speeds needed to blur water will vary according to the situation, but half a second is a good rule of thumb.

> ### Tip
> Filling the frame with a well-exposed moving subject is one of the hardest aspects of recording motion. To begin with, choose a focal length and camera-to-subject distance that leave the subject a little smaller in the frame, and crop the result later on your computer.

Composition

The term 'composition' refers to the relative placement of objects within the frame. Personal preferences and intuition are all-important, but it is always worth learning from other photographers. It is also worthwhile learning from your own mistakes, rather than trying to follow a set of rules without knowing how or why those so-called rules work.

Balance

Every photograph includes a number of different elements and each one contributes to its impact. Balance needs to be considered in terms of not just shape but colour, density, activity, mood, light and perspective.

Again, this is a matter of personal preference, but it also has a great deal to do with the dimensions of the final photo as well as the subject matter and its treatment.

In order to achieve balance, you must think in terms of the essence of the image. If the picture is highly dynamic then you will want it to have a 'busy' feel, which can be achieved with striking angles, vivid colour, blurred motion and lots of detail. Conversely, if you want to produce a restful image, then keep it as simple as possible and avoid hard shapes, straight lines and bold colours. A landscape format is usually selected for tranquil scenes.

BREAK THE RULES
Don't be afraid to experiment with composition. This shot breaks all the so-called 'rules' of composition but is highly effective.

Finally, remember to make use of the entire frame, including the edges and corners. Silhouetted foliage can make an attractive 'frame' when run along top and side edges, for instance, and diagonal lines can be made even more dynamic by running them into the frame from the corners of the image.

When it comes down to simple composition, one might say that a symmetrical photo is one which has absolute balance, but symmetry can make a composition seem far too anchored, so use it sparingly. Trust your instincts and shoot from a variety of viewpoints. The great thing about digital photography is that it will cost you nothing to experiment.

Directing the eye

It is generally accepted that an image will first have an immediate impact as a whole on the viewer. After that, there are a number of natural processes that can be harnessed to direct the viewer's eye to specific points in the image, and to lead the viewer through the image along particular lines. For instance, the eye will naturally be drawn towards colours which stand out, especially reds and yellows, and along strong lines.

Of particular importance are converging lines in an image. These tend to create triangles which act

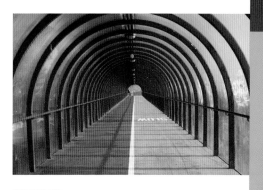

SYMMETRY
As it stands, this image of a pedestrian walkway works because it is so striking. But the addition of a person, even in the distance, would improve it by subtly breaking up the total symmetry.

as arrows, creating a degree of dynamism from diagonal lines in the composition. These points of convergence can also act as 'stoppers' that temporarily arrest the viewer's eye movement while they linger on a specific area of the image.

Western artists tend to paint with light flowing from the upper left and to compose an image so that it is 'read' from left to right. There is a school of thought that a person's first written language dictates their default reading direction and that this also determines how we 'read' a photograph or painting.

If this is true, photography for Chinese or Urdu audiences, for example, would have quite different requirements, as Chinese writing

runs from top to bottom in columns and Urdu is read from right to left. I once read of an art exhibition in Taipei which described the guide as leading his party round the exhibition in an anti-clockwise direction, so that each exhibit was approached from its right side and 'read' from right to left.

Golden rules

The so-called 'rule of thirds' is often referred to in photography as one of the essential guides to composition, and it can work very effectively with some, but not all, subject matter.

However, this 'rule' is actually a very simplistic tool that doesn't begin to compete with a centuries-old system that identifies certain ratios as being aesthetically pleasing. Examples of these can be found in nature as well as in the works of some of history's greatest artists. These principles gave rise to a series of expressions, including the Golden Ratio and the Golden Rectangle.

The Golden Ratio has been calculated to the order of 20 million decimal places, but let's simplify matters and call it 1:1.618 for the sake of sanity. As shown in the diagram opposite, we will start by constructing a Golden Rectangle (1) with sides displaying the Golden Ratio. We then identify a square at one end of the rectangle (2) with

TURNTABLE
Straight lines and bold use of colour dominate this image. The yellow lines demonstrate how the eye is directed though the image.

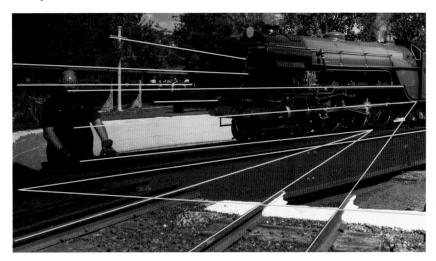

GOLDEN RATIO

(Right) The sides of a Golden Rectangle are measured in accordance with the Golden Ratio (1:1.618). The rectangles can be used within the photographic frame to aid composition (below).

dimensions the same as the height of the original rectangle. When the remainder (3) from that exercise is turned through 90°, its dimensions are exactly proportional to those of the original rectangle. This process can be continued (4) ad infinitum.

This gives us a set of rectangles which can be used within the whole frame as an aid to composition. As photographers we are mostly forced to work with an original rectangle using a ratio of 1:1.5, but there is nothing to stop you cropping your images to the proportions of a Golden Rectangle and composing your images with that in mind.

The dotted lines in the second diagram represent the thirds and the continuous lines represent just

a few of the rectangles which can be constructed along the principles outlined above. You can see how many more possibilities this system offers in terms of composition when compared to the rule of thirds.

RULE OF THIRDS

The main elements of this composition are placed on imaginary lines that divide the image into thirds, both vertically and horizontally. The principle works here because the content is simple and has a strong diagonal running top left to bottom right which adds drama.

Lighting

Light has qualities above and beyond its mere presence and it is the manipulation of these qualities that sets a good photograph apart from a mediocre one. True, there are occasions when the subject is powerful enough to stand alone, as with news photography, but even then a dramatic picture can be further enhanced by the use of colour, light direction or contrast.

Light sources

Photography commonly makes use of two types of light source: direct and reflected. The most-used direct source is the sun: even on a dull winter's day thick with cloud, any available light is still coming from that orb in the sky. The second source commonly used is flash, with artificial light sources such as domestic lighting, street lighting and studio lighting following behind. Each of these has particular qualities that can be harnessed to good effect, notably its inherent colour, which is known as its colour temperature.

Colour

Photography makes use of three types of colour. There is the colour which a subject appears to have in its own right, but which is actually just a function of reflected light. Then there is the colour of the light falling on the subject, and finally the colours used for printing or displaying the image. The last two, in particular, are ones which we can exercise a lot of control over, even removing colour from an image

TROPICAL SUNSET
The combination of ambient light at sunset and the colour reflected by the water makes for a stunning image.

JERSEY FARMER
This farmer posed for me in strong side-lighting outside the front door of his lovely farmhouse on Jersey. I used the strong directional sunlight to accentuate the strength of his pose and pick out the leeks against his dark jumper. The framing of the doorway and the white background of the door were a perfect backdrop.

to render it as a set of grey tones. One might argue that there is also a fourth category of colour, taking into account the way that specialist films such as infra-red record colour. The EOS 5D Mk II has the ability to select white-balance options in order to correct the colour temperature of the light emanating from various sources in different circumstances.

Direction of light

This plays a much more important role than most people realize and it affects far more than just the direction in which the shadows fall. It affects the overall appearance of the subject: frontal lighting produces little shadow and a more colourful appearance; side lighting can increase shadow, which

can mean less colour but more interesting shapes; back-lit subjects may appear as silhouettes or possess an ethereal, translucent quality.

There is always a temptation to shoot with the sun behind us on a sunny day, but it is worth exploring a subject for different possibilities and from different angles. If you have control over the direction of light – when using flash, for example – try out different set-ups with direct, diffused and reflected light. Similarly, if you can't control the light direction but have the option of moving the subject in relation to it, you can change the position of the subject to achieve varying results.

> **Tip**
> If shooting JPEGs, bracket your exposures in non-standard lighting situations as even $\frac{1}{3}$-stop can make a significant difference to highlight detail. RAW images can always be fine-tuned during post-processing.

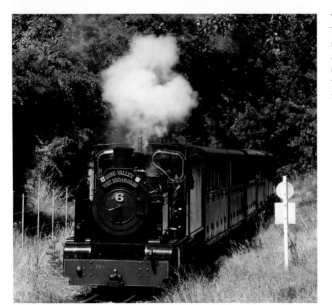

Contrast

Contrast is the term given to the difference between light and dark areas in an image. Ideally, we manage to render some detail in both of these, but it is possible to have too much of a good thing and strong lighting is one example.

This image of a narrow gauge railway contains the full range of tones, from the absolute blacks of the locomotive and the shadows under the trees through to the pure white of the sign on the right of the track. Choosing the sign as the white point, rather than the steam emanating from the loco, was an important choice as it meant that

Tip
Landscape Picture Style doesn't just intensify colours; it also opens out shadows and provides a smoother transition between tones in high contrast images.

the clouds of steam maintained some detail and consequently a sense of three-dimensionality.

Dynamic range

The spread of possible tones that can be recorded in an image – from the lightest highlights through to the deepest shadows – is described as dynamic range. While digital images can record a far wider range than, say, transparency (slide) film, they still fall a little short of the range that the human eye can distinguish.

As a result, the photographer is usually faced with three options: favouring the highlights and allowing the deepest shadow tones to merge; favouring the shadows and allowing the highlights to burn out; or aiming between the two and allowing some clipping at both ends of the range. Clipping is the term used to describe the merging of tones at either end of the brightness scale (see page 149).

The choice of which part of the tonal range to favour in an image is usually determined by the intended end product. For instance, when producing images for magazine or book use, the quality of the paper to be used by the intended publisher can play a major part. Photos solely for screen display, however, present fewer problems as they don't depend on reflected light and can usually harness a wider range of tones.

> **Tip**
> The sensor's dynamic range is greater with a lower ISO rating, so use the lowest possible ISO in high-contrast situations.

High Dynamic Range (HDR) software

Third-party computer software is now available that extends the dynamic range by combining bracketed images and then tone-mapping the outcome. This means that all the highlight detail and all the shadow detail can be retained, and highlight colour (e.g. a pale blue sky) is not lost. A choice between detail enhancement and tone compression may also be offered, providing two very different results. There are various dedicated HDR programs on the market, and recent versions of Adobe Photoshop (CS2 and up) also have HDR capabilities.

The biggest problem with this process is aligning the elements of the bracketed shots which were subject to movement at the time the images were captured. One way to overcome this is to combine different exposure renditions of a single RAW image. The results vary considerably and are not suitable for all subjects, so trial and error is necessary.

Image properties

One aspect of digital photography which perplexes newcomers and recent converts from film is the fact that digital images can suddenly appear to take on a life of their own, displaying some rather strange effects which the photographer definitely hadn't intended.

Flare

This is one problem that will be familiar to former film users. Flare occurs due to the scattering of light waves within the lens and manifests itself in the form of diffuse rays emanating from a pronounced highlight, with odd coloured shapes along their path. While photography software can remedy many things, flare isn't generally one of them, though if it is only minor it may be possible to copy sections of the image and paste them over the offending areas. The best solution is to avoid flare in the first place by using a lens hood and not shooting directly into a light source.

SUNBURST
Note how the shape of the lens aperture is featured just below and slightly to the left of the sunburst.

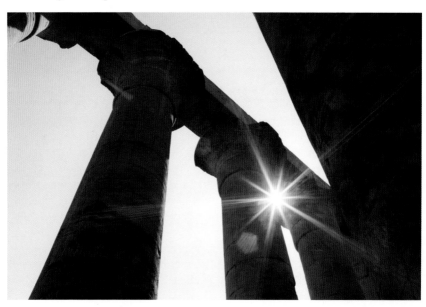

Noise

Noise occurs in digital images due to missing information at pixel level. Images are composed of millions of pixels, some of which may function poorly or even fail to function at all, in which case they may appear white or lacking the correct colour. These pixels blend into the image creating undesirable flecks of random colour, especially noticeable in darker areas of smooth colour such as shadows.

The appearance of noise can be exacerbated by a number of factors such as temperature, long exposures and a high ISO setting. When two or more factors are present, noise is more likely. A white speck in a constant position in images may indicate a 'hot' pixel due to failure of one of the pixels on the sensor, in which case the camera will need to be serviced to remedy the problem.

Clipping

If the tones in an image exceed the dynamic range (see page 147), detail will be lost, whether it's in the highlights or in the shadows or both. This loss of detail is referred to as clipping. The upper limit of the dynamic range is reached when a pixel records the brightest tone possible without being pure white. At the opposite end of the scale the reverse is true, with a pixel recording detail just short of being black. The extent of this range is determined by the ISO setting, with lower ISO settings providing the greatest range. Lower ISO settings will also give a smoother transition between tones.

SHELDUCK
Despite having a lot of plus points, this image 'fails' for two reasons: both blacks and whites display significant clipping, and the eye – a crucial element in any wildlife photo – isn't visible.

Aliasing

This is the term used to describe the process by which individual pixels start to become visible in the image at normal levels of magnification. It tends to be more apparent in low-resolution images, especially those with diagonal or curved lines – telephone lines running diagonally across your image are a common example. The answer is prevention rather than cure: as often as possible, shoot in RAW, sRAW or Large/Fine JPEG. It is far easier to create a quality small image from a larger one than the other way round.

A common cause of aliasing is the over-zealous use of sharpening, especially in images with smaller file sizes. If you are shooting JPEGs and know that your images are only going to be used as thumbnails or low-resolution images for use on screen, you can use the Picture Style options to reduce the setting for the sharpening parameter (see pages 84–5). This option is available in all the 5D Mk II's modes except Full Auto and Creative Auto.

Sharpening

One issue which film users find it hard to get used to is the need to sharpen digital images – not because of they are out of focus or blurred, but because digital images are inherently unsharp to a degree.

Tips

The 5D Mk II's features include long exposure noise reduction, enabled via Custom Function II-1, and high ISO speed noise reduction, enabled via Custom Function II-2. If the latter function is enabled, the maximum burst available in continuous shooting mode will be significantly reduced.

It has been suggested that Canon's ⅓-stop ISO settings are achieved by a different process, one that is not as effective at controlling noise, than that used for full-stop ISO settings. A whole-stop setting (eg ISO 200) may actually produce less noise than a lower intermediate ISO (eg ISO 160) but only be noticeable at huge enlargements.

Most casual amateur photographers remain blissfully unaware of this because they shoot JPEGs which are sharpened in-camera long before the results are printed or displayed on screen. However, anyone who shoots RAW files will quickly realize that most of their images require some degree of sharpening, certainly if they are to be used commercially.

Generally speaking, sharpening images works fine as long as the image is to be used at its original

size or larger. The computer software and the precise mechanism used for sharpening images has always been a very personal choice. However, sharpening images and subsequently reducing them in size significantly can result in an over-sharpened appearance, which is true relative to the image size. Therefore, if you want to produce thumbnails or other small images for any reason, it is better to do this before sharpening takes place. Sharpening JPEGs can always be carried out later on the computer. However, once it has been carried out, either in-camera or on the computer, it cannot be undone.

With RAW and sRAW files the original data is always retained. If you make changes to the original files in post-processing using Digital Photo Professional, those changes can be reversed. If you make changes and then convert the RAW or sRAW file to a different file format, you will not be able to undo those changes in the new file format. However, you can go back to the original RAW or sRAW file, undo the changes or make corrections, and then convert the file to another format again.

Any sharpening done in-camera using the Picture Style parameters when shooting RAW or sRAW files can also be undone later in Digital Photo Professional.

CLYDESIDE CRANE
Images like this must be pin-sharp to be effective, but you should consider the intended print size when sharpening in order to avoid giving the straight lines a jagged appearance when the image is reduced in size.

Creating a silhouette

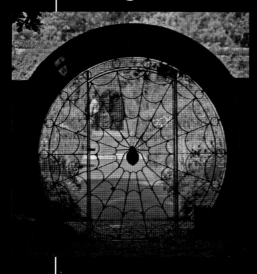

SPIDER GARDEN, NORFOLK, UK
This gate provided an opportunity
to apply a technique in an unusual
situation, but the same rules for
creating a silhouette still applied.

Settings
Aperture priority (Av)
ISO 100
1/500 sec at f/4
Partial metering
White balance: 5200°K
Picture Style: Landscape
One Shot AF

In one sense, capturing a silhouette
is simple because it only has two
elements: the silhouette itself and
the background. The first has line
and shape, but no tonal detail, and
the latter is simply a matter of
colour. So why do so many holiday
snaps of sunsets not work?

I would suggest three reasons:
people tend to get tunnel vision when
viewing sunsets and don't consider
the full image area; they put too much
emphasis on the sky and not enough
on the silhouette; and finally they
settle for one or two shots instead of
paying attention to all the subtle
changes that the scene goes through.
In short, they get carried away.

Before I even visit a location I print
off compass directions and times of
sunrises and sunsets for the dates
concerned. If a good sunset looks
likely I set out early to locate a scene
which will give me a strong
silhouette. A meter reading should be
taken from the sky area but without
including the sun itself; this will
determine the mid-tone, turning the
darker foreground into a silhouette.
Readings will change rapidly as the
sun sinks below the horizon.

A sense of depth

A popular technique in landscape photography is to use a physical feature such as a river, road, or other strong line that winds its way from the foreground into the distance, to lead the eye into the picture. This creates a feeling of depth. Another, more subtle, way to do this is to make use of foreground and middle-distance features which are on different planes. Planes running parallel across the image can act as 'stoppers', but can also provide the same sense of depth if used correctly.

This is illustrated very clearly by the simple example shown here. The photograph of a ruined temple in the Egyptian desert has just three planes – foreground, middle distance, and the mountains in the background – but the image retains a strong sense of depth.

Settings
Aperture priority (Av)
ISO 200
1/500 sec at f/8
Evaluative metering
White balance: 5200°K
Picture Style: Landscape
One Shot AF

TEMPLE RUINS
Strong foreground, middle distance and background create a strong sense of depth.

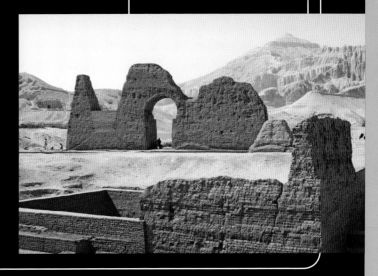

Photo essays

With digital photography you can fire off as many shots as you like at no extra cost. When I come across a favourable photographic situation I want to make the most of it and have a variety of usable images at the end, as with this series of images of Glasgow's Science Park. I also find that what I call 'stalking the subject' gradually hones my ideas and the shots obtained get better as I go along. However, it is usually still necessary to obtain a simple 'establishing shot', which is often little more than a technically competent record of the subject, in context if possible.

PORTRAIT FORMAT
I often shoot as many portrait-format frames as I do landscape-format.

ESTABLISHING SHOT
All the elements which I explored in detail afterwards were first included in this shot.

DETAIL
In any photographic situation, It is always worth recording some of the detail in its own right.

General settings
EF 24–105mm f/4 L
Aperture Priority (Av) mode
Evaluative metering
ISO 100
1/125–1/500 sec at f/8

ABSTRACT
Occasionally, one can create a fine abstract by judiciously cropping one of the other images, such as this crop from the establishing shot.

Reflections

RIPPLES
This image has been inverted so that the subject appears the right way up. In this instance the strong colours and blue sky are essential components in conjunction with the reflection.

Settings
Manual (M) mode
ISO 100
1/400 sec at f/5.6
Evaluative metering
White balance: 5200°K
One Shot AF

Reflective surfaces surround us in our everyday lives and can provide excellent opportunities for interesting images, even when other factors such as the weather seem to be working against us. Curved reflective surfaces can give a 'fish-eye' effect but demand good control of depth of field when working at close distances. Water probably provides the most frequently used reflective surface, but care should be taken to introduce strong reflected colours whenever possible.

Architecture

The single biggest problem you will face with architectural shots is that of converging vertical lines, especially near the edges of the frame. Canon's perspective-control lenses (see page 198) are one way to combat this, but if your funds won't run to one of these there are other ways to address the problem. The first solution involves finding a higher viewpoint so that the camera lens is not tilted, as in the image below. Increasing the camera-to-subject distance will also make this approach easier to apply. Secondly, instead of capturing the whole building or group of buildings, you can select just a portion of the subject. Finally, you can actually incorporate the tendency towards converging verticals into your shot, making it an integral part of the image. This will involve an open mind with regard to composition but can also produce some interesting images.

Settings

EF 24–105mm at 35mm
Aperture priority (Av) mode
ISO 100
1/160 sec at f/5.6
Evaluative metering
White balance: 5200°K
One Shot AF

ISLAND OF GOZO
Converging verticals were avoided in this image by selecting a higher and more distant viewpoint.

Vision

Settings
Manual (M) mode
ISO 400
1/30 sec at f/22
Evaluative metering
White balance: Auto
One Shot AF

Tunnel vision can be a major handicap to making the most of each situation in which we find ourselves as photographers, just as it can when driving a car. We don't focus intently on just the road ahead; we relax a little, keeping an eye out for situations unfolding around us and for things that catch the eye in our peripheral vision. In the same way, as photographers, we need to keep an eye open for what is around us, above us, beneath our feet, and even behind us.

WOODLAND FLOOR
This image of delicate white blooms emerging from the dead material on a woodland floor came about because I was looking around me for images, as well as straight ahead.

When the skies turn flat and grey, add a macro lens to your camera and start to look more closely at your surroundings: you'll be surprised at how many images are waiting for you.

Monochrome

One of the greatest advantages of digital photography is that you no longer have to commit to either colour or black and white when loading film. With Canon's bundled Digital Photo Professional software you can pull up any image and convert it to monochrome with the click of a mouse, provided you shot it as a RAW or sRAW file.

The same applies in reverse: if you captured the image with the Monochrome Picture Style selected, it can be converted to colour instantly. The RAW data for each image always records colour data, regardless of settings. The monochrome filter parameters, however, are fairly subtle and you may need to make additional adjustments to the contrast settings. Adjustments can only be made to the RGB tone curve, as the individual channels (Red, Green or Blue) will simply add an overall colour tint to the image. A more flexible solution is to adjust the Levels in Photoshop.

Settings
Aperture Priority (Av)
ISO 100
1/200 sec at f/4
Evaluative E-TTL II metering
White balance: Flash
One Shot AF

MASQUE
Evaluative E-TTL II metering did a fine job of rendering the highlights correctly in this study of a reveller during a Venetian carnival.

Caring for your camera

The EOS 5D Mk II performs reliably in a wide range of circumstances but it is not indestructible and the manufacturer's cautions regarding use and operating conditions should always be adhered to; full details can be found in the camera's manual. In contrast to the professional EOS 1D series, the 5D Mk II offers limited moisture and dust protection on the battery compartments and memory card only, and these won't solve all the problems of working in damp and dusty conditions.

Out in the field, dust and sand can be a real problem and more so if it is windy. Keeping dust from entering the camera via the lens mount is the priority, but you also need to keep dust and sand off the lens elements. Sand will scour the glass if you try to wipe it off, so careful use of a blower or blower-brush is recommended. A UV filter on the lens provides useful protection and can be replaced quickly and relatively cheaply. Avoid dropping the camera, or having it knocked out of your hand in a crowd, by ensuring that you use the camera strap or a wrist strap at all times.

In cold temperatures
The 5D Mk II is designed to operate in temperatures between 32°F and 104°F (0–40°C) at a maximum of

> **Tip**
> Never leave the camera close to anything which emits a magnetic field or strong radio waves that may affect the camera's electronics or damage data.

85% humidity. However, you should always pay heed to the effective temperature, allowing for wind chill, rather than the still air temperature – at 32°F (0°C) a wind speed of just 25mph (40km/h) will make it feel like 18°F (-8°C). Once temperatures drop below freezing and wind speed increases, the effective temperature drops alarmingly.

Batteries are notorious for their fall-off in performance when the temperature approaches freezing, so keep these inside your clothing when not needed. The camera body, too, should be kept as warm as possible while not in use: if you need to keep it in a camera bag then you can always wrap it something that will act as an extra layer of insulation. Signs that the camera is becoming too cold, apart from reduced battery performance, are the darkening of the LCD monitor and sluggishness in moving parts, especially those which are lubricated.

In heat and humidity

Short of dropping your camera into the sea, the worst thing that can happen to it is excessive heat. The recommended maximum working temperature of 104°F (40°C) may seem to cover most situations, but if you've ever had to climb into a car which has been parked in the sun for some time in a hot country, you'll know that 104°F (40°C) is easily surpassed. As a result, you should never leave an uninsulated camera in the car on a very hot day. You can leave the camera in an insulated coolbox such as those used for picnics or camping.

Protecting the camera against humidity requires wrapping the camera in an airtight plastic bag or container, ideally with a small bag of silica gel. Silica gel absorbs moisture and a small bag of it usually comes in the box when you buy a new camera or lens – store it somewhere dry for occasions like this. In order to reduce condensation, allow your equipment and the bag or container in which it is stored to reach the ambient temperature before taking the equipment out.

Water protection

Prevention is better, and usually a whole lot cheaper, than cure. However, there are times when we get caught out by the unexpected, and especially by the weather. It is worth investing in a camera bag that will prove good protection against the elements, such as Lowepro's AW (All Weather) models which have a rain cover that tucks away discreetly when not required. At the very least, always keep a pedal-bin liner in your pocket for emergencies!

Finally, it pays to be extra cautious when you are working in a marine environment, as spray can be carried huge distances on a windy day. Likewise, the sea air can be laden with salt for some considerable distance away from the shore.

GAPING GHYLL
If you are taking your camera into challenging situations like this limestone cavern beneath a waterfall, make sure you look after it.

Chapter **4**

Flash

Flash photography has developed to such an extent that it is often imbued with almost magical properties. Magic, say some, is simply the science that other people know but we don't: the following pages should help to dispel some of the mystery.

Many camera users have little or no understanding of the principles of flash photography. They can be seen on aircraft flying over the Alps as they use flash to photograph the dramatic scenery below. You don't need a scientific explanation of Guide Numbers to realize that these people are being more than a little optimistic.

E-TTL II flash exposure system

The third generation of Canon's auto flash exposure system provides almost seamless integration of flash and camera in most situations where flash would be either helpful or essential. The E-TTL designation stands for 'evaluative through-the-lens' metering, as opposed to measuring the flash exposure from a sensor housed within the flash gun. The fact that the exposure is based on what is seen through the lens means that you can safely position the flash off-camera, at a totally different angle to the subject compared with that of the camera, and still achieve accurate exposure. This facility becomes doubly useful when combining several flash units wirelessly.

When the shutter release is pressed, the Speedlite fires a pre-exposure metering burst. The data gathered on the brightness levels of the subject during this initial burst of flash is compared with the data for the same areas of the image under ambient light and the correct flash output and exposure are calculated automatically.

With many EF lenses this burst will also assess the distance to the subject. The shutter activation and the main flash burst (assuming that first-curtain sync is set) will follow so quickly on the back of the metering burst that the two will be inseparable to the naked eye.

> **Note**
> For E-TTL II compatible lenses which deliver distance information to help calculate flash exposure more accurately, see individual lens specifications on Canon's website.

Guide numbers

There is an easy way to compare the performance of different models of flashgun and that is to look at their guide numbers (GN). The guide number is a measurement of power that can be applied equally to any flash unit, and measures the maximum distance over which the flash will provide effective coverage. This distance is dependent on the sensitivity of the film or sensor, so the measurement is qualified by the addition of an ISO setting. The guide number for Canon's 580EX Speedlite is 190/58 (ft/m) at ISO 100.

Calculating flash exposure

Aperture also affects flash coverage, but the equations involved in calculating flash exposure are simple enough for us to calculate the third factor involved as long as we have the other two. (In the following examples, the term 'flash-to-subject distance' is used because the flash could be used off-camera.)

The basic equation is as follows: *Guide number / Flash-to-subject distance = Aperture.* This could also be written as *Guide number / Aperture = Flash-to-subject distance* or *Flash-to-subject distance × Aperture = Guide number.*

Take the 580EX as an example using the maximum flash-to-subject distance: *190 (GN) / 190ft = Aperture.* We would therefore need an aperture of f/1 to achieve flash coverage. As this is unrealistic, let's take another example using a flash-to-subject distance of 50ft: *190 (GN) / 50ft = f/3.8* (f/4 for practical purposes).

If we know the guide number and the aperture we want to use, f/16 for example, but aren't sure of the flash-to-subject distance limitations, we can still calculate this easily: *190 (GN) / f/16 = Flash-to-subject distance.* This would give us an answer of 11.9ft (3.6m) as the maximum distance over which the flash would perform adequately with f/16 as our working aperture.

To make our lives easier, Canon provide zoom heads on some of their flashguns. These sense the focal length in use and harness the power of the flash more effectively by narrowing (or widening) the flash beam to suit the lens. For this reason the full guide number also refers to the maximum focal length that the zoom head will accommodate automatically. Consequently, the full guide number for our example of the 580EX Speedlite is 190/58 (ft/m) ISO 100 at 105mm. EX Speedlites also display a useful graphic that indicates the distance over which flash can be used at current settings.

Flash exposure lock

When part of the subject is critical in terms of exposure, you can take a flash exposure reading of that area of the image using the same metering circle as the Partial metering mode, and lock it into the camera/flash combination.

1) Having adjusted all appropriate settings and switched on the external flash or raised the built-in flash, aim the camera at the critical part of the subject.

2) Focus with the centre of the viewfinder over the important part of the subject and press the ✱/☒• ⚲ FE lock button.

3) The flash head will emit a metering pre-flash and the camera will calculate the correct exposure.

4) In the viewfinder, **FEL** Flash Exposure Lock is displayed momentarily, then replaced with the ⚡* symbol.

5) Recompose the shot and press the shutter-release button.

6) The flash will fire, the picture will be taken, and the ⚡* symbol will disappear, indicating that no exposure settings have been retained.

Flash exposure compensation

Flash exposure compensation can be set in all modes except ⬭ or **CA**. It works in exactly the same way as normal exposure compensation.

1) Turn the camera's power switch to ⏻.

2) Press the ☒ button.

3) Rotate the ◯ Quick Control Dial to set flash exposure compensation in either $1/3$- or $1/2$- stop increments to a maximum of +/-2 stops. (The increment can be set in Custom Function I-1.)

4) The ☒ Flash exposure compensation symbol appears in the viewfinder and on the LCD top panel. The symbol is also shown on the Quick Control Screen, where the degree of compensation is also shown.

5) Take the picture and review the result, adjusting compensation and repeating the shot if necessary.

166

Tips

Flash exposure compensation shares the same display graphic **INFO** on the top panel as exposure compensation and auto exposure bracketing. The flash exposure compensation setting only becomes visible when the **⚡** button is depressed, but it is easy to get confused between the two.

Any flash exposure compensation setting is retained after switching the camera off. As the flash exposure compensation setting isn't normally visible in the top panel, it is important to pay attention to the viewfinder symbol as a reminder that an adjustment has been made.

Bounce and direct flash

The two most popular techniques for reducing the impact of direct flash are the use of a diffuser and bouncing the flash off a reflective surface, whether the flash unit is mounted on the hotshoe or used off-camera with the off-camera shoe cord.

Depending on the model, if the flashgun is mounted on the camera's hotshoe, bounce flash can be achieved by rotating and tilting the flash head to point at the reflecting surface, which should normally be a little above and to one side of the subject. Bounce flash, especially when used with the flash unit off-camera, is a

good way of both softening shadows and ensuring that they fall behind the subject and against any background at a height which is lower than the subject.

Tip

The Speedlight 580EX II is fitted with a retractable white panel which serves to produce catchlights in the subject's eyes when the flash head is pointed upwards.

Bounce flash

The concept of bounce flash is that the surface(s) being used to reflect the flash will provide, in effect, a larger and more diffuse light source. This also assumes that it is light enough in tone to perform this function and that it won't imbue the subject with a colour cast. If the reflecting surface is darker or has a matt finish, it will absorb some of the light and will therefore require a much wider aperture or shorter flash-to-subject distance to work.

With this technique, the flash-to-subject distance includes the distance to the reflecting surface and from that surface to the subject. Also, about two stops of light may be lost when using this technique, so the flash-to-subject distance will be much shorter than would normally be the case for any given aperture.

Direct flash

Direct flash must always be considered carefully, particularly the harshness of its impact when used on close or highly reflective subjects. It is worth noting that many professional press photographers keep a Sto-fen Omnibounce diffuser on their camera-mounted flashguns at all times to soften direct flash.

One of the other common problems with direct flash (i.e. not diffused or bounced) is red-eye, a phenomenon which occurs when light from the flash is picked up by the blood vessels at the back of the eye. It is particularly noticeable when the flash gun is mounted on top of the camera.

STRONG SUBJECT, SOFT LIGHTING
For this image I used a hotshoe-mounted Speedlite bounced off the soot-encrusted engine shed wall a couple of feet behind me. Although a lot of light was lost, there was still enough to illuminate the subject.

HIGH CONTRAST
For this picture I wanted much more contrast than in the previous image. I decided to risk direct flash because I hoped that the brushed finish of the metals would not reflect too much glare.

To ensure that the focal-plane shutter opens in conjunction with the flash exposure, every camera has a specific flash synchronization speed; today this is commonly 1/200 or 1/250 sec. When taking photographs in the dark, the flash sync speed isn't a problem, but when using flash to fill in shadows on a bright day, a higher flash sync speed is crucial. One of great advantages of medium-format cameras has always been the predominance of leaf-shutter lenses, rather than having a focal-plane shutter within the camera body, which allow higher flash sync speeds than could be achieved with 35mm cameras with their focal-plane shutters.

Current technology means that users of EX Speedlites can dial in high-speed flash sync speeds – right up to 1/8000 sec in the case of the EOS 5D Mk II. This can be applied to Manual (**M**), Shutter Priority (**Tv**) and Aperture Priority (**Av**) modes. To use high-speed sync in Aperture Priority mode you must first set Custom Function I-7 to **Auto** or the maximum sync speed (in this exposure mode only) will be set to 1/200 sec. When high-speed sync is enabled the ⚡H symbol will show on the Speedlite's display. This symbol will also be displayed in the viewfinder (but not in the LCD top panel or the Quick Control Screen), provided the shutter speed exceeds 1/200 sec.

FLASH

First- and second-curtain flash explained

A focal-plane shutter works by two shutter curtains moving across the frame. Both move across the focal plane at the same speed, but there is a small gap between them which is how the sensor is exposed to the image projected by the lens. With a higher shutter speed, the curtains don't move any faster but the gap between the curtains gets narrower. With an extremely slow shutter speed, the entire frame may be completely exposed before the second curtain begins to follow the first. This very precise system makes it possible to reach speeds of up to 1/8000 second.

With the E-TTL flash system, the flash actually fires twice. The first burst is a pre-flash in the sense that it fires just before the shutter opens in order to determine exposure. The second burst is the one which illuminates the subject.

When first-curtain synchronization is selected, the illuminating burst occurs as soon as the travel of the first curtain opens the gap between it and the second curtain. This second burst is normally so soon after the metering burst that, to the naked eye, the two are indistinguishable.

When second-curtain synchronization is selected, the illuminating burst is fired at the end of the exposure, just before the second curtain catches up with the first curtain. Because there is a longer time lag between metering and illumination, it may be more obvious that the flash has actually fired twice.

So how do these settings affect the image? The duration of the flash is very short and has the effect of freezing movement. However, if the exposure is long enough for the ambient light to record subject detail, the image will be illuminated by of a mixture of flash and ambient light. The subject will be frozen and sharp but there will also be a ghost image which is not, and there may also be light trails from moving highlights.

It is these light trails that are affected most significantly by switching from first- to second-curtain synchronization.

Imagine a subject moving across the frame from left to right. With first-curtain sync, the flash will fire immediately and will freeze the image towards the left of the frame. Any ambient light will continue to expose the subject as it continues to move across the frame. The end result is a sharp subject with light trails extending into the area into which it is moving, making it appear as if it is moving backwards.

With second-curtain sync, the subject is lit by the ambient light first and then frozen by the flash at the end of the exposure. This adds to the impression of forward movement and looks much more natural.

Wireless and multiple flash

When a single flash unit is no longer sufficient, either in terms of power or to control highlights and shadows, Canon make it easy to use multiple flash units with either wired or wireless connectivity. With a wired set-up it is important to note that, with the exception of the off-camera shoe cord, the benefits of E-TTL II metering will be lost. A wireless system, however, will retain full E-TTL II compatibility and can be established using either the Wireless Transmitter ST-E2 as the camera-mounted control unit or an EX Speedlite (550EX upwards) as the master unit. All other flash units will be deemed 'slave' units. The ST-E2 is purely a control unit and transmitter and does not incorporate a flash head.

EX Speedlites

Canon's EX range of Speedlites is fully compatible with E-TTL II metering. The range runs from the inexpensive 220EX to the high-powered 580EX II, and barely used discontinued models can readily be found on eBay. The model number is a quick and easy indication of the power of each unit, with the 580EX having a Guide Number of 58 (metres at ISO 100) and the 430EX having a Guide Number of 43 (metres at ISO 100), for example. If you are interested in wireless flash photography, you should always check whether any particular model is capable of acting as a master unit or only as a slave unit.

220EX Speedlite

The 220EX Speedlite is the smallest and least expensive of Canon's range. It includes flash exposure lock compatibility and high-speed (FP) synchronization. However, this model is not compatible with use as a wireless slave unit, and it can't take Canon's external power pack.

Max. guide number 72/22
(ISO 100 ft/m)
Zoom range 28mm fixed
Tilt/swivel No
Recycling time 0.1–4.5 sec
AF-assist beam Yes
Weight (w/o batteries) 160g

430EX II Speedlite

The 430EX II Speedlite provides flash exposure lock compatibility, high-speed (FP) synchronization and can be used as a wireless slave unit with the 550EX, 580EX, 580EX II, Speedlite Transmitter ST-E2, and Macro Twin Lite MT-24EX and Macro Ring Lite MR-14EX. The bottom end of its zoom range has been extended from 24mm on the 420EX down to a very useful 14mm.

Max. guide number 141/43 (ISO 100 ft/m) at 105mm
Zoom range 24–105mm (14mm with wide panel)
Tilt/swivel Yes
Recycling time 0.1–3.7 sec
AF-assist beam Yes
Custom functions/settings 9/20
Wireless channels 4
Weight (w/o batteries) 320g

580EX II Speedlite

The 580EX II Speedlite provides flash exposure lock, high-speed (FP) synchronization, 14 custom functions, flash exposure bracketing, automatic or manual zoom head and strobe facility. It can be used as either a master or slave unit for wireless flash photography. It even provides colour temperature control for optimal white balance and manual settings down to 1/128 power in $\frac{1}{3}$-stop increments. The Mk II version has added weathersealing, 20% faster recycling, a PC socket and external metering sensor for non-TTL flash.

Max. guide number 190/58 (ISO 100 ft/m) at 105mm
Zoom range 24–105mm (14mm with wide panel)
Tilt/swivel Yes
Recycling time 0.1–6 sec
AF-assist beam Yes
Custom functions/settings 14/32
Wireless channels 4
Catchlight reflector panel
Weight (w/o batteries) 375g

MR-14EX Macro Ring Lite

This unit consists of a control unit which is mounted on the hotshoe and a ring-flash unit which is mounted on the lens. The ring-flash unit has two flash tubes on opposite sides of the lens and the lighting ratio between these can be adjusted to provide better shadow control. It also has built-in focusing lamps and modelling flash and is capable of acting as master unit for wireless flash photography. The Ring Lite is designed for close-up photography where a hotshoe-mounted flash would be ineffective due to the short camera-to-subject distance.

Max. guide number 46/14 (ISO 100 ft/m)
Designed for use with EF macro lenses
Tilt/swivel No
Modelling flash Yes
Recycling time 0.1–7 sec
Weight (w/o batteries) 404g

MT-24EX Macro Twin Lite

The Twin Lite consists of a control unit which is mounted on the camera's hotshoe plus two small flash heads which are mounted on either side of the lens and can be adjusted independently. This model offers far more flexibility than the Ring Flash. It has the same wireless capabilities as the Ring Flash and is designed for use with the same EF Macro lenses.

Max. guide number 72/22 (ISO 100 ft/m)
(with both heads firing)
Zoom range N/A
Tilt/swivel Yes
Recycling time 4–7 sec
Weight (w/o batteries) 404g

Flash accessories

One of the great advantages of using a system camera like the 5D Mk II is the range of accessories available, and Canon produce a wide range of useful additions for its flash units. These increase both the range of situations in which you can work and the flexibility of use, giving you maximum control of the end result. In particular, they will help you to use the flash off-camera to reduce red-eye when shooting people and animals and for improved shadow placement, giving a more natural appearance to your photographs.

Speedlite Transmitter ST-E2

This unit acts as an on-camera wireless transmitter for all current EX Speedlites except the 220EX. It can control two groups of slave flash heads with flash ratio variable between the two groups. The ST-E2 is not entirely necessary for wireless flash as some EX models can also act as master units, with or without the master unit firing.

Off-camera Shoe Adaptor 2

This is a simple hotshoe socket for a Speedlite and incorporates a ¼-in tripod socket, to be used with either of the connecting cords (see page 175).

TTL Hotshoe Adaptor 3

The Hotshoe Adaptor can be used with either the connecting cords and the TTL distributor, or the off-camera shoe cord, to connect up to four separate Speedlites.

TTL Distributor

This accessory provides four connection sockets: one to connect to the TTL Hotshoe Adaptor 3 and three more for connecting to off-camera shoe adaptors via Connecting cords 60 and 300.

Off-camera Shoe Cord OC-E3

This is one of the first accessories many people buy, enabling an EX Speedlite to be used up to 2ft (0.6m) away from the camera while retaining all normal functions. It is ideal for close-ups with a small light cube such as the Lastolite ePhotomaker, as well as improving bounce flash capability and helping to avoid red-eye.

Compact Battery Pack CP-E4

The CP-E4 improves recycling times and the number of flashes available. It also permits the fast changeover of CPM-E4 battery magazines.

Speedlite L bracket SB-E2

This bracket allows a Speedlite to be positioned to the side of the camera rather than on the hotshoe, helping to reduce red-eye by taking the flash head off the camera-lens axis. It requires an off-camera shoe cord.

Connecting Cords 60 and 300

A 2ft (0.6m) coiled lead or a 10ft (3m) straight lead to connect the TTL Distributor and TTL Hotshoe Adaptor 3.

Tips

Wired flash accessories are not compatible with E-TTL II metering, irrespective of the capabilities of the flash unit you are using. For full E-TTL II compatibility, use a wireless system with the 550EX/580EX/580EX II or ST-E2 transmitter as the master unit.

To ensure maximum compatibility, new accessories are often released at the same time as new Speedlites. Sometimes, but not always, these are compatible with discontinued flash units. To check compatibility, consult the Canon website or, even better, obtain a copy of EOS Magazine's annual products supplement, which lists all current and discontinued Canon products, in some cases as far back as the late 1980s.

Expo Imaging have recently released a ring-flash accessory with adaptors to fit both the 580EX II and the original 580EX. It fits directly onto the flash head and, because of the flash unit's much higher guide number compared with dedicated ring-flash units, it provides a much greater flash-to-subject distance. This means that it can be used for portraits and other subjects in addition to close-up work. Called the Ray Flash Adaptor, it is considerably less expensive than either the Canon or Sigma ring flash units.

50mm

Chapter **5**

Close-up

The revealing world of close-up photography is both fascinating and rewarding, and is available to all photographers with the minimum of additional equipment. What it does require, however, is great attention to technique and rock-solid camera support. The high magnifications involved mean that a slight error in focusing or the smallest camera movement will be immediately noticeable.

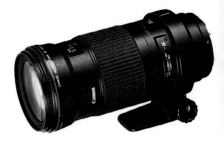

EF 180mm f/3.5 L MACRO
Canon's longest true macro lens employs a tripod collar for improved balance.

The other factors which are of greatest importance in close-up photography are lighting and depth of field. The latter is easily dealt with by choosing a very narrow aperture, though newcomers to close-up photography will still be surprised by how little depth of field is available – often no more than a few millimetres, even at the narrowest aperture. For this reason, purpose-built macro lenses often have a narrower aperture than usual, perhaps f/32 rather than f/16 or f/22. As well as making the use of depth-of-field preview more difficult (due to an impossibly dark viewfinder), apertures such as these require even slower shutter speeds, making lack of camera movement even more important, and this is one reason why a lot of extreme close-up photography is done using flash.

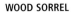

WOOD SORREL
Taking close-up shots outdoors can be a challenge, but it is very rewarding to view the resulting images full-screen and see the incredible detail you have recorded.

ISOLATE THE SUBJECT

This montbretia is captured in all its elegant simplicity by setting it against a plain background and using diffused flash. All the key elements are positioned on one plane to reduce the depth of field required.

Settings

Aperture Priority (Av)
ISO 100
1/200 sec at f/11
Evaluative E-TTL II metering
Manual focus
Wireless flash with 580EX
and 550 EX Speedlites

Lighting for close-ups

Lighting is one of the most difficult aspects of extreme close-up work. The very narrow apertures and slow shutter speeds necessary cannot be overcome by using a high ISO speed unless quality is to be sacrificed, so diffuse ambient lighting is often not sufficient unless working outdoors, when the additional problem of wind has to be borne in mind.

Flash might seem the obvious solution, but it has its own problems. To start with, a flashgun mounted on the camera's hotshoe cannot be tilted down sufficiently to illuminate the subject at close proximity.

Off-camera flash

The starting point for considering the subject of lighting is off-camera flash. This necessitates the purchase

of a Canon off-camera shoe cord OC-E3 that will retain all E-TTL II features. However, direct flash will produce a rather harsh light at such short distances so it is best to diffuse it. The two simplest ways of doing this are to either bounce the light off a white or near-white surface such as a sheet of white card or a Lastolite reflector, or to put translucent material between the flash and the subject. The oldest trick in the book is to drape a white handkerchief over the flash head. In truth, though, the hankie trick doesn't work very well, as effective diffusion comes with increasing the size of the light source rather than just masking it.

One reason why bounce flash is so effective is that the effective size of the light source is increased considerably. If you bounce the light off a standard Lastolite reflector you have a light source of approximately 3ft (0.9m) in diameter.

The best inexpensive solution for photographing small objects with a single off-camera flash is some form of light-tent or light-cube. Lastolite's ePhotomaker, originally designed to

PRODUCT SHOTS
The author's product shots were all taken using a single 580EX II Speedlite with an off-camera shoe cord and a Lastolite ePhotomaker.

180

help people photograph items for sale on eBay, is basically a small light-tent with one internal side consisting of reflective material, the rest being translucent fabric that acts as both diffuser and reflector. By mounting the off-camera flash outside the ePhotomaker on the opposite side to the reflective material, a good balance of light and shadow can be achieved quickly and easily.

For maximum control of shadows, two or more flash heads are even better. One solution is to use a ring-flash unit. This has two small flash heads within a circular reflector that fits on the front of the lens with the flash heads on opposite sides of the lens. However, this brings us back to the harsher effects of direct flash and can also produce small doughnut-shaped reflections in shiny surfaces. Ring flash is best reserved for matt subjects and for shooting flowers and similar subjects outdoors.

Canon's MR-14EX Macro Ring Lite has a hefty price tag but Sigma also market a less expensive version, the EM-140DG. A recent addition is the Marumi DR-F14, a very modestly priced ring flash which we could not assess in time for this book.

Canon also manufacture a (very expensive) lens-mounted two-head unit. This consists of a control unit that mounts on the hotshoe and has two independently adjustable heads.

There are also lots of proprietary products enabling the photographer to use two flash heads in a similar configuration using either wired or wireless flash. Remember that a wireless set-up is necessary for full E-TTL II compatibility.

Depth of field

Because depth of field is so limited in close-up photography, it is often impossible to get the whole of the subject, from front to back, in acceptably sharp focus. Subjective decisions may need to be made about which parts of the subject need to be in sharp focus and which can be sacrificed. This means that there are great advantages to be had from adopting manual focus for the task. This is where the EOS 5D Mk II's Live View feature comes into its own – it was originally designed with manual focusing very much in mind, even though AF Live View is possible.

With Live View you have the advantage of a large image on the new 920,000-dot high-resolution monitor that can be used to check depth of field. By making use of the 5× or 10× magnification function, which can be used in conjunction with depth-of-field preview and the ❖ Multi-controller button to roam around the image to check focus in detail, you have an ideal tool for close-up photography.

Working distance

The nature of the subjects you plan to photograph will play a large part in determining the working distance between the camera and subject, which in itself will help to determine the focal length(s) of the lens you use. Inanimate objects can be photographed from mere inches away, whereas live subjects will require a greater distance. If you plan to photograph live subjects that are camera-shy or dangerous, you should opt for a longer focal length to increase the working distance.

There are situations when it is better to set up the camera on a tripod and retreat to a safe distance to take the photograph, though this will require a good deal of trial and error. In these circumstances you can use the Remote Control RC-1, which allows you to position yourself up to 16ft (5m) away. The RC-1 permits either a 2 sec delay or immediate shooting. (The Remote Control RC-5 only offers a 2 sec delay and is not practical in this context.) The other alternative is to use the RS-80N3 remote release with the 30ft (10m) EC-1000N3 extension cable.

EF 50mm f/2.5 MACRO
A short focal length macro lens is excellent for still-life set-ups but may not provide sufficient working distance for live subjects.

HUMMINGBIRD HAWKMOTH
Your working distance needs to be great enough not to frighten away your subject.

Close-up attachment lenses

These are one of the easiest routes into close-up photography and screw onto the lens thread just like filters. If you are not planning significant enlargements of your photos, close-up attachment lenses are good value and can produce great results.

They are best used with prime lenses such as a 50mm standard lens or a moderate wide-angle with close focusing capability, and work by reducing the minimum focusing distance even further. Magnification is measured in dioptres, generally +1, +2, +3 or +4, and their great advantage for the novice is that all the camera functions are retained.

Close-up attachments can be used two or more at a time, for example combining a +2 with a +3 attachment to obtain +5 dioptres. However, the optical quality will not be of the same standard as your lens and using two or more will reduce image quality more noticeably. This is another reason to use prime (fixed focal length) lenses – their image quality, despite many advances in zoom lens quality, still tends to be better.

There are some very inexpensive close-up attachment lenses on the market, but as with filters, you will have to pay more for better quality. Canon produce both 2 dioptre (Type 500D) and 4 dioptre (Type 250D) lenses in both 52mm and 55mm fittings, plus a 2 dioptre (Type 500D) lens in both 72mm and 77mm fittings. All are double-element construction for higher quality. The Type number indicates the greatest possible lens-subject distance in millimetres. The 250D is optimized for use with lenses between 50mm and 135mm; the 500D is designed for lenses between 75mm and 300mm.

> **Tip**
> If you often shoot close-ups of flat or essentially two-dimensional subjects at 90°, a copy stand may be a worthwhile investment. This allows you to set up both camera and lighting in a semi-permanent configuration on a stable platform. A variety are available from the German manufacturer Kaiser Fototechnik.

Lens magnification tables

The table below shows the level of magnification you can achieve by attaching either the 250D or 500D close-up attachment lenses (see page 183) to a selection of prime (fixed focal length) lenses.

Lens	Filter size (mm)	Magnification 250D	500D
EF 20mm f/2.8 USM	72	N/A	0.17–0.04
EF 24mm f/2.8	58	0.25–0.10	0.20–0.05
EF 28mm f/2.8	52	0.24–0.12	0.19–0.06
EF 35mm f/2	52	0.36–0.14	0.30–0.07
EF 50mm f/1.0L	72	N/A	0.24–0.10
EF 50mm f/1.4 USM	58	0.35–0.21	0.25–0.10
EF 50mm f/1.8 II	52	0.36–0.20	0.25–0.10
EF 50mm f/2.5 Macro	52	0.68–0.20	0.59–0.10
EF-S 60mm f/2.8 Macro	52	1.41	1.21
EF 85mm f/1.2L USM	72	N/A	0.28–0.17
EF 85mm f/1.8 USM	58	0.50–0.34	0.31–0.17
EF 100mm f/2 USM	58	0.57–0.40	0.35–0.20
EF 100mm f/2.8 Macro	52	1.41–0.41	1.21–0.20
EF 135mm f/2.8 SF	52	0.70–0.55	0.41–0.27
EF 200mm f/2.8L USM	72	N/A	0.57–0.39
EF 300mm f/4L USM	77	N/A	0.70–0.59
EF 400mm f/5.6L USM	77	N/A	0.91–0.78

Extension tubes

Extension tubes fit between the lens and the camera body and can be used singly or in combination. Canon produce two: Extension Tube EF 12 II and Extension Tube EF 25 II. The former provides 12mm of extension and the latter 25mm. By increasing the distance from the lens to the lens mount and thus the focal plane, the minimum focusing distance and the magnification of the image are both increased. Both of Canon's extension tubes retain autofocus capability and are compatible with most EF lenses.

TUBES AND BELLOWS
(Right) Extension tubes EF 12 II and EF 25 II. (Below) This Balpro Novoflex bellows features tilt and shift adjustments for maximum control of perspective and depth of field. Metering is still possible with the appropriate adaptor.

Bellows

Bellows work on the same principles as extension tubes, but are a much more flexible tool. The basic concept is simplicity itself – a concertina-shaped light-proof tube with a male lens mount at one end and a female lens mount at the other, the whole affair being mounted on a base that allows minute adjustment. This facilitates better control over the magnification ratio and focusing. But the greatest benefit is that bellows do not employ any glass elements at all and consequently can be used to deliver maximum image quality. The downside is that

there is a significant loss of light involved, and exposure must be adjusted to correct this. At one time it was necessary to employ complex calculations to work out the correct exposure, but today's digital cameras are so easy to use that you may as well work on a trial-and-error basis. Canon do not produce this particular accessory, but alternatives are available from independent manufacturers, notably Novoflex.

Macro lenses

There are three types of lens that tend to be sold as macro lenses. The first is a specialist lens designed for extremely high magnifications, such as Canon's MP-E65 f/2.8 Macro lens (right, top) which has a maximum magnification of an astonishing 5× life-size. The second is a purpose-built conventional macro lens with a maximum reproduction ratio of 1:1, though half life-size is now commonly accepted in this category. These are excellent lenses for everyday use too, often giving crisp and contrasty results in everyday situations. Finally, there are those lenses that boast what they refer to as a 'macro setting', which may offer a magnification ratio of up to perhaps 1:4, or one quarter life-size.

For close-up photography in general, a dedicated fixed focal-length macro lens, such as the excellent EF 100mm f/2.8 Macro (right), is the ideal choice and provides excellent image quality at close-focusing distances as well as crisp results across the range. This particular lens is arguably Canon's best value EF macro lens, as the EF 50mm f/2.5 Macro only extends to

MP-E 65mm f/2.8 1–5× Macro

EF 100mm f/2.8 Macro

0.5× life-size and lacks the faster and quieter ultrasonic motor (USM), while the longer 180mm version is a much heavier and more costly L-series lens. The 50mm version can achieve 1:1 magnification with the addition of extension tubes or by using the dedicated four-element Life-size Converter.

186

CREAM TEA

Even when Evaluative metering is selected, switching the lens to manual focus will cause AE Lock to be applied at the centre AF point. This will clearly be unsuitable for close-up subjects such as this traditional cream tea. With Partial metering, Spot metering and Centre-weighted metering, the locked exposure is also linked to the centre AF point even when using AF.

Settings

Aperture Priority (Av)
ISO 400
1/1000 sec at f/8
Evaluative metering
White balance: Auto
One Shot AF

Chapter **6**

LENSES

Lenses

One reason why photographers choose a manufacturer like Canon is the extensive range of lenses and other accessories available. At the time of writing Canon offers no fewer than 70 lenses, including specialist items such as tilt-and-shift lenses. The range encompasses their standard EF lenses, which will fit all Canon EOS cameras; EF-S lenses, which will not fit the EOS 5D Mk II, and their renowned L-series lenses, which are popular with professionals due to their rugged design, weather-proofing and high optical quality. All three ranges feature ultrasonic (USM) motors on most lenses, and IS (Image Stabilization) is slowly being added model by model.

EF lenses

This is Canon's standard range that stretches from a 15mm fisheye up to 400mm and includes the macro lenses, with the exception of the 180mm L-series macro. It also includes two of the three manual-focus-only tilt-and-shift lenses and the 1.4× and 2× teleconverters ('extenders' in Canon parlance). Zooms range from 20–35mm to several models which extend up to 300mm. It is worth studying their specifications because some EF lenses use L-series technology

and represent terrific value. These include the EF 70–300mm f/4–5.6 IS USM, which replaced the 75-300mm model that was launched in 1995 as the first in the world to use image stabilization (IS) technology.

L-series lenses

Canon's L-series range of prime lenses stretches from 14mm f/2.8 to 800mm and includes all the super-fast lenses such as the 24mm f/1.4 II, 35mm f/1.4, 50mm f/1.2, 85mm f/1.2 II and the 400mm f/2.8. A recent addition is the 200mm f/2 with five-stop image stabilizer. Build quality is superb and later lenses have a rubber skirt on the mount to improve weather- and dust-proofing. Longer focal lengths and extended zooms are off-white in colour.

EF 24mm f/1.4 L II

EF-S lenses

EF-S lenses are not compatible with the Canon EOS 5D Mk II. The 'S' designation identifies this series as having shorter back focus, a smaller image circle, a specific mount not compatible with a standard EF mount, and a difference in build quality in order to reduce weight.

Focal length and angle of view

No matter how much is written, nor how often, about the focal length of lenses in this new age of 'less than full-frame' digital cameras, confusion and debate continue to fill internet forums with threads about related topics on a daily basis. These pages should clarify a few of those points.

Focal length

When parallel rays of light strike a lens that is focused at infinity, they converge on a single point known as the focal point. The focal length of the lens is defined as the distance from the middle of that lens to the focal point. Photographic lenses are a bit more complicated because the lens is comprised of multiple elements, but the principle holds good and the measurement is taken from the effective optical centre of

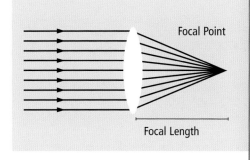

the lens group. The focal point is referred to in photography as the 'focal plane' and this is the plane on which the film or sensor lies. Focal length is an absolute characteristic of any lens and can be measured and replicated in laboratory conditions. The focal length of a lens always remains the same, irrespective of any other factor such as the type of camera it is mounted on.

Crop factor

Although this issue does not affect the EOS 5D Mk II, it is worth mentioning briefly here for the sake of clarification. This term has been coined as a simpler way of referring to the digital multiplier that must be used with 'less than full-frame' sensor cameras. The 'crop factor' refers only to the field of view that the sensor covers. Technically speaking, it should not be applied to the focal length of a lens used with a smaller sensor.

Field of view

The field of view of a lens, in photographic terms, is the arc through which objects are recorded on the film or sensor. This arc of coverage, as with all geometrical angles, is measured in degrees (°). Although the image projected by the lens is circular, in photography we are only concerned with the usable rectangle within that circle, and consequently the field of view of a camera lens can be found quoted as three figures: horizontal field of view, vertical field of view and diagonal field of view. Where only one figure is quoted, it is generally assumed to be the diagonal field of view.

The field of view of a lens is not an absolute measurement and depends on two factors: the focal length of the lens and the area of the sensor or film which is to record the image.

Lenses continue to be marketed using the focal length designation that would be applied to a full-frame (36mm × 24mm) sensor or 35mm film. As the focal length of a given lens is fixed, it would be helpful if the angle of view were to be quoted alongside the image area it is intended for. However, this practice is not followed by lens manufacturers, for several reasons.

Lenses designed to fill full-frame sensors can be also be used on smaller formats, necessitating several sets of figures: Canon's EF full-frame lenses can also be used with their APS-H (1.3×) and APS-C (1.6×) sensors, for example. To complicate matters, competing camera manufacturers use sensors which are slightly different in size: Canon's APS-C sensor (1.6×) measures 22.2mm × 14.8mm, whereas Nikon's equivalent measures 23.6mm × 15.8mm with a 1.5× crop factor. Finally, the angle of view for a given focal length may be slightly different from one lens manufacturer to another.

> **Tip**
> When you double the focal length, the area covered is one quarter of the previous area and vice-versa.

Standard lenses

The term 'standard lens' dates back to the early days of 35mm photography, long before today's extensive range of prime lenses and, particularly, zoom lenses were even conceived of. The working photographer would carry three bodies equipped with a moderate wide-angle lens of 28mm or 35mm, a 50mm standard lens and a short telephoto of up to 135mm. The standard 50mm lens was sold with the camera and approximated the field of view of the human eye. Today, the zoom lenses that are packaged with new cameras tend to straddle this figure.

Historically, the standard lens was often the least expensive in any line-up, because it could be manufactured more cheaply. But standard zooms have come down in price, size and weight, and have increased in quality. So is there still a market for a 50mm prime lens?

For the full-frame camera user the answer is a resounding 'yes' because of their sheer image quality, and it must also be remembered that these lenses are used with crop-sensor bodies as superb portrait lenses.

Canon still produce three 50mm lenses ranging from the cheap and cheerful 50mm f/1.8 through the excellent and moderately priced 50mm f/1.4 to the highly desirable but expensive 50mm f/1.2 version.

5D MK II WITH STANDARD LENS
The 5D Mk II is shown here with the EF 50mm f/1.4 lens and WFT-E4 wireless file transmitter fitted.

Wide-angle lenses

The original rectilinear 14mm f/2.8 L, the widest lens on offer from Canon, was introduced way back in 1991; it was so good that it has only recently been upgraded to a Mark II version (right). The next step up is the 15mm f/2.8 fisheye, but it is only after this point that the lens range broadens, and not until 24mm that non-L-series users get any real degree of choice.

The 16–35mm f/2.8 L, now also a Mark II, is favoured by many, but a smaller and lighter option is the 17–40mm f/4 L. Those unable to run to L-series prices must be content with the prime 20mm f/2.8 or the 20–35mm f/3.5–4.5. From 24mm there is the new superfast 24mm f/1.4 L, 24mm f/2.8, 24–70mm f/2.8 L, 24–85mm f/3.5–4.5 and 24–105mm f/4 L, which offers image stabilization and is a popular all-purpose lens with many professionals.

Today's wide zooms are really quite slow, so for the best results it is usually necessary to stop down a couple of stops from the maximum aperture, or perhaps just one stop with L-series lenses. This means working with an aperture of at least f/5.6, which places limits on working in low light because the shutter speeds will be very slow and, at the time of writing, only the 24–105mm L in this list offers image stabilization.

(Left) EF 14mm f/2.8 L II

(Right) EF 24–105mm f/4 L

There was a time when 28mm was considered 'wide' but today it is a focal length which is thought of as being on the wide side of normal. Nevertheless, Canon list a dozen full-frame lenses at or starting from this focal length, including three with image stabilization. The list features the wide-ranging 28–300mm L and two versions of the 28–200mm f/3.5–5.6, as only one of these sports the ultrasonic motor (USM). This is often the case with older designs, so check carefully before buying. This may well have a bearing on whether or not E-TTL II distance information is transmitted and whether the option of full-time manual focusing while in AF mode is provided, and of course the USM versions focus faster and more quietly.

Telephoto lenses

Telephoto lenses compress the different planes in an image, making distant subjects look closer than they are. The longer the focal length, the more this is true. Telephotos require faster shutter speeds, which is why you see sports photographers carrying such vast lenses. It is not the focal length alone that results in such huge lenses, but the combination of focal length and fast maximum apertures. But doesn't image stabilization remove the need for fast maximum apertures? No. Image stabilization compensates for camera shake but has no impact on the need for a high shutter speed (and therefore fast maximum aperture) when trying to freeze a moving subject.

One of the bonuses of longer lenses is the attractive out-of-focus background (known as 'bokeh') they can create. This is determined partly by the number of blades in the diaphragm and the extent to which they create a perfect circle when open. Anyone stepping up to a much longer focal length may well be surprised by just how limited the depth of field can be – but the most noticeable change will be the weight involved. Even the 200mm f/2 L IS weighs in at 2.5kg and the 400mm f/2.8 L IS weighs

all of 5.3kg. These differences mean far more than a lighter wallet and a heavier camera bag: they also affect insurance policies, choice of camera support, health considerations such as back and shoulder problems, and, for professionals, the scale of charges to your clients. Thankfully, there are cheaper and lighter alternatives such as using extenders in conjunction with high-quality prime lenses like the 200mm f/2.8 L II, or opting for something like the 70–300mm f/4.5–5.6 DO IS, which weighs just 720g, or even the relatively cheap non-L series 70–300mm f/4–5.6 which makes use of the same ultra-low dispersion glass as L-series lenses.

EF 200mm f/2 L IS

EF 800mm f/5.6 L

Teleconverters

Canon use the term 'extender' to describe their two teleconverters. The first is the 1.4× extender which is fitted between the camera body and the lens to increase the focal length by a factor of 1.4 and causes the loss of one stop of light. The 2× extender doubles the focal length with a loss of two stops.

Tip

If you are considering purchasing an extender, it is particularly important to pay attention to the maximum aperture of your lens. If the recalculated maximum aperture once an extender is fitted proves to be smaller than f/5.6, you will lose autofocus capability.

Warning!

Only selected lenses can be used with extenders without causing damage to the rear element of the lens. Check the specifications on the Canon website.

Teleconverters are an inexpensive way of increasing the pulling power of your telephoto lenses, but they do not provide the same quality as a lens of the same focal length. Autofocus will also be slower and you may find that the AF will 'hunt' unless it can lock onto a suitable contrasty part of the image.

Canon extenders EF 1.4× II (left) and EF 2× II.

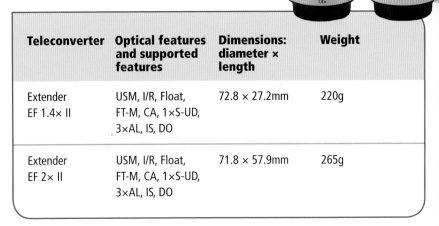

Teleconverter	Optical features and supported features	Dimensions: diameter × length	Weight
Extender EF 1.4× II	USM, I/R, Float, FT-M, CA, 1×S-UD, 3×AL, IS, DO	72.8 × 27.2mm	220g
Extender EF 2× II	USM, I/R, Float, FT-M, CA, 1×S-UD, 3×AL, IS, DO	71.8 × 57.9mm	265g

Perspective

There are several reasons why we might choose a particular focal length: angle of view, depth of field, and perspective chief among them. Perspective is the term used to describe the relationships between the different elements that comprise an image, particularly with regard to the apparent compression or expansion of planes.

Let's start with the most obvious examples. With a very wide-angle lens, taking a head and shoulders portrait will involve a very short camera-to-subject distance, and the nearest facial features will appear quite distorted and overly large. Conversely, try photographing a line of parking meters with a long telephoto and the image will give the impression that the meters are spaced only a couple of feet apart.

Between these two extremes are a host of options, especially if you use zoom lenses. There are no hard-and-fast rules except to say that if you want

natural-looking portraits, it is best to opt for a slightly longer than standard focal length, traditionally 85mm full-frame. Canon's prime lenses in this bracket are excellent value (not counting the fabulous but pricey 85mm f/1.2), with wide maximum apertures and superb image quality.

> **Tip**
> The perspective with any given focal length will change according to the camera-to-subject distance and the viewpoint. For example, looking downwards at a 45-degree angle will give a quite different perspective from approaching the subject at eye level.

POINT OF VIEW
Both these images were taken from exactly the same camera position. Note how the planes have been compressed in the telephoto shot.

Tilt-and-shift lenses

One of the main drawbacks of using normal lenses for any architectural subject is that tilting the camera and the lens to accommodate the height of the building results in the convergence of vertical lines, usually the sides of the building. You can get around this by finding a viewpoint that is at roughly half the height of the building. Alternatively, a more satisfactory solution comes in the shape of a tilt-and-shift lens.

Canon manufacture four such lenses, with the two widest being L-series versions: the TS-E 17mm f/4 L, TS-E 24mm f/3.5 II L, TS-E 45mm f/2.8 and the TS-E 90mm f/2.8. All of these are manual focus only and adopt the same principles as a view camera but are much more portable. They work by allowing the lens to perform three different movements (tilt, shift and rotate) in relation to

the plane of focus, with the added benefit of improving (or reducing) depth of field without changing the aperture. Tilt-and-shift locks on the L-series lenses prevent unwanted slipping of the settings.

Both the 17mm and 24mm Mark II versions allow independent rotation of the tilt and shift axes. Earlier versions could be set up as either parallel or at right angles by a Canon Service Centre but could not be changed in the field. The two new versions also boast a greatly increased image circle.

TS-E 17mm f/4 L

Lens	Field of view	Tilt	Shift	Rotation	Image circle
TS-E 17mm f/4 L	104° (diag.)	+/- 6.5°	+/- 12mm	+/- 90°	67.2mm
TS-E 24mm f/3.5 II L	84° (diag.)	+/- 8.5°	+/- 12mm	+/- 90°	67.2mm
TS-E 45mm f/2.8	51° (diag.)	+/- 8°	+/- 12mm		58.6mm
TS-E 90mm f/2.8	27° (diag.)	+/- 8°	+/- 12mm		58.6mm

198

WAR MEMORIAL, HARROGATE, UK
Converging vertical lines can also be corrected in Photoshop. Open the image, select Image > Canvas size and increase the size of the canvas by about 20%. Select View > Show > Grid to apply the grid overlay. Create a new layer, then select Edit > Transform > Perspective and drag the handles to adjust the perspective. Flatten the image before saving. This example (right) took only a couple of minutes to correct (above).

Settings
Aperture priority (Av)
Evaluative metering
ISO 100
1/250 sec at f/8

EF lens chart

Lens name	Optical features	Angle of view (horizontal) nearest 10th of a degree	Min. focus distance
EF 14mm f/2.8L USM	USM, 1×AL, I/R, FT-M, Float	76°48'	0.25m
EF 14mm f/2.8L II USM	L, USM, 1×AL, 1×UD, CA, SC	81°	0.20m
EF 15mm f/2.8 Fisheye	I/R	–	0.20m
EF 20mm f/2.8 USM	USM, I/R, FT-M, Float	58°6'	0.25m
EF 24mm f/1.4L USM	USM, 1×AL, 1×UD, I/R, FT-M, Float	49°36'	0.25m
EF 24mm f/2.8	I/R, Float	49°36'	0.25m
TS-E 24mm f/3.5L	1×AL	49°36'	0.30m
EF 28mm f/1.8 USM	USM, 1×AL, I/R, FT-M	43°12'	0.25m
EF 28mm f/2.8	1×AL, Float	43°12'	0.30m
EF 35mm f/1.4L USM	USM, 1×AL, I/R, FT-M, Float	35°12'	0.30m
EF 35mm f/2		35°12'	0.25m
TS-E 45mm f/2.8	Float	27°42'	0.40m
EF 50mm f/1.2L USM	L, USM, CA, SC	40°	0.45m
EF 50mm f/1.2L USM	L, USM	25°	0.45m
EF 50mm f/1.4 USM	USM, FT-M	25°	0.45m
EF 50mm f/1.8 II		25°	0.45m
EF 50mm f/2.5 Compact Macro	Float	25°	0.23m
MP-E 65mm f/2.8 1–5x Macro Photo	Float, 1×UD	19°24'	0.24m
EF 85mm f/1.2L USM	USM, 1×AL, FT-M, Float	14°54'	0.95m
EF 85mm f/1.8 USM	USM, I/R, FT-M	14°54'	0.85m
TS-E 90mm f/2.8		14°6'	0.50m
EF 100mm f/2 USM	USM, I/R, FT-M	12°42'	0.90m
EF 100mm f/2.8 Macro USM	USM, I/R, FT-M, Float	12°42'	0.31m
EF 135mm f/2L USM	USM, 2×UD, I/R, FT-M	9°24'	0.90m

200

Min. aperture	Max. magnification	Filter size dia. × length	Dimensions	Weight
f/22	0.10×	rear	77.0 × 89.0mm	560g
f/22	0.15×	rear	80.0 × 94.0mm	645g
f/22	0.14×	rear	73.0 × 62.2mm	330g
f/22	0.14×	72mm	77.5 × 70.6mm	405g
f/22	0.16×	77mm	83.5 × 77.4mm	550g
f/22	0.16×	58mm	67.5 × 48.5mm	270g
f/22	0.14×	72mm	78.0 × 86.7mm	570g
f/22	0.18×	58mm	73.6 × 55.6mm	310g
f/22	0.13×	52mm	67.4 × 42.5mm	185g
f/22	0.18×	72mm	79.0 × 86.0mm	580g
f/22	0.23×	52mm	67.4 × 42.5mm	210g
f/22	0.16×	72mm	81.0 × 98.0mm	645g
f/16	0.15×	72mm	85.8 × 65.5mm	580g
f/16	0.15×	72mm	85.4 × 65.5mm	545g
f/22	0.15×	58mm	73.8 × 50.5mm	290g
f/22	0.11×	52mm	68.2 × 41.0mm	130g
f/32	0.50×	52mm	67.6 × 63.0mm	280g
f/16	5.00×	58mm	81.0 × 98.0mm	730g
f/16	0.11×	72mm	91.5 × 84.0mm	1,025g
f/22	0.13×	58mm	75.0 × 71.5mm	425g
f/32	0.29×	58mm	73.6 × 88.0mm	220g
f/32	0.14×	58mm	75.0 × 73.5mm	460g
f/32	1.00×	58mm	79.0 × 119mm	600g
f/32	0.19×	72mm	82.5 × 112mm	750g

EF 135mm f/2.8 with soft focus	1×AL, I/R	9°24′	1.30m
EF 180mm f/3.5L Macro USM	USM, 3×UD, I/R, FT-M, Float	7°6′	0.48m
EF 200mm f/2L IS USM	USM, 5-stop IS, UD, FT-M, FP	10°	1.9m
EF 200mm f/2.8L II USM	USM, 2×UD, I/R, FT-M	6°24′	1.50m
EF 300mm f/2.8L IS USM	USM, 1×CaF2, 2×UD, I/R, FT-M, FP, IS, AF-S, DW-R	4°12′	2.50m
EF 300mm f/4L IS USM	USM, 2×UD, I/R, FT-M, IS	4°12′	1.50m
EF 400mm f/2.8L IS USM	USM, 1×CaF2, 2×UD, I/R, FT-M, FP, IS, AF-S, DW-R	3°12′	3.00m
EF 400mm f/4L DO IS USM	DO, USM, 1×CaF2, I/R, FT-M, FP, IS, AF-S, DW-R	3°12′	3.50m
EF 400mm f/5.6L USM	USM, 1×CaF2, 1×S-UD, I/R, FT-M	3°12′	3.50m
EF 500mm f/4L IS USM	USM, 1×CaF2, 2xUD, I/R, FT-M, FP, IS, AF-S, DW-R	2°30′	4.50m
EF 600mm f/4L IS USM	USM, 1×CaF2, 2×UD, I/R, FT-M, FP, IS, AF-S, DW-R	2°6′	5.50m
EF 800mm f/5.6L IS USM	USM, 4-stop IS, AS, UD, FT-M, FP	2°35′	6.0m
EF 16–35mm f/2.8L USM	USM, 3×AL, 2×UD, I/R, FT-M, DW-R	69°30′–35°12′	0.28m
EF 16–35mm f/2.8L II USM	L, USM, 3×AL, 2×UD, CA, DW-R, FT-M	98°–54°	0.28m
EF 17–40mm f/4L USM	USM, 3×AL, 1×S-UD, I/R, FT-M, DW-R	66°18′–31°	0.28m
EF 20–35mm f/3.5–4.5 USM	USM, I/R, FT-M	58°6′–35°12′	0.34m
EF 24–70mm f/2.8L USM	USM, 3×AL, 1×UD, I/R, FT-M, CA	49°36′–18°	0.38m
EF 24–85mm f/3.5–4.5 USM	USM, 2×AL, 1×UD, I/R, FT-M, CA, DW-R	49°36′–14°54′	0.50m
EF 24–105mm f/4L IS USM	USM, IS, 1×UD, FT-M	49°36′	0.45m
EF 28–80mm f/3.5–5.6 II	USM, I/R	43°12′–30°	0.38m
EF 28–80mm f/3.5–5.6 V USM	FP, AF-S, 3×AL	65°–25°	0.38m
EF 28–90mm f/4–5.6 II USM	USM, 1×AL	43°12′–22°40′	0.38m
EF 28–90mm f/4–5.6 III	1×AL	43°12′–22°40′	0.38m

f/32	0.12×	52mm	69.2 × 98.4mm	390g
f/32	1.00×	72mm	82.5 × 186.6mm	1,090g
f/32	0.12×	52mm drop-in	128 × 208mm	2,520g
f/32	0.16×	72mm	83.2 × 136.2mm	765g
f/32	0.13×	52mm drop-in	128 × 252mm	2,550g
f/32	0.24×	77mm	90.0 × 221.0mm	1,190g
f/32	0.15×	52mm drop-in	163 × 349mm	5,370g
f/32	0.12×	52mm drop-in	128.0 × 232.7mm	1,940g
f/32	0.12×	77mm	90 × 257.5mm	1,250g
f/32	0.12×	52mm drop-in	146 × 387.0mm	3,870g
f/32	0.12×	52mm drop-in	168 × 456.0mm	5,360g
f/32	0.14×	52mm drop-in	163 × 461mm	4,500g
f/22	0.22×	77mm	83.5 × 103.0mm	600g
f/22	0.22×	82mm	88.5 × 111.6mm	635g
f/22	0.24×	77mm	83.5 × 96.8mm	500g
f/22–f/27	0.13×	77mm	83.5 × 68.9mm	340g
f/22	0.29×	58mm	83.2 × 123.5mm	950g
f/22–f/32	0.16×	77mm	73.0 × 69.5mm	380g
f/22	0.23×	77mm	83.5 × 107.0mm	670g
f/28–f/38	0.26×	67mm	67.0 × 71.0mm	220g
f/22–f/38	0.26×	58mm	67 × 71mm	220g
f/22–f/32	0.30×	58mm	67.0 × 71.0mm	190g
f/22–f/32	0.30×	58mm	67.0 × 71.0mm	190g

EF 28–105mm f/3.5–5.6 II USM	USM, I/R, FT-M	43°12'–12°6'	0.50m
EF 28–105mm f/4–5.6 USM	USM, I/R, 1×AL	43°12'–12°6'	0.48m
EF 28–135mm f/3.5–5.6 IS USM	USM, 1×AL, I/R, FT-M, IS	43°12'–9°24'	0.50m
EF 28–200mm f/3.5–4.5 II USM	USM, 2×AL, I/R	43°12'–6°24'	0.45m
EF 28–300mm f/3.5–5.6L IS USM	USM, 3×AL, 3×UD, I/R, FT-M, IS	43°12'–4°12'	0.70m
EF 35–80mm f/4–5.6 III	1×AL	35°12'–15°48'	0.40m
EF 55–200mm f/4.5–5.6 II USM	USM	22°48'–6°24'	1.20m
EF 70–200mm f/2.8L IS USM	USM, 4×UD, I/R, FT-M, IS, DW-R,	18°–6°24'	1.40m
EF 70–200mm f/2.8L USM	USM, 4×UD, I/R, FT-M	18°–6°24'	1.50m
EF 70–200mm f/4L IS USM	USM, 1×CaF2, 2×UD, I/R, FT-M, IS	18°–6°24'	1.20m
EF 70–200mm f/4L USM	USM, 1×CaF2, 2×UD, I/R, FT-M	18°–6°24'	1.20m
EF 70–300mm f/4.5–5.6 DO IS USM	USM, 1×AL, I/R, FT-M, DO, IS	18°–4°12'	1.40m
EF 70–300mm f/4–5.6 IS USM	USM, UD, IS	18°–4°12'	1.50m
EF 75–300mm f/4–5.6 III USM	USM	16°42'–4°12'	1.50m
EF 75–300mm f/4–5.6 III		16°42'–4°12'	1.50m
EF 80–200mm f/4.5–5.6 II		15°48'–6°24'	1.50m
EF 90–300mm f/4.5–5.6	CA	22°40'–6°50'	1.5m
EF 100–300mm f/4.5–5.6 USM	USM, I/R, FT-M	12°42'–4°12'	1.50m
EF 100–400mm f/4.5–5.6L IS USM	USM, 1×CaF2, 1×S-UD, I/R, FT-M, Float, IS	12°42'–3°12'	1.80m

f/22–f/27	0.19×	58mm	72.0 × 75.0mm	375g
f/22–f/32	0.19×	58mm	67.0 × 68.0mm	210g
f/22–f/36	0.19×	72mm	78.4 × 96.8mm	540g
f/22–f/36	0.28×	72mm	78.4 × 89.6mm	500g
f/22–f/38	0.30×	77mm	92.0 × 184.0mm	1,670g
f/22–f/32	0.23×	52mm	65.0 × 63.5mm	175g
f/22–f/27	0.17×	77mm	86.2 × 197.0mm	1,470g
f/32	0.17×	77mm	84.6 × 193.6mm	1,310g
f/32	0.21×	67mm	76.0 × 172.0mm	705g
f/32	0.21×	67mm	76 × 172mm	760g
f/32	0.16×	77mm	78.5 × 137.2mm	650g
f/32–f/38	0.19×	67mm	82.4 × 99.9mm	720g
f/32–f/45	0.26×	58mm	76.5 × 142.8mm	630g
f/32–f/45	0.25×	58mm	71.0 × 122.0mm	480g
f/32–f/45	0.25×	58mm	71.0 × 122.0mm	480g
f/22–f/27	0.16×	52mm	69.0 × 78.5mm	250g
f/38–f/45	0.25×	58mm	71 × 114.7mm	420g
f/32–f/38	0.20×	58mm	73.0 × 121.5mm	540g
f/32–f/38	0.20×	77mm	92.0 × 189.0mm	1,380g

Chapter **7**

Accessories

All photographers have a shortlist of accessories we wouldn't consider being without. Here we examine some of the most useful items, covering a range of techniques and photographic styles, but concentrating largely on filters, as these are very popular with almost all photographers.

Filters

There are essentially four types of filter: colour-correction filters used on the lens, colour-correction filters used on the light source, filters that enhance an existing characteristic but preserve a fairly natural feel to the photograph, and special-effects filters. Under some circumstances a mixture of these types may be used.

The materials commonly used in the construction of filters range from gelatine (usually reserved for lighting), through resins to glass. The quality of any of these may vary widely and, generally speaking, you get what you pay for. A major factor to consider when purchasing glass filters is the number of additional coatings to reduce flare. Glass filters come with no coating at all, single-coated or multi-coated, the latter being considerably more expensive. The alternative to glass is one of the rectangular filter systems that use

CHINON, FRANCE
A four-point star filter was used to pick out the streetlights in this shot. Like all images taken at night, differences in the type of lighting produce a variety of colours depending on which inert gases the lights use (e.g. neon or helium).

> **Tip**
> To maintain the best possible image quality, filters should be treated like lenses and kept clean and free from dust, and protected from scratches and abrasions.

resin filters and a special holder into which the filters are inserted. The filter holder, which will accept two or three filters, fits onto an adaptor ring which screws into the lens's filter thread, and it is easy to carry several adaptor rings for different lenses as well as numerous filters.

Special effects filters

An astonishingly wide range of effects filters is available, far too many to describe here. It is worth exploring the websites of filter manufacturers such as Lee, Cokin, Hitech and Hoya to get some idea of what is available.

Drop-in glass and gelatine filters

Some lenses have very large front elements which would necessitate equally huge filters. This caused manufacturers to seek an alternative, which they found in the form of drop-in filters. These are literally dropped into a slot in the lens which is located near the back and thus only requires a relatively small filter.

LEE FILTER HOLDER
If you opt for a rectangular filter system, provided you choose one of the larger series, you will only ever have to buy adaptor rings.

Canon produces drop-in filters in two sizes, 48mm and 52mm. They also make drop-in holders for gelatine filters in the same sizes. Unfortunately, the glass versions are restricted to polarizing filters.

Filters can require a considerable outlay, so it pays to research the various systems available and their compatibility with your existing equipment. A professional system such as Lee can be expensive, but it is a worthwhile investment.

Polarizing filters

Polarizing filters are best known for boosting the depth of blue skies and making white clouds stand out against them. They are most effective when used at 90° to the sun. Of the hundreds of filters available, the polarizing filter is the

PROVENCE, FRANCE
Polarising filters are perennially popular with landscape photographers as they boost blue skies and enrich greens in the image.

one that landscape photographers would least like to do without – and, coincidentally, the polarizer is also the most expensive. The filter is mounted in a holder that allows it to be rotated using a knurled ring on the front of the filter mount. The filter effect is transitional, shifting through maximum effect at 90° to the direction of the sun and minimum effect at 180°. The sun's height in the sky also plays its part.

A polarizing filter always reduces the light reaching the camera sensor and therefore requires a degree of exposure adjustment, though this will be achieved automatically in any auto-exposure mode. The degree of exposure adjustment required is not constant and varies according to the extent to which the filter blocks polarized light waves. Sometimes the combination of side-lighting (i.e. the sun at 90°) and the maximum filter effect can produce images which have far too much contrast with a lot of deep shadow. Remember that the polarizing filter's effect is not 'all or nothing' and it does not necessarily have to be rotated to achieve maximum effect when partial effect will do.

The other main function of a polarizer, particularly in landscape photography, is to control reflections in an image. While its most obvious use is to reduce unwanted reflections from shiny surfaces and water, the polarizing filter can also reduce the light reflected by foliage, producing richer green tones in an image.

There are two types of polarizing filter: circular and linear. These terms refer to light-wave behaviour and the word 'circular' has nothing to do with the shape of the filter.

Tip
Step-up or step-down adaptor rings can be used to make a glass filter fit multiple lenses with different sizes of filter threads, significantly reducing the cost of using the more expensive filters such as polarizers.

Both types are equally effective, but linear polarizers don't work well with autofocus cameras that employ beam-splitter technology, so you should use a circular polarizing filter with your Canon EOS 5D Mk II.

Vignetting

This is the term given to the darkening and loss of image detail at the outer edges of the frame, starting at the corners, and may have several causes – including using filters on wide-angle lenses or using the wrong lens hood.

Manufacturers expect filters to be used on their lenses or they wouldn't incorporate filter threads on them. The problems usually start when you 'stack' filters, using two or more screw-in filters together, especially if you then screw a lens hood on to the front of them.

Vignetting can also occur when using rectangular filter holders, especially if you add a second one to allow for rotation. The extent to which vignetting is noticeable will also depend on the aperture used.

To combat this problem, several manufacturers of rectangular filter systems produce filter holders with a circular threaded holder on the front of the filter holder to take a glass polarizing filter. However, this will usually demand a large and very expensive polarizer.

UV and skylight filters

These are designed to absorb ultraviolet light, reducing the blue colour cast which can be a nuisance in landscape shots at high altitude and on hazy days. The UV filter gives a natural result; the skylight version provides a warmer, pinkish tone.

In reality, far more photographers use UV filters to protect the front element of the lens from wear and tear than to filter out ultraviolet light. Others wouldn't dream of unnecessarily using a filter on their expensive high-quality lens as the optical quality of the filter cannot match that of the finest lenses.

Warm-up filters

Warm-up filters are available in several densities, with 81A being the weakest and 81E being the densest, though the 81D and 81E versions are often only available to order. An 81A or 81B can provide a slightly tanned skin tone and can be useful for studio shots of models or for beach shots on holiday. An 81B or 81C can be very effective for landscapes, providing a distinct earthy appearance which also makes greens less cold. These are now largely redundant for EOS 5D Mk II users who have the option of colour-temperature correction in-camera. However, several years ago, an American photographer hit on

the idea of combining a polarizing filter with a warming filter; the combined effect is quite distinctive and not quite the same as using a polarizing filter with in-camera colour-temperature control.

Neutral density filters

Sometimes there can be too much available light. The most common scenario is when a very slow shutter speed is needed to create blur – when shooting a waterfall, for example. In these circumstances a neutral density (ND) filter, which reduces the light passing through the lens equally across the frame, is a valuable aid. Theoretically, ND filters should not affect the colour balance, but resin ones in particular can have a grey tinge to them.

ND filters come in a range of strengths and are available in 1- to 4-stop versions in both glass screw-in and resin varieties. Their strength may be indicated as ND2 for 1 stop then ND4 for 2 stops, and so on; or ND0.3 for 1 stop followed by ND0.6 for 2 stops and so on, with ND0.45 being 1½ stops.

Graduated neutral density filters

Second only to the polarizing filter in terms of importance in the landscape photographer's tool kit, graduated neutral density (GND) filters are half clear, with the other

half having a neutral density coating which is increasingly dense as it approaches the upper edge of the filter. They are available in various strengths, as indicated for plain ND filters above. The filter's designation, in terms of strength, relates to the maximum light reduction at the upper edge. The area in the centre of the filter, where the clear half merges with the weakest edge of the neutral density coating, can have different gradings of transition: commonly soft, hard or razor. Hard- or razor-edged graduations are useful when you are photographing a flat horizon such as a seascape.

Graduated ND filters are used to balance exposure in different areas of the image and rectangular filter systems score more favourably for flexibility of use. You can vary the effect by how far you slide the filter into the holder, and you can insert a filter upside down to darken the bottom of the image. Furthermore, if you 'piggy back' two filter holders, you can rotate one of them to darken a corner of the image.

MULTIPLE GND FILTERS
Graduated rectangular filters can be inserted either way up so it is possible to use one on the sky and another on the foreground.

Settings
Aperture priority (Av)
Evaluative metering
ISO 100
1/500 at f/4
3-stop GND filter on sky
1-stop GND filter (inverted) on foreground

Camera supports

Two aspects of digital technology that are continually being improved are image stabilization (IS) and noise reduction, both of which have some impact on the need to provide additional support for your camera.

Canon claim an effective 4-stop reduction in shutter speeds for their more affordable IS lenses, but the new 200mm f/2 L-series lens offers a staggering 5-stop IS facility.

Using a 4-stop IS lens means that a previous shutter speed of, say, 1/250 sec could now be reduced to 1/15 sec without significant loss of sharpness due to camera shake. Improved noise reduction also means that a higher ISO setting can be used, also reducing the need for additional camera support.

Tripods

Despite these advances, there will always be circumstances in which a tripod or other form of support is necessary. The tripod remains the

> **Tip**
> Image stabilization technology is effective in reducing the effects of camera shake at low shutter speeds, but will have no impact on blur caused by subject movement.

photographer's primary and most popular form of support and relies on three things for its effectiveness: weight, appropriate feet for the situation, and leg-angle. Ironically, much recent development has gone into reducing the first of these factors using alternative materials like carbon fibre.

Tripod feet aren't something you think about about too often, but if you own a tripod that offers various alternatives, such as a Manfrotto, it is something you will be more aware of. Spiked feet are good for using on soft ground but no use on a wooden floor, for example, as they will scratch it and – more importantly in this context – they will mean that the entire set-up is balanced on three tiny points. The most common compromise consists of threaded spikes with rubber feet which can be screwed up or down according to your requirements. But there are also wider, flat feet designed for use on snow or soft ground.

As for leg angle, the broader the base of the extended tripod, the more stable it will be. This concept has been extended to produce tripods like the Benbo, which offers unlimited leg movement in any direction for absolute stability. Mini-tripods and table-top tripods

are a lightweight solution out in the field, and for lightweight cameras there are some intriguing versions with flexible legs which can be manipulated to improve stability.

Alternative supports

The monopod is a firm favourite for action photography, especially when used with the tripod collar that is attached part-way along some longer focal-length lenses. There are also clamps that can be mounted in birdwatching hides or over a partly opened car window; ball heads mounted on short columns with a large suction pad at the base; chestpods;

Tips
Bean bags are a particular favourite of birdwatching enthusiasts as they can be filled with bird seed, some of which can also be scattered on the ground or on a tree stump to attract birds into a photogenic setting.

clamps for screwing onto trees; and even bean bags on which to rest the lens or camera body when using a wall or other feature for support.

No single camera support will serve in every situation and most photographers end up collecting a variety over the years.

(Right) This professional tripod is built with lightweight carbon fibre.

(Below) This tripod head has a three-way pan-and-tilt mechanism to allow easy adjustment in both the horizontal and vertical planes.

(Below) Monopods such as this Gitzo model are widely used in action photography and are very light and easy to carry when closed.

ACCESSORIES

Other accessories

Canon manufacture a wide range of accessories to support the EOS 5D Mk II and a full accessories brochure can be downloaded from their website (see page 237). Here we will examine some of the most useful accessories available.

AC Adaptor kit ACK-E6
A mains adaptor enabling the use of household power directly on the EOS 5D Mk II.

Battery Pack LP-E6
A rechargeable lithium-ion battery for the 5D Mk II with a capacity of 1800 mAh. Beware of using non-Canon products.

CR1616 battery
This lithium battery is used separately on the EOS 5D Mk II for the date/time function and should last about five years.

Battery charger LC-E6E
A mains charger for the 5D's batteries.

Car charger CBC-E6E
A car charger can be very useful when you're out in the field.

CompactFlash cards
Both Type I and Type II CF cards are compatible with the 5D Mk II. A 2GB card will hold approximately 286 large/fine JPEGs, 70 RAW files, 126 sRAW1 files, or 174 sRAW2 files.

E-Series Dioptric adjustment lenses
Dioptric adjustment removes the need to wear spectacles while shooting. Available in ten strengths between +3 and -4 dioptres.

Focusing screens
The 5D Mk II is fitted with an Ef-A Standard Precision Matte screen but will also allow use of the Ef-D Precision Matte screen with grid and the Ef-S Super Precision Matte screen designed for manual focus and optimized for lenses of f/2.8 or faster. Custom Function IV-5 must be changed to suit any change of focusing screen.

Remote switch RS-80 N3

A short electronic remote-release cable for which the 33ft (10m) Extension Cord ET-1000 N3 is also available. The shutter-release switch can be half-depressed to activate autofocus and metering, just as on the camera.

Timer/Remote Controller TC-80 N3

A remote release combined with a self-timer, an interval timer, a long-exposure timer and an exposure count setting function. The timer can be set from 1 sec to 99 hrs 59 mins 59 secs. Also accepts Extension cord ET-1000 N3.

Remote Control RC-1 and RC-5

Both versions of the remote control permit use from up to 16ft (5m) away. The RC-1 permits either a 2-second delay or immediate shooting. The RC-5 version only works with a 2-second delay.

Battery grip BG-E6

An EOS 5D Mk II-dedicated grip which attaches to the base of the camera, doubles shooting time by carrying two batteries and provides an additional shutter release when shooting vertical images. It can significantly improve handling.

Eyepiece extender EP-EX15

Extends the eyepiece by 15mm to provide more comfortable viewing and also reduces contact with the LCD monitor.

Angle finder C

Allows viewing at right angles to the camera eyepiece for low-viewpoint photography.

Wireless Controller LC-5

Infra-red remote controller providing control over key camera functions from up to 330ft (100m) away.

Wireless File Transmitter WFT-E4

Looking rather like the battery grip, this unit enables secure wireless uploading of images to FTP servers and supports GPS tagging when used with a portable GPS device.

Omm 1:1.4

Chapter **8**

Connection

If you want to save and organize your images, print them, or show them to others on your TV set, it's necessary to connect your camera to a variety of other devices. Using EOS Utility software, you can connect the EOS 5D Mk II to a computer and control shooting remotely from the keyboard. Your images can be also transferred wirelessly to an FTP server using the Wireless File Transmitter WFT-E4 (sold separately, see page 217).

Connecting to a computer

Screen calibration

Before manipulating images on your computer, ensure that your monitor is calibrated for brightness, contrast and colour using dedicated software or graphics freely available on the internet. You should be able to discern a good range of tones from pure black to pure white. If the dark grey tones blend into black, the screen is too dark. If the light grey tones blend into white, the screen is too bright.

When calibrating colour on your monitor, ensure that both RGB and CMYK colours are represented. A very useful screen calibration image – which includes a colour photo, grey scales, RGB and CMYK panels, and a colour chart – can be downloaded from Adobe's website.

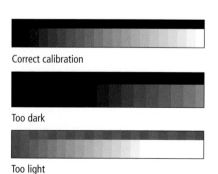

Correct calibration

Too dark

Too light

Correct colour calibration

220

Installing the software

EOS Digital Solution Disk

1) Ensure that your camera is NOT connected to your computer.

2) Insert the EOS Digital Solution Disk (provided with the camera).

3) Click on **Easy Installation** and follow the prompts through the rest of the installation procedure.

4) When installation is completed, you will be prompted to restart the computer (leave the CD in the drive).

5) When your computer has rebooted, remove the CD from the drive.

EOS Digital Software Instruction Manuals Disk

1) Insert the disk into the CD drive of the computer.

2) Open the CD in **My Computer** (or in the Finder if using a Mac).

3) Click on **START.pdf files**.

4) Adobe Reader will display the Instruction Manuals index.

5) Save each PDF file to your computer as desired.

Warning!
All Canon's software instruction manuals are in PDF format so ensure that you have the necessary reader software installed before you start. You can download Adobe Reader free from www.adobe.com.

Note
Software updates for the programs on the EOS Digital Solutions Disk are available to download from the Canon website (see page 237).

Firmware updates are also available from the Canon website. Your EOS 5D Mk II should be running version 1.0.7 or later.

1) Ensure that the camera is switched off.

2) Connect the USB cable (provided with the camera) to the camera's ⟷ terminal. Note that the ⟷ symbol must face the front of the camera.

3) Connect the other end of the cable to a USB port on the computer.

4) Turn the camera's power switch to **ON**.

5) Select **EOS Utility** from the program selection screen. Next, If the camera model selection screen is displayed, select **EOS 5D Mk II**.

6) The **EOS Utility** screen will be displayed on the computer and the direct transfer screen will be shown on the LCD monitor on the camera.

Warning!
Prior to connecting the camera to a computer, install the EOS Digital Solution Disk and ensure that the camera battery is fully charged.

Transferring images

Images will be saved in My Pictures (Windows) or Pictures (Mac) and organised by shooting date.

You can choose to transfer **All images**, **New images**, **Transfer order images**, **Select & transfer** or **Wallpaper**.

The **New images** option will select images which have not yet been transferred. The **Wallpaper** setting will not transfer RAW or sRAW images. If you choose **Select & transfer** you can use the **Transfer order** function in ▶ Playback menu 1 to select the images.

7) Select your preference for which images you wish to transfer and press the ⬜/⎙∿ button. The button's blue lamp will blink to indicate the transfer process.

8) Press **MENU** to exit.

Canon software

Canon's own software, specifically designed to work with its digital cameras, is largely aimed at EOS digital SLR users but also works with certain Powershot models. Canon has also designed the software so that it is sometimes possible to launch one program from within another. Due to the complexity of this integration, and because programs such as Digital Photo Professional and Picture Style Editor now represent significant pieces of software in their own right, only a brief outline of their capabilities can be given here. For detailed information, refer to the instruction manuals on the CD provided with your camera.

Digital Photo Professional

Digital Photo Professional is designed as a standalone RAW workflow tool that links with or incorporates other Canon software such as PhotoStitch and Picture Style Editor. It can be used to adjust RAW images, apply Picture Styles, and convert RAW to JPEG or TIFF files. It also supports the use of JPEG and TIFF files as base images with which to work. Digital Photo Professional includes sophisticated colour-management techniques including CMYK simulation.

EOS Utility

The EOS Utility software facilitates batch downloading of your images from the camera to the computer, also allowing you to only download selected images. It also enables the remote capture of images by controlling the camera from the computer. The latter supports Live View shooting in the EOS 5D Mk II. EOS Utility links with Digital Photo Professional in order to view and work with remotely captured images. It also links with Wireless File Transfer software and Original Data Security Tools.

PhotoStitch

PhotoStitch permits you to open and arrange images to be merged, saved and printed (right). However, you are limited to working with JPEG files only.

ZoomBrowser EX

ZoomBrowser EX downloads images from the camera to the computer for editing, organizing and printing. Secondary software such as Camera Window and Raw Image Task may be started from within ZoomBrowser. The programme's editing suite supports adjustments to brightness, colour, cropping, sharpness, red-eye correction, adding images to emails, creating screensavers and inserting text into images. It also facilitates the transfer of images to Canon iMAGE Gateway.

Picture Style Editor

Picture Style Editor applies six Picture Styles to base images, saving you from repeatedly making the same adjustments to each one. Each Picture Style can be customized and registered in order to fine-tune the desired results. Changes to colour tone, saturation, contrast, sharpness and gamma characteristics can all be applied. Picture styles that have been defined in-camera can also be saved onto the computer. Picture Styles can be even applied to images that have been shot previously on cameras which do not support Picture Styles.

Canon iMAGE Gateway

Canon iMAGE Gateway provides 100MB of web space, allowing you to share photos with friends and family by creating online albums. It even supports the customization of your camera by adding start-up images and sound effects as well as downloadable Picture Styles.

224

File formats

JPEG files

JPEG stands for 'Joint Photographic Experts Group', the committee that developed the format. A JPEG file uses 'lossy' compression, which means that some quality is lost. If the image is compressed too much or too frequently the image degrades significantly. A useful attribute of JPEGs for commercial purposes is that they are 'cross-platform', meaning that any file will look the same on both a Mac and a PC. Its file extensions are .JPEG or .JPG (in either upper or lower case).

JPEGs take up a lot less memory than any lossless format, regardless of whether they are saved at low, medium or high quality settings. They are useful at low resolution for use as thumbnails, for emailing, and on websites. Saved at maximum quality at 300 ppi they are good enough to be used for publication.

The disadvantage of using JPEG files is that cameras tend to perform a number of processing tasks on them at the time of shooting, so you have far less control over the final result than with a RAW file, even if you're using sophisticated post-processing software. To some extent, the EOS 5D Mk II gets around this by giving the user some control over shooting parameters.

RAW files

RAW formats leave images entirely unprocessed, making them popular with professionals who prefer to retain total control over their images. Because RAW files are uncompressed, they take up more space than typical JPEG images. This means using higher-capacity memory cards or downloading images from the camera more frequently.

The usual analogy is that RAW files are like negatives and the computer is the darkroom. With a RAW file you retain complete control over the colour temperature adjustments (for white balance), exposure, sharpness and contrast. However, RAW files cannot be opened by most image-viewing programs and require specialist software to process and save them to JPEG or TIFF. When you save a RAW image in another file format, you still retain the original file. The EOS 5D Mk II saves both RAW and sRAW files with the file extension .CR2.

However, at the time of writing, the 5D Mk II's raw files cannot be read directly by Adobe Bridge or Photoshop. Adobe provides a free conversion tool to change these files to DNG format – but conversion to DNG means that the files cannot be read by Digital Photo Professional.

Using a printer

You can connect the EOS 5D Mk II directly to a printer and print the images held on the memory card. It is even possible to pre-select which images you wish to print from the card. The camera is compatible with PictBridge. The printing procedure is controlled directly from the camera using the LCD monitor to view the operation. If your printer has slots for memory cards you may also be able to insert your memory card straight into the printer without connecting the camera.

Warning!
Printers which are only compatible with CP Direct or Bubble Jet Direct cannot be used with the EOS 5D Mk II.

Any default settings referred to in this section are the printer's default settings and not those of the camera.

Connecting to a printer

1) Check that the camera's battery is charged or use the AC Adaptor Kit ACK-E6 (sold separately) to use mains power.

2) Ensure that the camera and printer are switched off.

3) Connect the USB cable (provided) to the camera's ← terminal. The ← symbol must face the front of the camera.

4) Connect the cable to the printer according to the printer's manual.

5) Turn on the printer.

6) Turn the camera's power switch to **ON**.

7) Press the ▶ button. The ⚡ symbol will show on the monitor at top left indicating camera-printer connection. At this point some printers may emit a beep. If this beep is prolonged, there is a problem with the printer. To discover the error, press the ▶ Playback button on the camera. When the image is played back, press **SET**. On the Print Setting screen, select **Print** and the error message should be displayed on the LCD monitor. Error messages include Paper Error, Ink Error, Hardware Error, and File Error.

8) Press the ▶ Playback button to bring up the first image.

9) If this is not the image you wish to print, rotate the ◯ Quick Control Dial to select the image to be printed.

10) Press **SET**.

11) The camera's LCD monitor will display the **Print Setting** screen with a reduced image size and a list of settings (see page 228 for detailed information) covering printing effects, date, file number, quantity, trimming, paper size and layout. Amend these as desired using the ◯ Quick Control Dial and **SET** controls.

At this point you may wish to go to step 12 on page 228, where you can find the full setting procedure followed by trimming instructions. If you want to skip the full Print Settings procedure and Trimming at this stage, or are familiar with them, go to step 27 immediately below.

27) When you are ready to print, rotate the ◯ Quick Control Dial to highlight **Print** and press **SET**.

28) The 🔲/🖨∿ Print/share button's blue lamp will blink and printing will start.

29) While **Stop** is displayed you can stop printing by pressing **SET** and then **OK**.

30) To print further images using the same settings, select the first image to be printed and press the 🔲/🖨∿ Print/share button. Repeat as necessary.

31) When you've finished printing, turn off the camera and the printer.

32) Disconnect the cable.

> **Tips**
> It is also possible to print RAW and sRAW images recorded with the EOS 5D Mk II.
>
> More information about using Canon cameras with PictBridge can be found on Canon's website (see page 237).

Paper Settings

12) From the **Print Setting** screen reached in step 11, rotate the ⊙ Quick Control Dial to select **Paper Settings** and press **SET**.

13) The **Paper Size** screen will be displayed. Rotate the ⊙ Quick Control Dial to select the dimensions of the paper to be used and press **SET**. (If you are intending to trim the image, choose an appropriate ratio.)

14) The **Paper Type** screen will be displayed. Rotate the ⊙ Quick Control Dial to select the type of paper to be used for printing and press **SET**.

Note
The extent to which your printer supports different functions will determine whether or not some functions will be displayed or can be performed.

15) The **Page Layout** screen will appear. Rotate the ⊙ Quick Control Dial to select the **Page Layout** to be used and press **SET**.

16) The display will now revert to the **Print Setting** screen.

Print Settings

Bordered	The print will have a white border along each edge.
Borderless	The print will have no white borders. (If your printer cannot print borderless prints, the print will still have borders.)
Bordered 🅸	The shooting information will be imprinted on the border of prints that are 3½ × 5in (9 × 13cm) or larger prints.
xx-up	Option to print 2, 4, 8, 9, 16 or 20 images on one print.
20-up/35-up	On A4 or Letter size paper, 20 or 35 thumbnails of DPOF ordered images will be printed.
20-up 🅸	Shooting information will be printed on the border.
Default	Page layout will depend on the printer type and its default settings.

Shooting information from the Exif data will include camera name, lens, shooting mode, shutter speed, aperture, exposure compensation, ISO speed, white balance.

228

Printing Effects

17) From the **Print Setting** screen, rotate the ⊙ Quick Control Dial to select the option on the upper right and press **SET**.

18) The **Printing Effects** screen will be displayed. Use the ⊙ Quick Control Dial to select each item to change and press **SET**. Refer to the table below for information on the options available. The actual display will depend on the printer being used. The

table is based on the assumption that the full list of effects will be available.

19) If the ⊞ icon is displayed next to INFO on the **Printing Effects** screen, additional options are available if you press the camera's **INFO** button. The options available will depend on the choices you made from the table below. If no options are available, skip this step.

Preset Printing Effects	
Item	**Description**
⊙ Off	No automatic correction will be performed.
⊙ On	The image will be printed according to the printer's standard colours. The image's Exif data is used to make automatic corrections.
⊙ Vivid	The image will be printed with higher saturation to produce more vivid blues and greens.
⊙ NR	The image noise is reduced before printing.
B/W B/W	Prints in black and white with true blacks.
B/W Cool tone	Prints in black and white with cool, bluish blacks.
B/W Warm tone	Prints in black and white with warm, yellowish blacks.
🖻 Natural	Prints the image in the actual colours and contrast. No automatic colour adjustments will be applied.
🖻 Natural M	The printing characteristics are the same as the **Natural** setting. However, this setting enables finer printing adjustments than with the **Natural** setting.
⊙ Default	The printing will differ depending on the printer. For details, see the printer's instruction manual.

* The screen display may differ depending on the printer.
* When the printing effects are changed, the changes will be reflected on the screen. However, the actual result of the printing effects might look different from what you see on screen. The screen only shows an approximate rendition.

Adjustable Printing Effects

Brightness	The image brightness can be adjusted.
Adjust levels	When you select **Manual**, you can change the histogram's distribution and adjust the image's brightness and contrast. With the **Adjust Levels** screen displayed, press the **INFO** button to change the position of the indicator. Turn the ◯ Quick Control Dial to freely adjust the shadow level (0–127) or highlight level (128–255).
Brightener	Effective in back-lit conditions which can make the subject's face look dark. When **On** is set, the face will be brightened for printing.
Red-eye corr.	Effective in flash images where the subject has red eye. When **On** is set, the red eye will be corrected for printing.

* The **Brightener** and **Red-eye corr.** effects will not show up on the screen.
* When you select **Detail set.** you can adjust the **Contrast**, **Saturation**, **Colour tone** and **Colour balance**.
* When you select **Clear all**, all the printing effects will revert to the default.

Date / Time / File Number

20) Rotate the ◯ Quick Control Dial to select ⊘, then press **SET**.

21) Use the ◯ Quick Control Dial to select the desired setting and press **SET**.

Number of copies

22) Rotate the ◯ Quick Control Dial to select 🖫 then press **SET**. Use the ◯ Quick Control Dial to select desired setting and press **SET**.

23) Go to step 27 on page 227 to start printing.

Trimming the image

Trimming should only be done after the other print settings are completed.

24) On the **Print Setting** screen, select **Trimming**.

25) Use the ⊞/⊕ Enlarge and ✳/◳• ⊖ Reduce buttons to adjust the size of the trimming frame and the ❖ Multi-controller to move the frame.

26) Press the **INFO** button to rotate the image through 90°. Use the ◯ Quick Control Dial to rotate the image by up to +/- 10°. Press **SET** to exit Trimming and go back to step 27 on page 227.

Commonly abbreviated to DPOF, this is a system for recording printing instructions to the memory card. The DPOF system is managed through the Print Order option in ► Playback menu 1. With the camera connected to a compatible printer, it is possible to use the **Print Order** menu to manage the direct printing of your images from the memory card in the camera. Digital Print Order Format (DPOF) settings can be applied to all JPEG images on the memory card or to selected images. However, different settings cannot be applied to individual images. The same print type, date and file number settings will be applied to all print-ordered images.

Print ordering

Before printing with DPOF, you will need to select the images you wish to print. You can do this with single images displayed on the monitor or a group of three images. Use the ✳/▦•⊖ Reduce button and the ▦/⊕ Enlarge button to toggle between the two different display formats.

When you have decided which image to print, press **SET**. This will automatically order a single print of that image. If you require more than one, rotate the ◌ Quick Control Dial to set the desired number of copies, to a maximum of 99.

You can create an index sheet from the menu, or select **All images** which will add all the photos on the memory card to the print order. Even if you select **All images**, any RAW or sRAW files on the memory card will not be included.

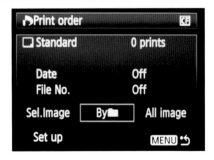

Common errors

RAW and sRAW images cannot be selected for DPOF.

You must use the memory card for which DPOF specifications have been set. Do not use a memory card for which DPOF specifications have been set on a different camera body.

Setting the printing options

1) Select ⏎ on the camera power switch.

2) Press the **MENU** button and use the ⚙️ Main Dial to scroll through the menus until you reach ▶ Playback Menu 1.

3) Rotate the ⭕ Quick Control Dial to select **Print order** and press **SET**.

4) Rotate the ⭕ Quick Control Dial to select **Set up** and press **SET**.

5) To set a particular item, rotate the ⭕ Quick Control Dial to select the item and press **SET**.

6) Set all the Print type, Date and File number options as desired (see table below).

7) Press **MENU** and the Print order screen will reappear. Choose **Select Image**, **By**📷 or **All images** to order printing.

Common errors
Date and File number printing is dependent on the Print type setting and printer model.

Printing Options		
Print type	● Standard	Prints one image on one sheet.
	⊞ Index	Multiple thumbnail images are printed on one sheet.
	● ⊞ Both	Prints both the standard and index prints.
Date	On	**On** imprints the recorded date on the print.
	Off	
File No.	On	**On** imprints the file number on the print.
	Off	

The EOS 5D Mk II comes supplied with the leads necessary for this method of playing back your photos on a television, which is an ideal way of displaying them to large numbers of friends and family.

To connect to a television:

1) Ensure that both the camera and television are turned off.

2) Open the terminal cover on the camera's left side.

3) Insert the stereo video cable into the camera's **A/V OUT** terminal.

4) Insert the other end of the stereo video cable into the television set's **VIDEO IN** and **AUDIO IN** terminals.

5) Switch on the television and select the **VIDEO IN** channel.

6) Turn the camera's power switch to **ON**.

7) Press the ▶ Playback button on the camera. When images are displayed on the television the camera's LCD monitor will remain blank. However, you can manage playback options on television using the camera's controls just as you would when using the camera's LCD monitor.

8) To disconnect, turn the camera's power switch to **OFF**, turn off the television and disconnect the video cable.

Common problems

If the video system selected in Set-up menu 2 does not match that of the television, images will not be displayed properly. Change the camera setting.

Some televisions use different screen formats. You may need to consult your television's instruction manual to change the screen format.

Tip
Using the same camera/television connections it is also possible to take photos and to manage the camera's menus while connected to the television.

Glossary

Aberration An imperfection in the image caused by the optics of a lens.

AE (auto exposure) lock A camera control that locks in the exposure value, allowing an image to be recomposed.

Angle of view The area of a scene that a lens takes in, measured in degrees.

Aperture The opening in a camera lens through which light passes to expose the CMOS sensor. The relative size of the aperture is denoted by f-stops.

Autofocus (AF) A reliable through-the-lens focusing system allowing accurate focus without the user manually turning the lens.

Bracketing Taking a series of identical pictures, changing only the exposure, usually in half or one f-stop (+/-) differences.

Buffer The in-camera memory of a digital camera.

Burst size The maximum number of frames that a digital camera can shoot before its buffer becomes full.

Cable release A device used to trigger the shutter of a tripod-mounted camera at a distance to avoid camera shake.

Centre-weighted metering A way of determining the exposure of a photograph placing importance on the light-meter reading at the centre of the frame.

Chromic aberration The inability of a lens to bring spectrum colours into focus at one point.

CMOS (complementary oxide semi-conductor) A microchip consisting of a grid of millions of light-sensitive cells – the more sensors, the greater the number of pixels and the higher the resolution of the final image.

Colour temperature The colour of a light source expressed in degrees Kelvin (°K).

CompactFlash card A digital storage mechanism offering safe, reliable storage.

Compression The process by which digital files are reduced in size.

Contrast The range between the highlight and shadow areas of an image, or a marked difference in illumination between colours or adjacent areas.

Depth of field (DOF) The amount of an image that appears acceptably sharp. This is controlled by the aperture: the smaller the aperture, the greater the depth of field.

Dioptre Unit expressing the power of a lens.

dpi (dots per inch) Measure of the resolution of a printer or a scanner. The more dots per inch, the higher the resolution.

Dynamic range The ability of the camera's sensor to capture a full range of shadows and highlights.

EF (extended focus) lenses Canon's range of fast, ultra-quiet autofocus lenses.

Evaluative metering A metering system whereby light reflected from several subject areas is calculated based on algorithms.

234

Exposure The amount of light allowed to hit the CMOS sensor, controlled by aperture, shutter speed and ISO-E. Also the act of taking a photograph, as in 'making an exposure'.

Exposure compensation A control that allows intentional over- or under-exposure.

Extension tubes Hollow spacers that fit between the camera body and lens, typically used for close-up work. The tubes increase the focal length of the lens, and magnify the subject.

Fill-in flash Flash combined with daylight in an exposure. Used with naturally back-lit or harshly side-lit or top-lit subjects to prevent silhouettes forming, or to add extra light to the shadow areas of a well-lit scene.

Filter A piece of coloured, or coated, glass or plastic placed in front of the lens.

f-stop Number assigned to a particular lens aperture. Wide apertures are denoted by small numbers such as f/2; and small apertures by large numbers such as f/22.

Focal length The distance, usually in millimetres, from the optical centre point of a lens element to its focal point.

Focal length and multiplication factor. The CMOS sensor of the EOS 5D Mk II measures 22.2 × 14.8mm – smaller than 35mm film. The effective focal length of the lens appears to be multiplied by 1.6.

fps (frames per second) The ability of a digital camera to process one image and be ready to shoot the next.

Histogram A graph used to represent the distribution of tones in an image.

Hotshoe An accessory shoe with electrical contacts that allows synchronization between the camera and a flashgun.

Hotspot A light area with a loss of detail in the highlights. This is a common problem in flash photography.

Incident-light reading Meter reading based on the light falling on the subject.

Interpolation A way of increasing the file size of a digital image by adding pixels, thereby increasing its resolution.

ISO-E (International Organization for Standardization) The sensitivity of the CMOS sensor measured in terms equivalent to the ISO rating of a film.

JPEG (Joint Photographic Experts Group) JPEG compression can reduce file sizes to about 5% of their original size.

LCD (liquid crystal display) The flat screen on a digital camera that allows the user to preview digital images.

Macro A term used to describe close focusing and the close-focusing ability of a lens.

Megapixel One million pixels equals one megapixel.

Memory card A removable storage device for digital cameras.

Microdrives Small hard disks that fit in a CompactFlash slot, resulting in larger storage capabilities.

Mirror lock-up A function that allows the reflex mirror of an SLR to be raised and held in the 'up' position, before the exposure is made.

Pixel Short for 'picture element' – the smallest bits of information in a digital image.

Predictive autofocus An autofocus system that can continuously track a moving subject.

Noise Coloured image interference caused by stray electrical signals.

Partial metering A metering system that is unique to Canon, it meters a relatively small area at the centre of the frame.

PictBridge The industry standard for sending information directly from a camera to a printer, without having to connect to a computer.

Red-eye reduction A system that causes the pupils of a subject to shrink by shining a light prior to taking the flash picture.

RAW The file format in which the raw data from the sensor is stored without permanent alteration being made.

Resolution The number of pixels used to capture or display an image. The higher the resolution, the finer the detail.

RGB (red, green, blue) Computers and other digital devices understand colour information as combinations of red, green and blue.

Rule of thirds A rule of thumb that places the key elements of a picture at points along imagined lines that divide the frame into thirds.

Shading The effect of light striking a photosensor at anything other than right angles, incurring a loss of resolution.

Shutter The mechanism that controls the amount of light reaching the sensor by opening and closing.

SLR (single lens reflex) A type of camera (such as the EOS 5D Mk II) that allows the user to view the scene through the lens, using a reflex mirror.

Spot metering A metering system that places importance on the intensity of light reflected by a very small portion of the scene.

Teleconverter A lens that is inserted between the camera body and main lens, increasing the effective focal length.

Telephoto lens A lens with a large focal length and a narrow angle of view.

TTL (through the lens) metering A metering system built into the camera that measures light passing through the lens at the time of shooting.

TIFF (Tagged Image File Format) A universal file format supported by virtually all relevant software applications. TIFFs are uncompressed digital files.

USB (universal serial bus) A data transfer standard, used by the Canon EOS 5D Mk II when connecting to a computer.

Viewfinder An optical system used for composing and sometimes focusing the subject.

White balance A function that allows the correct colour balance to be recorded for any given lighting situation.

Wide-angle lens A lens with a short focal length and consequently a wide angle of view.

Useful websites

CANON

Worldwide Canon Gateway
www.canon.com

Canon USA
www.usa.canon.com

Canon UK
www.canon.co.uk

Canon Europe
www.canon-europe.com

Canon Oceania
www.canon.com.au

Canon EOS
Site dedicated to the EOS range
of cameras and accessories
www.canoneos.com

Canon Camera Museum
Online history of Canon cameras and
their technology and design
www.canon.com/camera-museum

Canon Enjoy Digital SLR Cameras
A website from Canon with advice on
how to use digital SLRs
web.canon.jp/Imaging/enjoydslr/index.html

GENERAL SITES

Photonet
Photography discussion forum
www.photo.net

The EOS Experience
EOS-related seminars
www.eos-experience.co.uk

Bureau of Freelance Photographers
Expert advice and tuition for freelance
and aspiring freelance photographers
www.thebfp.com

ePHOTOzine
Online magazine with a photographic
forum, features and monthly competitions
www.ephotozine.co.uk

SOFTWARE

Adobe USA
www.adobe.com

Adobe UK
www.adobe.co.uk

EQUIPMENT

SanDisk
CompactFlash cards
www.sandisk.com

Speedgraphic
Mail order dealers in photographic
equipment and materials
www.speedgraphic.co.uk

PHOTOGRAPHY PUBLICATIONS

Photography books
www.pipress.com

***Black & White Photography* magazine**
***Outdoor Photography* magazine**
www.thegmcgroup.com

EOS magazine
www.eos-magazine.com

Index

Contact us for a complete catalogue or visit our website:
Ammonite Press, Castle Place, 166 High Street, Lewes, East Sussex, BN7 1XU, United Kingdom
Tel: 01273 488005 Fax: 01273 402866
www.ae-publications.com